The Life and Death of
Buffalo's Great Northern Grain Elevator

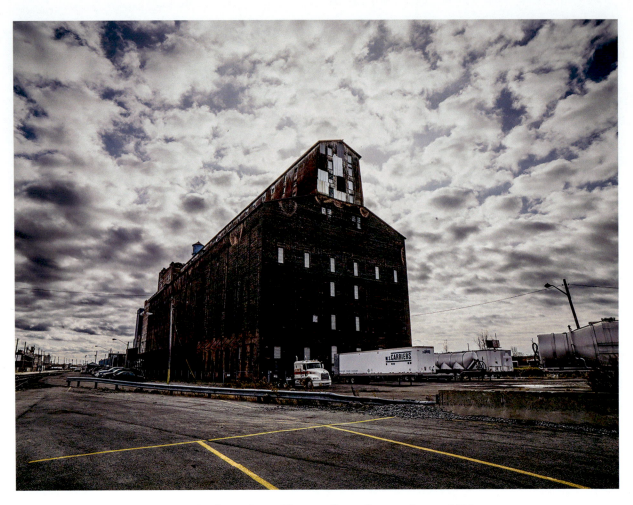

Great Northern Grain Elevator from Ganson Street, 2010.

The Life and Death of Buffalo's Great Northern Grain Elevator

1897–2023

BRUCE JACKSON

EXCELSIOR
EDITIONS

Published by the State University of New York Press, Albany

© 2024 State University of New York

All rights reserved

Printed in the United States of America

No part of this book may be used or reproduced in any manner whatsoever without written permission. No part of this book may be stored in a retrieval system or transmitted in any form or by any means including electronic, electrostatic, magnetic tape, mechanical, photocopying, recording, or otherwise without the prior permission in writing of the publisher.

Excelsior Editions is an imprint of State University of New York Press

For information, contact State University of New York Press, Albany, NY
www.sunypress.edu

Library of Congress Cataloging-in-Publication Data

Name: Jackson, Bruce, 1936– author.
Title: The life and death of Buffalo's Great Northern Grain Elevator : 1897–2023 / Bruce Jackson.
Description: Albany, NY : State University of New York Press, [2024] | Includes bibliographical references and index.
Identifiers: LCCN 2023033023 | ISBN 9781438497037 (pbk. : alk. paper) | ISBN 9781438497044 (ebook)
Subjects: LCSH: Great Northern Grain Elevator (Buffalo, N.Y.) | Grain elevators—New York (State)—Buffalo. | Historic warehouses—New York (State)—Buffalo. | Lost architecture—New York (State)—Buffalo. | Historic preservation—New York (State)—Buffalo. | Buffalo (N.Y.)—Buildings, structures, etc.
Classification: LCC F129.B88 G745 2024 | DDC 974.7/97—dc23/eng/20231018
LC record available at https://lccn.loc.gov/2023033023

10 9 8 7 6 5 4 3 2 1

The grain elevators of Buffalo comprise the most outstanding collection of extant grain elevators in the United States, and collectively represent the variety of construction materials, building forms, and technological innovations that revolutionized the handling of grain in this country.

—US Department of the Interior, "Historic American Engineering Report: The Great Northern" (1990)

"When I use a word," Humpty Dumpty said in rather a scornful tone, "it means just what I choose it to mean—neither more nor less."

"The question is," said Alice, "whether you can make words mean so many different things."

"The question is," said Humpty Dumpty, "which is to be master—that's all."

—Lewis Carroll, *Through the Looking Glass* (1871)

I am his Highness' dog at Kew
Pray tell me, sir, whose dog are you?

—Alexander Pope (1738)

Contents

Acknowledgment and Sources　　　　　　　　　　　　　　　　　　　ix

Chronology　　　　　　　　　　　　　　　　　　　　　　　　　　　xi

I: The Life and Death of the Great Northern Grain Elevator, 1897–2023

Chapter 1.　A Fierce Wind　　　　　　　　　　　　　　　　　　　　3

Chapter 2.　Buffalo and Its Grain Elevators　　　　　　　　　　　　　5

Chapter 3.　Buffalo's Architecture　　　　　　　　　　　　　　　　　7

Chapter 4.　The Great Northern　　　　　　　　　　　　　　　　　　9

Chapter 5.　After the Fall　　　　　　　　　　　　　　　　　　　　11

Chapter 6.　The Fire Commissioner's Fears　　　　　　　　　　　　13

Chapter 7.　The Mayor Waffles　　　　　　　　　　　　　　　　　　17

Chapter 8.　Parsing the President (of ADM)　　　　　　　　　　　　21

Chapter 9.　Before the Bar　　　　　　　　　　　　　　　　　　　25

Chapter 10. Two Courtly Matters　　　　　　　　　　　　　　　　　35

Chapter 11. Four Red Herrings　　　　　　　　　　　　　　　　　　37

Chapter 12. Reason　　　　　　　　　　　　　　　　　　　　　　　43

Chapter 13. If　　　　　　　　　　　　　　　　　　　　　　　　　45

Chapter 14. What Paul McDonnell Said　　　　　　　　　　　　　　47

Chapter 15. Utility　　　　　　　　　　　　　　　　　　　　　　　49

Chapter 16. Some Things I Heard　　　　　　　　　　　　　　　　　51

Chapter 17. Me	53
Chapter 18. What the Great Northern Said	55

II: Photographs

Plates	59

III: Documents

HAER Report text and drawings	122–156
ADM Submission to Commissioner James Comerford, Dec. 15, 2021 (not exhibits)	157–166
Commissioner James Comerford: Great Northern Condemnation Dec. 17, 2021	167–168
Rep. Brian Higgins to ADM president Juan Luciano, Dec 13, 2021	169
Anne Dafchik, President, AIA Buffalo/WNY, to Mayor Byron Brown, Dec. 16, 2021	170–171
Mayor Byron Brown to ADM President Juan Luciano, Dec. 23, 2021	172
New York AIA President Paul McDonnell to Mayor Byron Brown, January 9, 2022, with key graphic documentation from HAER Report and other sources.	173–182
Campaign for Greater Buffalo graphic showing vertical beam supports of the Great Northern	183
Index	185

Acknowledgments and Sources

Two books provided much of my understanding of the history of Buffalo's grain elevators, their place in Buffalo's industrial economy, and their global importance as cultural objects. The first was Reyner Banham's *A Concrete Atlantis: U.S. Industrial Building and European Modern Architecture, 1900—1925* (Cambridge, MA: MIT Press, 1986). The second was a volume Lynda Schneekloth edited, *Reconsidering Concrete Atlantis: Buffalo Grain Elevators* (Buffalo: University at Buffalo School of Architecture and Planning, Urban Design Project, and The Landmark Society of the Niagara Frontier, 2007).

The most useful document on the design and history of the Great Northern, and the people who built it and organizations that owned it, is the 1990 Historic American Engineering Record (HAER), "Great Northern Elevator, 250 Ganson Street, Buffalo, Erie County, NY." A full copy of the text and the report's two supplementary drawings are included in the "Documents" section of this book. (The HAER Report, the two drawings, and all fifty of Jet Lowe's Great Northern photographs are online and available for download on the Library of Congress website: https://www.loc.gov/item/ny1668/.)

The section "Buffalo and its Grain Elevators" is adapted from the introduction to my *American Chartres: Buffalo's Waterfront Grain Elevators* (State University of New York Press, 2016).

My thanks to Anthony Greco, Director of Exhibits and Interpretive Planning, for scheduling the exhibit of many of the photographs included here (May 17–August 31, 2024). That exhibit provided the impetus for this book.

Thanks to the University at Buffalo for its long and generous support of my research.

Thanks to the Library of Congress for its American Memory project; a huge wealth of material on an enormous range of subjects (including the HAER Report) is online and freely available. I remember hearing James Billington, Librarian of Congress, talk about the American Memory project in 1989 at the Washington Press Club and later that same year in his office overlooking the Capitol. Both times he said the same thing. It was something like, "We've got to get these things out of this building and to a place where anyone, anywhere, can have free access to them." A year later, American Memory went online and Jim Billington's vision of free access has been growing exponentially ever since.

Thanks to Diane Christian, Rachel Jackson, James Dady, and Larry Mruk for assistance and advice.

Most of all, thanks to Tim Tielman, who pointed me to many of the documents I cite in this book and who quickly answered scores of my questions about the Great Northern and the court proceedings that resulted in its demolition. Many people tried to save the Great Northern. No one, I think, fought as diligently and long on its behalf as Tim, and to him this book is dedicated.

—B. J.
June 1, 2023

Chronology

(Asterisked items are included in the "Documents" section of this book, beginning on page 121.)

1824
First Welland Canal, with forty wooden locks, connecting Port Colborne in Lake Erie to Port Weller on Lake Ontario, opens forty miles west of Buffalo.

1825
Erie Canal opens.

1842
Joseph Dart and Robert Dunbar build first steam-powered grain elevator with a moveable marine leg, vastly increasing speed with which boats could be unloaded. Humans could unload sixty bushels an hour, the marine leg could unload two thousand bushels an hour.

1893
February: The Great Northern Railroad Company begins excavation work for Great Northern Grain Elevator.

September 29: First cargo arrives.

1907
Portion of south wall collapses in 87-mph windstorm and, as soon as warm weather arrives, is repaired in a few months.

1903
Purchased by Mutual Elevator Company.

1906
Buffalo's first reinforced-concrete elevator, the Washburn Crosby B, in operation.

1921

Purchased by Island Warehouse Company.

Southern and middle 125-foot towers blown into canal-boat slip adjacent to north wall. A worker had neglected to lock them down, so they rolled along their rails until their rails ran out. The third tower is taken down. They are replaced by two 145-foot towers built by Monarch Engineering.

1924

Flour mill built adjacent to Great Northern.

1932

Fourth Welland Canal, wide and deep enough to accept large ships, opens.

1935

Purchased by Pillsbury Company.

1959

St. Lawrence Seaway, giving Upper Great Lake ports direct route to the Atlantic Ocean, opens.

1981

Great Northern taken out of operation (some sources say 1982).

1993

Purchased by ADM Milling Company.

2006

Buffalo's last surviving wood elevator, the Wollenburg (built 1912), burns and is demolished. The concrete H-O Oats elevator (built 1911) demolished to make room for gambling casino parking lot.

2021

December 11: large segment of Great Northern's north wall collapses in windstorm.

December 13: Congressman Bryan Higgins (NY 26) writes Juan R. Luciano, ADM's board chair, president, and CEO, urging rehabilitation and preservation of the Great Northern. He mentions tax credit programs that could help with this and requests a meeting.*

City of Buffalo issues an "Order to Remedy" directing ADM to "provide Buffalo with a statement of Intent on the repair plan or demolition to the damaged section of the building withing five days."

December 15: ADM submits "Submission Concerning Emergency Demolition Order Due to Safety." It is stamped "RECEIVED AND FILED" and signed by "James Comerford Jr." (Printed under the signature is "Commissioner, Permit & Inspections.")*

December 16, 2021: Anne Dafchik, President of the Buffalo chapter of the American Institute of Architects (AIA) writes Mayor Brown and other elected officials, urging a sixty-day moratorium

on demolition, citing the structure's historical importance architecturally and in terms of Buffalo's history. She offers AIA's support in researching the issue.*

December 16: Bakery, Confectionery, Tobacco Workers and Grain Millers Local 36G announces "they are interested in determining the feasibility of purchasing the endangered Great Northern Grain Elevator and re-purposing it as a Union Hall to serve their members as well as a public museum space."

December 17: James Comerford Jr, Buffalo Commissioner of the Department of Permit & Inspection Services send New York Department of Labor, Division of Safety and Health, a "Notice of Condemnation" for "8 CITY SHIP CANAL AKA 250 GANSON." The notice ends: "Due to emergency conditions, we request that the ten-day notification be waived."*

December 19: Developer Douglas Jemal offers to fix the hole in the north wall and to purchase the Great Northern.

December 19: The Campaign for Greater Buffalo History, Architecture & Culture (petitioner) requests an Order to Show Cause with a Temporary Restraining Order (TRO) on the City of Buffalo and ADM Milling Co. (respondents). Emergency Judge Dennis E. Ward issues the TRO halting demolition until a court hearing on December 22, 2021.

December 23, 2021: Buffalo Mayor Byron Brown writes Archer Daniels Midland CEO Juan Luciano urging him to preserve the Great Northern.*

December 30, 2021: Judge Emilio Colaiacovo continues the restraining order and sets a January 3, 2022, hearing date.

2022

January 3: Hearing on the Campaign for Greater Buffalo's Article 78 motion.

January 5: Judge Colaiacovo vacates restraining order, allowing demolition to proceed.

January 9, 2022: Paul McDonnell, president of the Campaign for Greater Buffalo, former chair of the Buffalo Preservation Board, and Buffalo city architect for twenty-five years, writes documented letter to Mayor Byron Brown, urging him to rescind Comerford's demolition order.*

January 14, 2022: Fourth Department of New York's Appellate Division reinstates the TRO; it extends that the following day and enjoins the City of Buffalo and ADM from "taking any steps to demolish the Great Northern."

January 31: James Comerford Jr. retires.

April 29: Fourth Department reverses Colaiacovo's January decision and order because he allowed testimony and evidence from a witness for ADM and the City of Buffalo (the respondents) but not from the Campaign for Greater Buffalo (the petitioner).

June 2–3: Colaiacovo holds fact-finding hearings, this time allowing both sides to offer evidence and present witnesses.

July 5, 2022: Colaiacovo again rules for the respondents and lifts the TRO.

September 15: Preservation Buffalo Niagara writes ADM President/CEO Juan Luciano urging a stay on demolition and offering a long-term lease partnership in which PBN would be a steward of the building.

September 15: Judge Colaiacovo dismisses Campaign for Greater Buffalo's Article 78 and TRO petition.

September 16: Demolition begins on north wall and bins

December 12: Court of Appeals hears second appeal from the Campaign for Greater Buffalo. The appeal is denied.

2023

April 26: South marine leg, last metal part of Great Northern, is pulled down.

I

The Life and Death of the Great Northern Grain Elevator, 1897–2023

1

A Fierce Wind

Archer Daniels Midland Milling Co. got lucky the night of December 11, 2021: a fierce winter wind took out a third of the north brick wall of the Great Northern Grain Elevator on Ganson Street in Buffalo. ADM had wanted to demolish the Great Northern soon after it purchased the elevator from Pillsbury in 1993, but each of its demolition requests to the city had been blocked by the Preservation Board, the Common Council, and preservationist groups. The elevator had been inactive since 1981.

That hole in the wall changed everything. Four days later, on December 15, ADM submitted a request to do an emergency demolition. Two days after that, with no public hearings and minimal inspection of the elevator, and less apparent knowledge of its structure, James Comerford Jr., Buffalo Commissioner of Permit and Inspection Services, issued a condemnation order. He gave bullet-point reasons, all of which turned out to be peripheral or spurious.

There were court actions: ADM wanted to move ahead with the demolition (rumored to be so it could use the space for a truck parking lot); preservationists wanted the structure repaired and maintained because of its unique place in Buffalo's economic history and global architectural history.

There had been a similar collapse in the south wall in 1907. It had been repaired in a few months. The brick curtain wall presented no other problems until the collapse of part of the north wall December 11, 2021, more than a century later. There was no reason why it should: it was well made and, other than the lakefront winds and lack of maintenance for decades, it had borne no burdens: it supported nothing. Its only function was to shield the steel grain elevator and workers on the floor from rain, wind, and snow, and to minimize the effects of winter cold and summer heat.

In two rulings, the first on January 5, 2022, and the second on July 5, 2022, New York State Supreme Court[1] Judge Emilio Colaiacovo seemed to take all statements from Comerford and ADM's consultants at face value and seemed to discount all comments from expert witnesses speaking for the Campaign for Greater Buffalo History, Architecture & Culture (hereafter, the Campaign for Greater

1. In New York State, the "Supreme Court" is the lowest level of the state judiciary. Above it is the Appellate Division, and above that the Court of Appeals, which is the highest state court.

Buffalo), a local nonprofit preservation organization, because they were "biased." Their bias? They were experts on and were interested in preservation of historically important buildings. He held up dismissing the second restraining order case for ten weeks—from July 5 until September 15, 2022. Demolition began the following day.

During the time between Judge Colaiacovo's denial of the petition from the Campaign for Greater Buffalo and his dismissal of the case, ADM was able to get the key demolition equipment it needed in place—particularly the Caterpillar 165' Ultra High Demolition Excavator, only three of which were then available in the United States. Because the case was still in limbo, the Campaign for Greater Buffalo was blocked from submitting an appeal. By the time the judge did dismiss the case and the organization's pro bono lawyers were able to submit an appeal, the 165' Cat UHD had made its way from Florida to Buffalo and demolition was well underway.

Not that it mattered: the organization's appeal was quickly denied by a Fourth District judge based in Buffalo. Neither the preservationists nor the Great Northern ever had a chance.

2

Buffalo and Its Grain Elevators

Thanks to the Erie Canal, which was completed in 1825, Buffalo went from being a small village at the beginning of the nineteenth century to one of the richest cities in America at the end of it. Because of the confluence of the waterways and the technology of the grain elevator, Buffalo was the world's largest grain port through the second half of the nineteenth century. Shipping across the Great Lakes from the west could connect to the world via the Erie Canal, which had its western terminus in Buffalo. Raw materials moved east and processed goods moved west, and Buffalo was the hinge that made it all work. The inexhaustible nearby power source at Niagara Falls turned Buffalo into a major manufacturing center as well. Huge steel mills were built there because the ore could be shipped in cheaply and the mills could be powered cheaply. Hundreds of smaller manufacturing industries that could profit from easy access to heavy metal appeared, making the city even richer.

Like aircraft carriers and the great cathedrals of Europe, grain elevators are huge, complex machines with a single function. Aircraft carriers are designed to give aircraft a runway from which to take off and on which to land far from any friendly airfield. The cathedrals were machines designed to put the individual in closer context with divinity. The elevators were machines designed to lift grain from one transportation mode and store it in bins until it could be dropped into another. "What makes an elevator an elevator," the architectural critic Reyner Banham (who spent 1976–1980 in Buffalo) wrote, "is not that it occupies a particular building form, but that it has machinery for raising the grain to the top of the storage bins."[1]

The grain shipped to Buffalo's grain elevators would be dropped into boats, trains, or trucks that would take it elsewhere to be milled. Some of those mills were nearby; most of the grain was shipped to other parts of the United States, to Europe, and elsewhere.

1. Reyner Banham, *A Concrete Atlantis: U.S. Industrial Building and European Modern Architecture, 1900–1925* (Cambridge, MA: MIT Press, 1986), 109.

Buffalo's grain elevators—the 70- to 140-foot-tall structures along the Buffalo River, Buffalo's City Ship Canal, and the southern tip of Lake Erie—were invented in Buffalo in 1842 and 1843 by Joseph Dart, a merchant, and Robert Dunbar, an engineer. The problem they set out to solve was twofold. It involved the huge quantities of grain transshipped through Buffalo across the Great Lakes from the west and along the Erie Canal to the east. Grain arrived in huge ships, but it left Buffalo in small canal barges; the longer grain remained in storage, the more susceptible it was to vermin and rot. How could the merchants and brokers manage that traffic differential, and how could they be sure that the oldest grain went out first? The solution invented by Dart and Dunbar centered on a device called the "marine leg," which drew grain from the large lake ships and carried it to the tops of the "marine towers." Grain being processed at mills in Buffalo or shipped east would then be drawn from the bottom in whatever quantities were required at the moment. The oldest grain went out first.

The Erie Canal was made obsolete by railroads, which were a far more expensive way to move goods than the lakes and canals but got things where they were going far more quickly and didn't have to shut down in winter because of ice. The railroads, in turn, were made partially obsolete by trucks moving on paved highways, which could be set almost anywhere and weren't dependent on flatland routes.[2]

Various factors contributed to the demise of Buffalo's shipping industry. Water, which was the key to the beginning was the key to the end: the Welland Ship Canal (the fourth and largest version of which was built in 1932) let lake shipping get from Lake Erie to Lake Ontario west of Buffalo, and the St. Lawrence Seaway (1959) cut a waterway from Lake Ontario to Montreal and the Atlantic Ocean. And the railroads could ship anything anywhere, with no need to transship to another mode in Buffalo and, indeed, no need to transship at all.

2. The best summary of all of this, and the larger legal and economic context in which it is embedded, is John Henry Schlegel's *While Waiting for Rain: Community, Economy, and Law in a Time of Change* (Ann Arbor: University of Michigan Press, 2022).

3

Buffalo's Architecture

Buffalo is a museum of great architecture. It is home to important buildings by Frank Lloyd Wright, Louis Sullivan, H. H. Richardson, Eliel and Eero Saarinen, Louise Blanchard Bethune, Stanford White, and others. It has what is arguably Frederick Law Olmsted's most complex work: a group of parks linked by a network of broad parkways crossing much of the city.

Some of that work has been destroyed: Wright's Larkin Administration Building, constructed in 1904, was demolished in 1950 to make room for a truck stop that was never built. (But seven other Wright buildings survive.) A key section of one of Olmsted's parkways was torn up to make room for a highway from downtown to the suburbs, a smaller highway bisects the largest of his Buffalo parks, one of his parks was mostly taken over for a bridge plaza and government offices, and most of the campus he designed for Richardson's enormous psychiatric center has been taken over by a state college. (But most of his park and parkway system survives, and some of the mutilated parts may be restored.) Some of the classics barely escaped the executioner: Louis Sullivan's magnificent Guaranty Building, the first skyscraper, was near demolition when it was rescued and restored by Hodgson Russ, a law firm.

Enough of that classic residential, landscape, institutional, and commercial architecture survives to make Buffalo a major architectural destination.

The grain elevators are part of that architectural heritage—grittier than the well-wrought buildings of Mead, McKim and White, lacking the exquisite ornamentation of Louis Sullivan, but, in their own way, exquisite in their simplicity and functionality. The houses and office buildings in town designed by those nineteenth- and early-twentieth-century masters are great examples of their mature work. But it was the grain elevators that had a major influence on Gropius, Corbusier and other modernist and Bauhaus architects,[1] and, through them, influenced much twentieth- and twenty-first-century architecture.

1. See, for example, Reyner Banham, *A Concrete Atlantis: U.S. Industrial Building and European Modern Architecture, 1900–1925* (Cambridge, MA: MIT Press, 1986), 153–154.

Most of Buffalo's grain elevators are long gone. The elevators made of wood had a tendency to burn down or blow up. Not one of the elevators made of reinforced concrete (all after 1900) left on its own; the ones that are gone were destroyed by wrecking balls to make room for other things. The H-O Oats elevator, for example, was demolished in 2006 to make room for a gambling casino's parking ramp, while part of the Agway-GLF elevator was torn down to make way for RiverWorks, an amusement center with two hockey rinks, a Ferris wheel, a bar and restaurant, and, using one of the surviving elevators, a climbing wall and another as the surface for advertising a huge Labatt's sixpack.[2]

Cargill Pool Elevator (previously the Saskatchewan Cooperative Elevator), the only Buffalo elevator on Lake Erie, is now used to house speed boats in winter. Some, like Concrete Central and Cargill Superior, are so far off the beaten path that no one has bothered to demolish or repurpose them. And some, like the cluster that begins at the north end of Ganson Street, now called Silo City, is in a state of transition. One of its buildings is being converted to apartments and offices. Another serves as a site for poetry readings and musical performances. As part of the urban landscape, they all provide a favorite background for boaters, kayakers, and paddleboarders. The stretch of the Buffalo River between Silo City and the Standard Elevator (which is still in use) is often called "Elevator Alley."

There are enough of those surviving concrete elevators for them to constitute an industrial partner to the structures that were built for people. As the authors of the 1990 Historic American Engineering Report (hereafter "HAER") on the Great Northern Grain Elevator declared, on their first page, "*The grain elevators of Buffalo comprise the most outstanding collection of extant grain elevators in the United States, and collectively represent the variety of construction materials, building forms, and technological innovations that revolutionized the handling of grain in this country.*"[3]

2. That demolition was also done on an emergency basis, side-stepping the Preservation Board. Some of the lawyers representing ADM in the emergency demolition of the Great Northern worked on that earlier demolition as well. Commissioner Comerford issued both permits.

3. Historical American Engineering Record, "Great Northern Elevator" (NY-240, National Park Service, 1990), 1; emphasis mine. The Buffalo HAER project, prepared for the US Department of the Interior, included detailed examination of the current condition of several of Buffalo's grain elevators. Their researchers also examined original construction blueprints and narrated histories of the elevators' ownership and use. It is the only such report extant for the Great Northern Grain Elevator. All the engineers' reports presented in the various legal hearings regarding the Great Northern were based on little more than visual inspection and sometimes not much of that.

4

The Great Northern

The Great Northern played a pivotal role in all of this. It was designed and built to deal with the instability of elevators made of wood. It was made of steel and therefore fireproof: nothing to burn. It had a powerful dust-collection system (grain dust is more explosive than gunpowder): nothing to blow up. The steel bins kept the grain dry and the rats out.

It was the first grain elevator powered by electricity: no need for steam furnaces and the coal to feed them to power the elevator's three movable marine legs and the complex mechanisms within the elevator itself that moved, sorted, and transferred the grain. The entire steel structure was riveted and bolted into a single entity. Even the girders that supported the four-story cupola (sometimes called a workhouse) atop the bins passed between the bins on their way to the ground.

On December 18, 1921, two of the elevator's three marine legs were driven by wind into a canal-boat slip then adjacent to the north wall. Someone had neglected to lock the wheels on those two towers, so they rolled along their rails until the rails ran out, whereupon they toppled into the water. Those towers went down not because of any inherent instability or defect in design or construction but because of human error.

The Great Northern couldn't burn down or blow up. It couldn't be knocked down, and it was incapable of falling down. The four-story cupola atop the bins "consisted of a structural steel trussed framework clad in corrugated iron and rising to a height of 184'. The entire weight of the structure was carried by the extensions of the basement columns."[1]

The single mass of steel created by countless rivets and welds, had 30 main bins that were 38' in diameter and 70' high, and 30 interspace bins 18' in diameter and 70' 6" high. There were also several outerspace and shipping bins. Sixty smaller elliptical interspace bins were added in or after 1922.[2]

1. Historical American Engineering Record, "Great Northern Elevator" (NY-240, National Park Service, 1990–91), 7–8. See item 10 in "Documents" for a CAD rendering of this support system.
2. Historical American Engineering Record, "Great Northern Elevator," 31.

All that steel under the cupola was surrounded by a brick curtain, the sole function of which was to keep wind, rain, and snow away from the steel interior and to mitigate the effects of winter cold and summer heat. The cold just affected the workers in the building, but if the summer sun warmed up the steel bins, the grain in them might have germinated.

The brick curtain had some supports consisting of bars connecting it to the steel, but they were incidental; the brick curtain was designed and built to stand on its own, with each wall independent of the other three. "The brick curtain walling was of pier and panel form. The piers were 4' wide, and the panels 15' 7½" wide. The first 12' of wall was 25½' thick, the next 12' to 28' of wall was 21½' thick, and above this the wall was made of 21" thick, 4' piers, and 17" thick, 15' 7½" wide panels."[3]

Pier and panel design is important; minor problems with one panel wouldn't travel to the next panel because the pier would interrupt it. The 400' east and west walls and the 140' north and south walls were the brick equivalent of an enormous greenhouse where the frame or leading between the panes meant a crack in a pane stopped with that pane; the adjoining panes would not be affected by it. The long sides of a greenhouse are not at all like a huge single pane of glass. The same was true of the pier and panel structure of Great Northern's bricks.

When the Great Northern was completed seven months after the shovels broke ground, it was the largest grain elevator in the world. It was built to last, and—save for those two holes in its narrow walls, one in 1907 quickly repaired, the other in 2021 used as justification for demolition of the entire structure—last it did until the Cat 165' UHD Excavator began tearing it apart on September 16, 2022.

What were they tearing down? "Weird as this may sound," wrote Reyner Banham,

> it is a highly impressive space, monumental in scale and in the quality of the work, and that is a rare experience in the world of grain elevators, which are not usually, nor need be, provided with anything like public spaces. The head-house too is almost cathedral-like: long, lit by ranks of industrial windows in the corrugated roofing on either side, filled with a golden-gray atmosphere of flying grain dust sliced by low shafts of sunlight. The space is laced lengthwise by flat rubber belt conveyors loaded with grain and laced diagonally by more movable chutes for directing the flow of grain. Weigh bins over the heads of the main bins measure the flow, batch by batch, as it goes from bin to bin. The whole is monitored by men who watch steelyards connected to the weigh bins and mounted on decks whose legs are in the form of short cast-iron Doric columns—a touch I particularly enjoyed, since the use of Doric columns as supports for mechanical or scientific equipment was a piece of "typical" early-Victorian stylistic impropriety much abused by the propagandists of the modern movement in architecture when I was a lad!
>
> This then is a grand old monument to an intermediate phase of the rise of modern industrial architecture in the United States.[4]

3. Historical American Engineering Record, "Great Northern Elevator," 8.

4. Reyner Banham, *Concrete Atlantis: U.S. Industrial Building and European Modern Architecture, 1900–1925* (Cambridge, MA: MIT Press, 1986), 121.

5

After the Fall[1]

Things moved quickly after the bricks fell on December 11, 2021.

Two days later, December 13, the City of Buffalo issued an "Order to Remedy," directing ADM to "provide Buffalo with a statement of Intent on the repair plan or demolition of the damaged section of the building within five days."

On the same day, Congressman Brian Higgins (NY-26, which includes all of Buffalo) wrote ADM President Juan R. Luciano urging him to "rehabilitate this structure" and "to consider the long overdue designation of this structure on the National Register of Historic Places."[2] He mentioned tax credits and other incentives.

Two days after that, local attorneys for ADM Milling Co. delivered a nine-page document, with exhibits, dated December 15, titled "Submission Concerning Emergency Demolition Order Due to Safety" to Buffalo Commissioner of Permit and Inspections James B. Comerford Jr. On the cover page, beneath a stamped "RECEIVED AND FILED," was, in cursive, Comerford's signature, then, printed, his title "Commissioner," and, in parenthesis, his department "(Permit & Inspections)." There were a few undated photos of pieces of metal on the ground, but most of the exhibits were comprised of four engineering reports commissioned by ADM: September 27, 1994; January 28, 2014; May 2019; and December 12, 2021, the day after the collapse. All coincided with ADM attempts to get a demolition order. The reports were all flimsy: six pages, five pages, three pages, and seven pages long. Not one of them involved any testing or measuring. This surprisingly fast response to the order about fixing or demolishing the north wall resulted in a request to demolish the entire building.

On December 16, architect Anne Dafchik, in her capacity as president of American Institute of Architects Buffalo, WNY, wrote to Buffalo Mayor Byron Brown urging a "60-day moratorium on any demolition measures to allow the City and its residents to fully understand the impacts of any

1. All the letters and filings in this section are included in Part III of this book, "Documents."
2. Brian Higgins to Mr. Juan R. Luciano, December 13, 2021.

proposed demolition. This building, that has been part of the City of Buffalo's historic fabric for 14 years deserves at least a 60 day pause before its powerful presence is potentially erased." She went on to comment on the Great Northern's historical and current significance. She offered organizational support for a real analysis of the Great Northern's condition and urged the City of Buffalo to "seek short-term stabilization of the structure and consider an independent structural assessment, while also gaining an understanding of the environmental and social impacts that will forever shape our future skyline and identity as Buffalonians."[3]

The next day, December 17, 2021, Buffalo's fire commissioner, William Renaldo, wrote to Comerford that the Great Northern was a fire hazard, at risk of immediate collapse, and that the towers might topple into the Buffalo Ship Canal at any time; it was an emergency situation. Comerford issued a two-page emergency "Notice of Condemnation." He asserted all sorts of structural problems in the Great Northern, but the only basis he gave for his evaluation and decision is "visual and drone inspection" of the building and the support of the Buffalo fire commissioner, who had opined that "the likelihood of a fire exists." Renaldo's final paragraph began: "After reviewing aerial drone footage along with still photos, the Buffalo Fire Department has determined that the risk versus reward is simply too high and is therefore recommending that the building be taken down via emergency demolition."

The word *emergency* is key. It appears only once in Comerford's notice, in the final sentence of the penultimate paragraph: "Due to emergency conditions, we request that the ten-day notification be waved." That one word is what permits Comerford and ADM to sidestep presenting the case to the city's appointed Preservation Board.

In court testimony on June 9, 2021, Comerford would expand on that. He "said he based his decision on visual inspections, drone footage, consultations with staff and reports submitted by ADM, including [engineer and geologist John A. Schenne's report."[4]

So Commissioner Comerford's demolition order was based on an eyeball, ground-level visit by himself (neither an architect or engineer), drone footage done by an unnamed staffer, conversations with unnamed staff, a letter from the fire commissioner, a long brief submitted by ADM, and perhaps other ADM reports in writing or in print (he referred to them in the plural: "reports"; the only one he named was Schenne's). The only item in all of that possibly going beyond ground-level, external eyeballing was the long and detailed brief from ADM, consisting almost entirely of material that had previously been rejected as adequate justification for demolition by the City Council and the Preservation Board and even by Comerford himself.

3. Anne Dafchick to Mayor Byron Brown, December 16, 2021. Emphasis in the original.

4. Mark Sommer, "Expert Witness for Owner of Great Northern Elevator: 'Another Portion of This Building Can Fall Down,'" *Buffalo News*, June 9, 2022, https://buffalonews.com/news/local/expert-witness-for-owner-of-great-northern-elevator-another-portion-of-this-building-can-fall/article_e1ef0b62-e795-11ec-99fe-939b2df0b619.html.

6

The Fire Commissioner's Fears

Fire Commissioner William Renaldo, who apparently knew nothing of the Great Northern's structure and seems never to have been inside it, based his letter and subsequent court testimony entirely on information provided by Comerford and his own decades in the Buffalo Fire Department. His college degree was in criminal justice.

In his December 17 letter, he listed several areas of concern: interference with the city's fireboat and other ships, harm to casual boaters and onlookers, disruption of rail goods to General Mills and ADM milling. "The constant vibration from trains still in use will greatly increase the deterioration of any structural stability to an already weakened building, along with risking the health and safety of any railroad personnel that are on board." It would jeopardize people in "apartments, the River-Works facility, various cafes and coffee houses," and more. A collapse would block firetrucks going to a fire via Ganson Street. And there was the danger of a fire in the building.

This is all nonsense. There are no apartments anywhere near Ganson Street; RiverWorks is a quarter mile away; there are no cafes; there is only one coffee house, and its owner objected to the takedown. Trains moving in that area are limited to the speed of five miles per hour. On many occasions I've stood by the tracks as a train went to or came from the General Mills facility at the north end of Ganson Street and never noticed any train vibration; if I couldn't feel it, I very much doubt the Great Northern grain elevator would.

In his June 3, 2022, court testimony, Renaldo reiterated the same concerns and added that the two marine towers were so rusted they were in danger of falling into the City Ship Canal, endangering recreational boaters and blocking the city's fireboat should it have business in the canal that day.

There was no evidence for any of this. It was all "could happen."

Just about anything *could* happen. Frogs could rain from the sky—as they did in Kansas City in 1873; Dubuque, Iowa, in 1882; and Odzaci, Serbia, in 2005—but the likelihood is extremely close to zero.

The same can be said about the possibility of Buffalo's marine towers falling into the Ship Canal or Buffalo River. No marine tower in Buffalo has ever collapsed. The two marine towers of the Great

Northern that went into the boat slip went there, as noted earlier, because a worker failed to set the brakes on the towers' wheels. They were replaced by two towers of newer design. They stood perfectly straight until they were pulled down during the 2023 demolition.

There are presently similar towers/marine legs on the Standard, American, Marine A, Concrete Central, Cargill Superior, and Lake and Rail elevators. All of them stand on rails, just like the Great Northern's did. None of them has been maintained for decades; all are in the same or worse condition than the Great Northern's. I've climbed to the top of three of them. The city's fireboat goes by them all the time, as do, in warm months, recreational boaters and paddleboarders. Neither the fire commissioner nor any other Buffalo official has ever expressed any concern about danger from them.

There is no record of any fire ever having happened in the Great Northern. Little surprise, since it was built specifically to be fireproof. Renaldo testified in court that he'd never heard of a fire there in his forty years in the department. He also testified that he hadn't been in the building in the past decade. (He wasn't asked if he'd *ever* been inside. From his testimony, I'm pretty sure the answer would be "No.")

All of Renaldo's fears and dire predictions proved unfounded. During the entire time between Comerford's December 17, 2021, demolition order and the start of demolition on September 16, 2022, nothing fell into the water, onto the railroad tracks, or onto Ganson Street. During the eight months of demolition, from September 16 to the pull-down of the south tower on April 26, nothing fell into the water, onto the railroad tracks, or onto Ganson Street.

Fire department equipment blocked Ganson Street only once: on December 11, 2021, the night of the collapse of the north wall. Police cars briefly blocked Ganson Street protectively only once: when the south tower was pulled to the ground after workers with cutting torches made large notches at the base of steel girders supporting it. That day, too, nothing fell onto the railroad tracks or onto Ganson Street.

The commissioner's fears proved wrong in all regards, either because they were made-to-order or because he was writing and testifying about things of which he knew very little.

Perhaps the most absurd moment in his testimony occurred in this exchange on June 3, 2022, with Brian Melber, an attorney for ADM:

Q: And if we look at the Great Northern Elevator, if you look at the west side of the structure immediately next to the canal, do you see those two large rectangular structures that are right on the edge of the canal?

A: Yes, I do.

Q: Do you know what those are?

A: Well, it looks like storage containers

Q: All right. Whatever those are, and I'll represent to you that we've been referring to them as marine towers, if one or both of those marine towers tipped over into the canal, what impact would that have on navigation and safety as it relates to your department's operations?

Then Renaldo goes into his gloom and doom about the fearful marine towers and the damage he was certain they might do should they topple from their rails. Yet, when shown their photo, he hadn't a clue what they were. Melber even had to tell him how tall they were.

From the City Ship Canal, the Great Northern's three, then two, marine towers were its most prominent feature. They stood tall against the smooth face of that 400' east wall. No one who plied that canal—boater, ship worker, fireman on the city's fireboat—did not know what those towers were. They were as much part of the visual environment of that part of the city as Daniel Burnham's Flatiron Building to the intersection of Broadway, Fifth Avenue, and 23rd Street in Manhattan.

But to Commissioner Comerford's key consultant in his decision on the demolition process and the City of Buffalo's expert witness on the necessity of demolition, they were storage containers. Look at the photos of them in this book.[1] How much credence would you give to the testimony about the architectural "emergency" from someone whose only recent information about the building in question came from the man who would sign its death warrant the same day?

A final irony: On May 30, 2023, the City of Buffalo closed the Michigan Avenue bridge for repairs. That meant the only access to Ganson Street would be from the Ohio Street end a mile away. The bridge closing accomplished all the blocking to cars, trucks, emergency equipment and pedestrians that Renaldo had predicted if the Great Northern fell on its own, but it blocked Ganson Street for four months, not a single day! The fire department's response to this four-month blockage? None, none at all.

1. Plates 2, 3, 4, 7, 8, 12, 13, 14, 15, 33, 53, 54, etc.

7

The Mayor Waffles

On December 23, six days after Comerford's condemnation order, Buffalo Mayor Byron Brown wrote to Juan Luciano, CEO of ADM, asking him to "make every effort to preserve the Great Northern Elevator."

Brown might have been responding to public comments by developers Douglas Jemal and Rocco Termini insisting that the structure was repairable.

Brown also wrote that "the story of our city is told through our buildings and would be deeply impacted by the loss of the elevator. I appeal to you to save the Great Northern Elevator and make our legacy part of yours." The *Buffalo News* reported that he "offered to assist ADM in obtaining a range of resources, including historic and brownfield tax credits, if the company decides to preserve the structure."[1]

"Chances of that," reporter Mark Sommer wrote, "appear slim. ADM attempted to demolish the building in 1996, 2003, 2020 and now again in 2021. A company spokeswoman declined over the past few days to discuss ADM's intentions or Jemal's offer to buy the building."

Brown alluded to the letters from Higgins and Dafchik. He concluded, "I appeal to you to save the Great Northern Elevator and make our legacy part of yours."[2]

Comerford was Brown's political appointee, part of his administration. If Comerford was acting in a way contradictory to administration policy, why not tell him to get in line or replace him with someone who would?

"In his first public comments on the Great Northern since Comerford's ruling," Mark Sommer wrote,

1. Byron W. Brown to Mr. Juan Luciano, December 23, 2021.
2. Mark Sommer, "Brown Urges ADM to Save Damaged Grain Elevator; Preservation Attorney Can Still Do That," *Buffalo News*, December 23, 2021, https://buffalonews.com/news/local/brown-urges-adm-to-save-damaged-grain-elevator-preservation-attorney-says-city-can-still-do/article_d694dc26-6430-11ec-a5f6-ab3d991d0114.html.

Brown told The News the city's reason for having waited to release the demolition permit to ADM was merely procedural. The application for demolition had been incomplete, Brown said. Presented with a completed application, the city was legally obligated to issue a demolition permit to ADM under the law and the Jan. 5 court decision, Brown said.

Brown said the city "worked strenuously" to convince ADM to "preserve the building," but was unsuccessful, even as his administration contends the building cannot be salvaged.

"I brought letters and other communications we have received to ADM, and stated my desire to see the structure preserved," Brown said. "I told them we would work with federal, state and local tax benefits, tax exemptions, historic tax credits, new market tax credits to find resources to help with the preservation and stabilization of the structure."

Developer Douglas Jemal on Wednesday offered to give ADM $100,000 to stabilize the property and to pay for the cost of an independent evaluation by structural engineers.

Brown said Jemal's offer has nothing to do with the city.

"That is between Mr. Jemal and ADM," Brown said. "The city is not the owner of this property." . . .

The mayor questioned whether he or the commissioner, under the city charter, could reverse the decision to issue the emergency demolition permit.

"While I supervise the commissioner, legally it is not believed that the mayor can reverse or overturn a decision by the commissioner of permit and inspection services proposing those assigned duties," Brown said.

He said the same could apply to Comerford.

"The commissioner's authority to rescind or change the notice of condemnation is not specifically set forth in the city charter and city code," Brown said. . . .

Paul McDonnell, the Campaign for Greater Buffalo's president, delivered a point-by-point refutation of the ADM reports to the mayor on Monday. McConnell, as director of facilities for the Board of Education, oversaw the $1.3 billion Joint Schools Construction Board Project that restored or rehabilitated 48 Buffalo public schools.

"ADM did not thoroughly investigate the true condition of the building and whether it can be repaired, and therefore we believe their conclusions that the building needed to be torn down are in error," McDonnell said. "Mitigation of the public harm does not require demolition."

The mayor was asked if these opinions were grounds for revisiting the decision. The city code allows revocation of permits if "misrepresentation as to a material fact in the accepted application, plans or specifications" is found.

"I don't know, legally, if there is, necessarily, another path because this went through a legal process that lasted a few weeks, and in that legal process there was nothing that was presented where the judge determined that the emergency demolition should not move forward," Brown said.[3]

3. Mark Sommer, "Mayor Allows Great Northern Grain Elevator Demolition to Proceed," *Buffalo News*, January 13, 2022, https://buffalonews.com/news/local/mayor-allows-great-northern-grain-elevator-demolition-to-proceed/article_3b91f0e0-73be-11ec-ad7b-03b4883c31f0.html.

None of this makes any sense. Brown's administration "worked strenuously" to convince ADM to preserve the building right after someone in his administration said the building could not be saved and issued a condemnation order? An offer to stabilize the building and have a real independent evaluation done at no cost to the city was a private matter between a property owner and a very active developer in which the city had no interest? City governments—including Brown's—intervene in and broker such relationships all the time.

The language is a tip-off, particularly "legally it is not believed": when a public official drops into the passive voice for justification, waffling or obfuscation is in process. "He said the same could apply to Comerford": now the passive is further qualified by a conditional. If a mayor has questions about matters such as these, it is easy enough to find unambiguous answers in court decisions past or current. By whom was it legally "not believed?" Brown never said.

Brown said the city charter prohibited him from overriding a permit issued by the Commissioner of Permit and Inspection Services. Neither he nor anyone on his staff ever cited a passage saying that. I spent hours going through that document and found nothing approximating it. I did, however, find a passage that suggests the opposite.

Paragraphs (j) and (k) of section 17.2 Commissioner of Permit and Inspection Services; Duties and Powers," say that the commissioner shall:

(j)

Direct or cause to be torn down, blown up or otherwise destroyed on an emergency basis, any building or buildings which he or she deems to be an immediate threat to the health, welfare and safety to the public;

(k)

Exercise such other powers and perform such other duties as may be conferred or imposed upon him by this charter, as the same may be amended from time to time, by the mayor or by any general law, local law, ordinance or federal or state law.

As I read it, paragraph (j) says that Comerford indeed had the authority to issue emergency demolition orders, as he did here. But paragraph (k) notes that he shall "perform such other duties as conferred or imposed upon him by the mayor."

So what prevented the mayor from ordering Comerford to hold off on the condemnation and have an independent evaluation done to determine first if an emergency situation *really* existed, and, if not, to run this by the Preservation Board?

All city commissioners in Buffalo were mayoral appointments. They served at the pleasure of the mayor. The mayor could replace them at any time. When a new mayor came in, new commissioners appeared. Those were not civil service jobs. If Brown really disagreed with Comerford having greenlighted the demolition, as his letter to Juan Luciano suggests, and if Comerford wouldn't reverse himself or even hit "pause," what prevented the mayor from replacing him with a commissioner who would read and act in terms of paragraph 17.2.(k) of the City Charter?

8

Parsing the President (of ADM)

ADM didn't limit its campaign to demolish the Great Northern to engineers' reports and litigation. It also went public. It had to. The *Buffalo News* had run op-eds from preservationists and articles quoting developer Douglas Jemal saying things like, "They're getting rewarded for being terrible citizens and terrible property owners, and getting exactly what they wanted after 30 years. It's a sad day to see something like that go and someone be rewarded for neglect. I was hoping the judge would get a third-party engineer to get another assessment. This was not in the best interest of preservation, the community and the city, and the history that exists in that grain elevator."[1]

Earlier, according to the *Buffalo* News, Jemal had said, "That building absolutely could be saved. It's a magnificent building. I have tackled a hundred times worse than that. If ADM wants to sell the building, I will buy the building and preserve and stabilize that building. ADM has a ready, willing, and able buyer."[2]

Jemal also said, according to *Buffalo News* reporter Mark Sommer,

> the city should have had an independent structural engineer with a knowledge of historic buildings analyze the Great Northern before issuing the emergency demolition order. He called it a mistake to rely on a report by engineers hired by ADM, since the company has tried to demolish the structure on three previous occasions since taking ownership in 1996.
>
> Sanjay Khanna, a consulting structural engineer who works with Jemal, reviewed a number of concerns raised by engineers working with ADM, but he said they all appeared correctable.

1. Mark Sommer, "Judge Allows Demolition of Great Northern Grain Elevator," *Buffalo News*, January 5, 2021, https://buffalonews.com/news/local/judge-allows-demolition-of-great-northern-grain-elevator/article_b6ad7aa0-6da7-11ec-a0dd-97147626cadf.html.

2. Mark Sommer, "Demolition of Great Northern Grain Elevator Stayed; Douglass Jemal Wants to Buy and Save Structure," *Buffalo News*, December 19, 2021, https://buffalonews.com/news/local/demolition-of-great-northern-grain-elevator-stayed-douglas-jemal-wants-to-buy-and-save-structure/article_6e489e92-60dd-11ec-a3d5-8b2ade47a22e.html.

"There is no question in our mind that this building can be retained," Khanna said. . . .

"My God, it's a gem," Jemal said, noting the structure's appearance has suffered from ADM's lack of attention during the 29 years the company has owned it.

"In its present state it is a blighted structure, but it's a blighted structure strictly by neglect," he said.

Jemal has made a career in Washington, D.C., and now Buffalo of resuscitating blighted buildings.

"Seneca One was a blighted structure. The Statler was a blighted structure. The police station was a blighted structure," Jemal said of the former Buffalo Police Headquarters on Franklin Street that he converted into apartments last year. "Private properties are blighted only by neglect, not because they're bad."[3]

This is powerful stuff coming from the developer who had rescued some of the city's iconic buildings and who was in the process of doing more. He couldn't be written off as a preservationist who lived in an airy world of ideas; this was somebody who'd dealt with exactly what was at issue here.

Tedd Kruse, president of ADM Milling, published op-eds in the *Buffalo News* on January 21, 2022,[4] and on February 12, 2022.[5] Both seem to me to be attempts to take control of the narrative, one that Jemal was interrupting. Both attempted to justify the demolition. Both were full of untenable or arguable assumptions and assertions. The two articles took pretty much the same tack: the Great Northern endangered citizens, it was beyond repair, and the only responsible action was demolition with a few "artifacts" preserved for historical purposes.[6]

Here are a dozen of his lines in those two articles, with the comments or questions they invoke in italics. I could adduce more; this dozen is enough to make the point. Kruse's entire case is a microcosm of the reports produced by ADM's hired engineers. Unlike Jemal, who could point to

3. Mark Sommer, "Douglas Jemal Offers ADM $100,000 to Stabilize Great Northern Grain Elevator," *Buffalo News*, January 12, 2022, https://buffalonews.com/news/local/douglas-jemal-offers-adm-100-000-to-stabilize-great-northern-grain-elevator/article_98b3b1d8-7327-11ec-a937-67f274b76f51.html.

4. Tedd Kruse, "Safety Must Remain Top of Mind in Great Northern Grain Elevator Discussions," *Buffalo News*, January 21, 2022, https://buffalonews.com/opinion/another-voice-safety-must-remain-top-of-mind-in-great-northern-grain-elevator-discussions/article_ef191e06-7aab-11ec-a8aa-67cd9fb1285c.html.

5. Tedd Kruse, "Demolition of Grain Elevator Remains the Only Safe Choice," *Buffalo News*, February 12, 2022, https://buffalonews.com/opinion/another-voice-demolition-of-grain-elevator-remains-the-only-safe-choice/article_49046944-8cd0-11ec-9303-d3687e1f9356.html.

6. Nate Benson, " 'Gigantic Loss': Preservationists End Their Fight to Save Historic Great Northern Elevator," WGRZ, February 9, 2023, https://www.wgrz.com/article/news/local/preservationists-end-fight-save-historic-great-northern-elevator/71-8ab97436-9de2-4483-b1d0-4736fcaccc1c: "2 On Your Side reached out to ADM to ask if anything had been preserved before demolition started. A spokesperson for ADM said: '*We have developed a list of artifacts that can potentially be preserved safely and are in the process of looking for the right partners for the individual assets. We are reaching out directly to potential partners and have a formal application process in place to evaluate interested local parties.*' ADM also said they donated a locomotive to the Railroad Museum of the Niagara Frontier." ADM referred to these artifacts in a variety of press statements. The Campaign for Greater Buffalo several times tried to find out what and where they were, but they got no response. At the time of this writing, I've seen no evidence suggesting they exist.

a track record of major restoration in Washington, DC, and Buffalo, everything Kruse says comes down to, "Trust us."

- "Upon evaluation of the significant damage and the remainder of the compromised structure, independent engineers and the city determined that the only path forward to protect nearby employees and the community was to dismantle the elevator." *[The "independent engineers" to whom he refers were all hired by ADM; the city hired no independent engineers and made only a cursory inspection. The only "independent engineer" I found in the entire narrative was Paul McDonnell. More about him in the discussion of Judge Colaiavaco's third order in the chapter that follows.]*

- "The structure was built 125 years ago with engineering techniques that are now outdated." *[So what? The US Capitol was up and running in 1829; British Parliament was finished in 1840; the Eiffel Tower was completed in 1889. All these buildings were built "with engineering techniques that are now outdated"; all of them have been maintained; all of them are in fine shape today.]*

- "The only solution that can truly guarantee safety is to dismantle the elevator and we need to be allowed to take the immediate actions deemed necessary by independent engineers and the city to protect our employees, our neighbors and the public." *[Why is demolition "the only solution"? How assiduously were repair and stabilization—if needed—explored? There is no suggestion of that in any of the engineers' reports, nor are there any reports from "independent engineers." How seriously was repurposing the structure considered? Was it considered at all? His claim that this is "the only solution" is an assertion, nothing more.]*

- "Demolition of grain elevator remains the only safe choice." *[Ditto.]*

- "First and foremost, this absolutely remains an emergency situation." *["Absolutely"? The only reason it was an "emergency situation" is that the hole in the north wall permitted the city to accede to ADM's demolition request and declare an emergency without any public hearings and without running it by the Preservation Board. No independent inspections had been done. No serious inspection of any kind had been done.]*

- "This is not demolition by neglect and could not have been prevented with regular maintenance." *[Saying doesn't make it so, and Jemal had argued otherwise. Nothing in any of the testimony indicated any brick-pointing or ordinary roof, gutter, and downspout maintenance during ADM's ownership. The occasional pieces of metal falling from the roof suggests decades of neglect.]*

- "The reality is that the original design of the structure cannot be altered or repaired." *[So what? Nor can the original design of the French Parthenon, completed in 1790; Castel Sant'Angelo in Rome, completed in 130; or the Pyramid of Djoser, completed 2648 BC.]*

- "The structure reached a point years ago where repairs were no longer possible due to contractor safety concerns." *[Whose concerns about what? Large structures with issues due*

to age or lack of care are rehabilitated all the time. Why were repairs "no longer possible"? Is he blaming the lack of maintenance on contractors' nervousness? As in, "Don't blame me. They wouldn't go up on the scaffolding"?]

- "Demolition is simply the only safe path forward at this point in time." *[Why? What evidence is there for this? This is an assertion, not a conclusion.]*

- "There is not a viable way to repurpose the structure and preserve it in its current state." *[Another assertion. What serious investigation was made or even allowed into repurposing? If the "present state" means the neglected building with the hole in its north wall and flaking roof, why not alter the nature of the present state? Why not fix the hole and patch the roof?]*

- "The best way to preserve the legacy of the elevator is to dismantle it and preserve artifacts that can be displayed in a museum for members of the community and visitors to enjoy for years to come." *[Who says demolition of the entire elevator because of a hole in a brick curtain wall that supports nothing is "the best way to do anything"? Not Douglas Jemal, not Preservation Buffalo Niagara, not the Campaign for Greater Buffalo.]*

- "Multiple engineers evaluated the structure and reached the same conclusion in the name of safety. That information was presented to the City of Buffalo, which conducted its own independent analysis and agreed that the only responsible path forward is demolition under the circumstances." *[Those "multiple engineers" were all paid by ADM for work done as part of ADM's demolition requests. The City of Buffalo issued its demolition order three days after ADM's request. There was no time for a responsible "independent analysis" to be done, nor was one attempted.]*

Nothing in those two op-eds goes beyond assumptions, assertions, and unsupported conclusions. There is nothing that comes close to the kind of specificity Douglas Jemal said any decision on the Great Northern required. The word *safety* is like a shibboleth: it appears in more than a third of the paragraphs, sometimes more than once.

In the end, this public argument between a corporation president and a prominent developer meant nothing. The fate of the Great Northern would rest with one Buffalo judge.

9

Before the Bar[1]

The Campaign for Greater Buffalo immediately sought a temporary restraining order (TRO) as part of an article 78 procedure. Article 78 is invoked when public officials are charged with using the power of their office to make wrong or ungrounded actions or inactions. The case (NY index number 8169024/2021) was assigned to New York State Supreme Court Judge Emilio Colaiacovo. He issued four decisions and orders.

Colaiacovo 1

His first, dated December 30, 2021, was a response to the temporary restraining order issued by another judge earlier, the Article 78 proceeding filed by the Campaign for Greater Buffalo against the "City of Buffalo and ADM Milling, Co." In the section on "Procedural History," Judge Colaiacovo noted he had heard oral argument on the petition on December 27 and had "directed both parties to submit to mediation." The mediation failed.

 The judge cited a report from John A. Schenne, an engineer and geologist, which noted "that soft lime mortar used with the bricks had all but deteriorated over 125 years." Schenne also noted pieces of the roof sheeting that had fallen. "In his [Schenne's] expert opinion," Judge Colaiacovo wrote, "GNE was extremely dangerous and presented a serious safety hazard to the public. Schenne found it impractical to remediate the structure and found that the only option was immediate demolition."

 The judge also noted that Comerford looked at aerial drone footage and requested input from the Buffalo Fire Department. "On December 17, 2021, Buffalo Fire Commissioner William Renaldo agreed with the emergency determination. Later that day, Commissioner Comerford, after 'conducting

1. This section refers to four opinions written by Judge Emilio Colaiacovo, all in reference to case index number 816904/2021. Page numbers for quotations in each section refer to that decision. Colaiacovo 1 is December 30, 2021; 2 is January 5, 2022; 3 is July 5, 2022; and 4 is September 15, 2022.

and completing an extensive analysis of all available evidence . . . determined that the former grain elevator was structurally unsound, in imminent danger of collapse, and posed an immediate threat to the health, welfare and safety of the public, and . . . issued the Notice of Condemnation.'"

Next was a section titled "Standard of Law & Review," in which Colaiacovo cited a variety of New York cases he thought apposite to this one. The section concluded with a paragraph that would dominate all subsequent litigation in this case. In his later opinions, Judge Colaiacovo would repeat it again and again. It would have the effect of keeping errors and ungrounded assumptions in and pushing facts out. The paragraph began: "*As such the only issue before this court is whether Commissioner Comerford's decision to issue the emergency order had a rational basis.*"[2] That goes to the presumed nature of Comerford's thinking on December 17, not to the actual condition of the Great Northern and certainly not to reasons for stabilizing, preserving, and repurposing it.

In the final section, "Decision," Judge Colaiacovo repeated that limitation: "*As previously noted, the Court's decision rests squarely on whether there was a rational basis to the demolition order.*" He "schedules a fact-finding hearing for January 3, 2022, at 9:30 a.m. This hearing will be limited to the issue of how the City reached its decision and, specifically, whether the Commissioner had a rational basis for the Order for the demolition."

That's three *rationals* in three pages. Judge Colaiacovo glossed the repetition himself: "This should not be perceived as an invitation for a battle of the experts—engineers versus engineers—as to whether or not the property can be salvaged. . . . The issue is narrowly defined by how the city reached the conclusion that a demolition order would be necessary."[3]

Colaiacovo 2

Judge Colaiacovo's second document, "Decisions and Order," is dated January 5, 2022. It refers to the January 3 "fact-finding hearing." Only one witness was permitted to testify: James Comerford Jr. There were eight "Court's exhibits": a letter from Fire Commissioner William Renaldo, the notice of condemnation, a photograph of the hole in the north wall, two photographs of the Richardson psychiatric center, a photograph of debris near the elevator, and a Department of Labor decision having to do with "Controlled Demolition of unsound structures and non-friable asbestos."

The document began with a history of Comerford's city jobs since he started as a building inspector in 1979. It mentioned qualifications of some of his staff: one had an engineering degree (but is not a licensed engineer), another "a special expertise in building demolition." There was no mention of Comerford's educational background; I've been unable to find any suggestion that he was an engineer, architect, or even a college graduate. All his city jobs had been political appointments. Comerford testified that he "met with Brian Melber, legal counsel for ADM, and John Schenne, an engineer and geologist retained by ADM" to learn about "ADM's intentions as to the building's

2. Emphasis mine. Rather than repeating this note, here or in the text, again and again: all italics from this point on, unless otherwise noted, are mine.

3. Mark Sommer, "Judge Allows Demolition of Great Northern Grain Elevator," *Buffalo News*, January 5, 2021, https://buffalonews.com/news/local/judge-allows-demolition-of-great-northern-grain-elevator/article_b6ad7aa0-6da7-11ec-a0dd-97147626cadf.html.

future." He testified that he asked Fire Commissioner William Renaldo for an opinion because "he wanted someone to tell him the building could be salvaged" and that he had received John Schenne's December 15 engineering report commissioned by ADM.

Judge Colaiacovo referred to the letter from Fire Commissioner Renaldo: he "found the building to be unstable and that 'the size and scope of the building present a multitude of life safety hazards to both workers at the site, and civilians due to the building's close proximity to the waterfront and increased attractions to the area' and that the Commissioner determined that the 'risk versus reward is simply too high and he therefore recommend[s] that the building be taken down via emergency demolition.'"

Emergency demolition, as I noted above, is a key term here, because that keeps ADM's demolition request away from the Preservation Board. Comerford himself testified to that: "He did testify that if the condition did not constitute an emergency, the matter would have been referred to housing court or the historic preservation board for remedial action. However, he was quite adamant that it was his opinion that the building could not be repaired or abated and met alt [sic] requirement for an emergency demolition."

Then Judge Colaiacovo wrote something curious: "Comerford also testified that he denied ADM's previous request for an emergency demolition a year and a half ago. At that time, however, the walls were not compromised as they are now."

Comerford had turned down that earlier emergency request because there was no emergency: other than the hole in the north wall, ADM had no new data to add to the reports that had already been ruled inadequate. There was no evidence suggesting the huge steel structure inside the curtain wall was at risk, nor any suggesting any other parts of the wall were at risk.

Comerford also "noted that it was possible that the entire headhouse could blow off the structure." This is, other than the December 15 "Submission" to Comerford by ADM's lawyers, the first time the provocative, unsupported contention about the headhouse being unstable because of the hole in the wall surfaces. The headhouse, as noted twice in the 1990 HAER report (the only one I've seen that involves not only close interior inspection of the entire elevator and wall but also inspection of the 1897 blueprints) was supported entirely by steel girders going all the way into the ground. It was part of the elevator, connected by bolts and welds and its own structural supports.[4] (More on this in chapter 11.)

The following section, "Standard of Review," surveyed some case law and noted that the "court must uphold the administrative exercise of discretion unless it has 'no *rational basis*' or the action is 'arbitrary and capricious.'" It continued, "Where the administrative interpretation is founded on a *rational basis*, that interpretation should be affirmed even if the court might have come to a different conclusion." The final paragraph began with a reiteration of that: "As noted previously, the only issue before this Court is whether Commissioner Comerford's decision to issue the emergency demolition order had *a rational basis*."

The phrase *rational basis* was becoming a mantra.

The final section, "Decision," carried that forward: "The Court finds that the Commissioner did have a rational basis in rendering his decision to condemn the Great Northern Grain Elevator

4. The computer-generated graphic in "Documents," submitted by the Campaign for Greater Buffalo, clearly illustrates this support structure.

and order its demolition. The Commissioner's testimony evidences the deliberative and thoughtful process his department undertook before, ultimately, condemning the Great Northern Elevator and ordering its demolition." He cited an affidavit prepared by John Schenne, noting degradation in the mortar over the past 125 years, and that "Schenne reported to Comerford that because the mortar was not adhered to the bricks, the structural steel at ground level was corroded, and the headhouse steel foundation was compromised, the structure was unsound and in imminent danger of collapse." The judge repeated the mantra: "Taken together, the submissions previously made to the Court as well as the testimony of Comerford, the Court finds that the City had a rational basis when rendering its emergency decision to condemn and order the demolition of the building."

Colaiacovo then denied the request for an Article 78 hearing and dismissed the temporary restraining order. He went on to say that he was sorry he had to do this, that he knew preserving historically significant buildings was important, and that "while unfortunately the Great Northern Elevator cannot be salvaged due to the hazard it presents to the public and the surrounding area, this should not doom other similarly important structures to a similar fate. Their decisions rest in the hands off those who are charge with the high responsibility of public service and those who champion these worthy causes."

Noble words, but did he believe any of them? Was that a sincere statement of a judge who found his hands tied, or were they the crocodile tears of an architectural Pontius Pilate, washing his hands in a mealy-mouthed flow of words about the importance of preservation and the responsibilities of public officials somewhere else, sometime later?

We don't know, and it doesn't matter. What matters is the practical effect of the next paragraph and final text line of the document: "This shall constitute the Decision and Order of the Court." ADM had a green light to proceed with its demolition plan.

Colaiacovo 3

The Campaign for Greater Buffalo didn't buy it. Their lawyers appealed the same day. On January 14, the Fourth Department of New York's Appellate Division issued a preliminary injunction reinstating the TRO and restraining the City of Buffalo and ADM from "taking actions to demolish or destroy the historic structure known as the Great Northern Grain elevator . . . during the pendency of this motion and until this Court issues a decision on the motion." On February 15, the Fourth Department continued the TRO and enjoined the City of Buffalo and AM from "taking any steps to demolish the Great Northern."

On April 29, the Fourth Department reversed Judge Colaiacovo's January 2 "Decision and Order." It didn't agree that Comerford had acted outside of his emergency authority or that he didn't have "a rational basis for issuing the order for demolition." It didn't disagree either. It only noted it and didn't engage it because it wasn't relative to the key issue at hand: in a trial, is a judge obligated to listen to both sides before rendering a verdict?

Its answer was yes; the Fourth Department found that Judge Colaiacovo had "erred in refusing to consider petitioner's proposed evidence inasmuch as it should had afforded petitioner the opportunity

to submit 'any competent and relevant proof . . . bearing on the triable issues here presented and showing that any of the underlying material on which the [Commissioner] bases [his] determination has no basis in fact . . . or that the determination was irrational or arbitrary.'"

After that, Judge Colaiacovo wrote, he engaged in two days of settlement discussions, which got nowhere, then on May 31, took a look for himself: "The court was able to view the exterior of the building, including the opening on the northern wall, the cantilevered head house, the debris field, and the West wall, which, at the last hearing, the Court learned was 'bowing.'"

What expert eye did Colaiacovo take to that May 31 view of the building? What other than the hole in the wall, which was already in evidence, did he see? What did he learn? What part did his look at the Great Northern play in his subsequent decision? He doesn't say.

That trip to the waterfront was followed on June 2 and 3 by the fact-finding hearing involving both sides ordered by the Court of Appeals.

Exhibits included all the exhibits from the first trial, footage from Comerford's drone, diagrams of the Great Northern's structure, interior photos taken for the 1990 HAER report by Jet Lowe, a number of other photos, and "Selections from HAER Report."

During cross-examination, Comerford "acknowledged that neither he nor any member of his staff are engineers or architects. While noting that his deputy commissioner is an engineer, she is not licensed. He testified he did speak with Gwen Howard, the chair of the Preservation Board and herself an architect, about the wall collapse, a pending emergency declaration, and possible demolition. He noted that after reviewing all the potential options with Howard she was adamant that the site should not be condemned or demolished."

The judge noted that testimony by architect Paul McDonnell rebutted almost everything Comerford claimed:

> Given that no one has been inside the building to inspect the foundation, and accounting for the manner in which the foundation was first constructed, McDonnell found the Commissioner's determination to be without support. Lastly, he found the conclusion that the Great Northern was a fire hazard to be flawed. He noted that the Great Northern was built to be fireproof. Recounting the early history of combustible grain elevators, McDonnell stated that the Great Northern was built precisely to deter fire or flammable events. McDonnel firmly believed that any risk of fire or explosion was minimal. Further, he could find no evidence in the record before Comerford that noted the existence of combustible materials inside the elevator.

McDonnell spent a significant amount of his testimony on the cupola. Contrary to what Comerford noted in his determination, McDonnell stated that the cupola, or head house, was not attached to the brick walls. Instead, he insisted that the cupola was "supported all the way down to bedrock." He maintained that the steel cupola was attached to the steel bin frame. Because he contended that the cupola was designed to cantilever, the head house was in no danger of collapse. He concluded that a crane could easily be used to repair the cupola and replace existing sheeting.

Then Judge Colaiacovo wrote a paragraph that seems to me textually loaded:

McDonnell, who acknowledged that he has an interest in this case since he is President of the Preservation Society, admitted to writing a letter to Mayor Brown after the City's determination became apparent. In his letter he stated that he "disagreed with all of [Comerford's] findings." However, under cross-examination, he acknowledged that he agreed with Comerford's finding that the North wall was compromised. He also contradicted his own letter when he agreed with the Commissioner that there were indeed stress cracks on the East Wall. . . . Further, he conceded the Commissioner was correct when he determined the corrugated metal panels to be a safety hazard. He also agreed that the Commissioner had a basis to conclude the structure presented a fire risk, since his conclusion was based on representations made by the Fire Commissioner. He also acknowledged that the Commissioner was indeed correct when he mentioned the Great Northern did not meet current code. As such, after cross-examination, Petitioner's expert witness conceded and acknowledged that five of the bullet points contained in Comerford's notice of condemnation were factually correct.

Where to begin with this? First, there is no "Preservation Society." There is a Preservation Board, appointed by the city, tasked with protecting the city's architectural treasures. McDonnell had been chair of it and he served on it for eleven years. He was, at the time he testified, president of the Campaign for Greater Buffalo and had been a member of its board for eleven years. He wasn't testifying because of his involvement in the nonexistent Preservation Society; he was testifying because of his long interest in and involvement with historical architecture and because of his years of work as senior architect in the Buffalo Department of Public Works and other capacities.

Second, and more important, the fact that he agreed with some of Comerford's bullet points was irrelevant. His argument wasn't that they were all wrong; it was that some were wrong, some were irrelevant, and none of them alone or in sum provided justification for destroying the Great Northern.

Third, the judge did not mention that McConnell also testified that there were cracks that appeared to be older that had not worsened, that these cracks were not an indication that they had compromised the wall, and that the cupola might touch the brick curtain but that the brick curtain provided no support for the cupola (and cited sources for that opinion).

And fourth, the judge did not raise the issue of having an "interest" possibly tilting testimony with any of ADM's hired witnesses or with ADM itself.

Then Colaiacovo introduced a conclusion into a part of his document that purported to be a report: "Notwithstanding evidence to the contrary, on re-direct, McDonnell insisted that there were no signs of imminent failure or in danger of complete collapse."

Notwithstanding evidence to the contrary? What evidence to the contrary? Other than the hole in the north wall, which supported nothing, there wasn't any—just opinions.

Gwen Howard Mann, a licensed architect with a degree in historic preservation, also testified for the Campaign for Greater Buffalo. A building inspector for Buffalo, she had worked on several historic buildings in town and was twice chair of Buffalo's Preservation Board, once when ADM submitted one of its early failed demolition requests. She insisted the hole in the wall could be repaired. She was not cross-examined.

Fire Commissioner William Renaldo then testified about a lot of bad things that could happen if the entire structure collapsed into the Ship Canal, onto the railroad tracks, or onto Ganson Street. But he offered no evidence of the likelihood of any of those remote possibilities. He "testified that he would not let his crew 'anywhere near it' because of the danger it posed. Because the structure was opened, he testified that he had 'no idea' what could be inside. This general uncertainty led to his opinion that something inside could be combustible and present a fire hazard."

This is paranoid testimony that amounts to saying, "We won't go in there because it's scary, but a fire might start." A fire of what? That building had been out of service since 1981. Fires need something to burn. The entire structure was made of steel. What in there, other than dead birds and river rats, might burn? "During ADM's cross-examination, Renaldo admitted that the key factor in his determination was the gaping hole in the North wall. He testified that he believed Comerford's decision was a practical one based on emergent decisions."

So Comerford based his decision partly on Renaldo's report, which Renaldo said was the practical decision to have made. That's not evidence leading to a reasoned conclusion; it's a tautology.

Next was ADM's and the City's key witness, John Schenne, a licensed engineer and geologist. He had prepared previous reports on Great Northern for ADM.

> Schenne testified that he was contacted by ADM regarding the collapse of the Great Northern on either December 11 or December 12, 2021. He noted that he visited the site on Monday, December 13, 2021. He testified that, given the large hole in the North wall and sizeable debris field, he found the building to be dangerous and opined that further collapse was likely. While he acknowledged he did not review historical documents, he reviewed structural plans, drone footage, and photos. Thereafter, he prepared a report on December 15, 2021, that recommended demolition.

Not reviewing historical documents is important: does that mean he didn't look at the 1990 HAER on-site and historical report? That he didn't look at the permits and plans in City Hall? That he was ignoring hard data in favor of brief, external walkaround-eyeball impressions? That he didn't try to find out how many years or decades it took for that "debris field" to accumulate?

At least one of his key statements was factually untrue: "With respect to the cupola, or head house, Schenne opined that it was definitely supported by the walls and not the interior steel frame. The existence of heavy-duty bearing placed on the exterior walls supported this conclusion." Not only is this contradicted by the original building plans and by the plans in Buffalo City Hall, but it contradicts Schenne himself in an earlier report, as I'll note in chapter 11.

He was followed by Allen Rhett Whitlock, a civil engineer from South Carolina. Whitlock said he was "familiar with the notice of condemnation, the Schenne report, other older reports, the drone video footage, as well as historical records of the Great Northern." There is no suggestion in the judge's summary of his testimony that he inspected the site or did any tests. "Agreeing with Schenne, Whitlock testified that the exterior walls supported the cupola. The fact that the walls were compromised presented a dangerous condition for the cupola. . . . Whitlock concluded that the weight of the roof and the end of the cupola was supported by the exterior brick walls. . . . Because the cupola is poorly supported, in Whitlock's opinion to be 'pushing down,' Comerford had a rational

basis to conclude the building to be 'unsafe and unsound.'" This was a pooling of ignorance and error. Whitlock's testimony was based on what he was told and shown in photographs. The judge's comment? "Taken all together, Whitlock found Comerford's determination was rational."

More error came up during cross-examination. "He also testified that he thought the interior bins also were compromised and had faulty support. He believed that the masonry also supported some of the bins." There is no evidence for any of that anywhere.

The judge then turned to his sense of credibility of the witnesses. He accepted Comerford without question. He found Paul McDonnell credible, but his statements disputing much of ADM's consultant's reports "slightly improbable and farfetched. Although a credible witness, the Court cannot ignore the fact that he certainly has a bias, since he is President of the Petitioning organization."

He did not note anywhere in his ruling what McDonnell said on the stand when asked about the nature of his bias:

Q: You testified in cross examination that you had a bias concerning this building?

A: Oh, yes. Yes, I'm sorry. Yes.

Q: Would you explain what that bias is?

A: I mean, as an architect, as a preservationist, as someone that has—that knows the building very, very well, as someone that has given tours of Buffalo for over twenty-five years—yes, I am—I feel very strongly about the importance of that building and to architectural legacy.

Q: And would any bias that you have affect your professional opinions given yesterday and today?

A: No, because my professional opinions are also—they are based on my technical knowledge and my experience as an architect.[5]

This strikes me as being like dismissing testimony from a physician involved with promoting public health because he is informed about, interested, and working for public health.

The judge said Gwen Howard-Mann was persuasive, but she didn't tackle "disagreements she had with the Commissioner's findings. She simply concluded there were alternatives to demolition." Demolition as the only course of action *was* Comerford's finding. What else was she supposed to disagree with? She had seen some of the ADM engineer's reports previously and knew how epidermal they were. She was the current chair of the city's Preservation Board.

The Court also found John Schenne to be credible. It could not discount his report nor the conclusions he reached. The Court found him to be "committed to his cause" and credited his testimony accordingly. However, the Court found Dr. Allan Rhett Whitlock to be the most credible

5. Court transcript, June 3, 2022, pp. 267–266.

witness. The Court found him to be singularly impressive and quite persuasive. Like Schenne, he found the Commissioner's determination to be rational. However, Whitlock was able to corroborate each finding with photographic evidence that supported the prior determination. As such, the Court afforded his testimony significant weight.

Whitlock based his testimony on previous reports, including Schenne's. Other than a few photos at the scene, he introduced no new information. Schenne, on the ADM payroll, was "committed to his cause," while McDonnell, working pro bono, was discounted because he was committed to his cause. This is dizzying logic.

In the final section, "Decision," Judge Colaiacovo again and again noted the Petitioner's failure to present evidence that Comerford wasn't acting rationally. Everything was subsumed to that. He wrote, "The Court is puzzled that Petitioner only called witnesses who have a clear interest in the outcome, as opposed to a witness, perhaps an engineer, who is unaffiliated with the organization seeking the relief requests?" Why did he not ask the same question of the ADM consultants, all of whom were on the ADM payroll?

It got worse: "While Petitioner's witnesses failed to do so, ADM's witnesses clearly demonstrated that Comerford's decision was rational and made with a basis in fact. . . . Whereas Petitioner's witnesses brought conjecture, Whitlock brought data." This is simply untrue: ADM's witnesses brought conjecture and hypotheses; the closest they got to facts were impressions from brief eyeball walkarounds and reading old reports commissioned by ADM.

"Whereas McDonnell argued that the cantilevered cupola was attached to the interior steel bin frame, Whitlock actually showed, using photographic evidence, that the bearing plates attached to the cupola were completely ripped away from the masonry. He demonstrated that, contrary to McDonnell's testimony, the beams supporting the cupola were clearly resting on the exterior walls. Noting the poor condition of the remaining walls, he found the cupola poorly supported and bearing down on the already fragile walls."

But Whitlock's photographs were not evidence of the structure; the beams were not resting on the exterior walls. He had it wrong because his testimony was predicated on prior testimony that had it wrong. What his photo appeared to show was, as Paul McDonnell pointed out, an artifact of photographing distant objects with a telephoto lens. (More about this in chapter 11.)

Colaiacovo wrote, "After a complete hearing, with both sides afforded the opportunity to call witnesses, the Court finds that Comerford clearly had a rational basis in fact to act within his authority to order the demolition of the Great Northern."

There is some blather after that, but that's it. Colaiacovo concluded, "Since the Petitioner has failed to satisfy its burden that would otherwise entitle it to injunctive relief, the Court hereby DENIES the request for a preliminary injunction. The Court also VACATES the Temporary Restraining Order."

Colaiacovo 4

That wasn't quite the end of it. There would be one more turn of the screw. Normally, when a TRO is vacated, the case is dismissed. If the case is not dismissed, the losing side cannot appeal

the order. Colaiacovo's delay effectively blocked an appeal.[6] He would not dismiss the case until ten weeks later. During that time, as I noted earlier, ADM was able to bring to Buffalo the demolition equipment it needed, especially the 165' Ultra High Demolition Excavator, which would do all of the ripping and tearing of the steel. There were only three of them available in the United States. By the time Colaiacovo dismissed the case on September 15, the UHD Excavator was on site, set up, and ready to go.

Demolition began the next day.

6. The separation of decision and final order isn't unique to the Great Northern. One egregious example involves Susan B. Anthony. The judge found her guilty of the crime of voting and fined her $100, which she had no intention of paying. He never entered a final order in the case, so she could never appeal his ruling.

10

Two Courtly Matters

Other than defendants, witnesses in court fall into two categories: fact witnesses and expert witnesses. Fact witnesses are limited to statements about things of which they have direct knowledge: what they saw, heard, and did. They qualify themselves as witnesses with statements about how they acquired that knowledge: "I was standing at the corner of 47th and South Park when I saw a blue car run a red light." They can say things only in response to direct questions from attorneys. If they are asked a question that calls for an opinion or conclusion, opposing counsel will usually object and the judge will usually sustain the objection. Expert witnesses, on the other hand, are qualified not by their connection to the case at hand but to previous experience that permits them to offer opinions and conclusions based on what they know about that case, either from examining documents, direct observation and testing, or some combination of both.

All the witnesses in both hearings before Judge Colaiacovo were admitted as expert witnesses. Much of what they said was right, and a good deal of it was wrong. The parts that were wrong provided the grounds for the demolition of the Great Northern.

All trial lawyers know, and most plaintiffs and defendants learn, that what matters in court is not what happened in the world but what is admitted into evidence. If the judge is willing to look at data in a bench trial, the data matters; if the judge declares that matter of no interest, it is not part of the record and not part of the case. If a judge is willing to let a jury see and hear evidence, the jury incorporates that into its decision on the verdict; if a judge excludes evidence, the jury is unaware of its existence. A trial is a closed system of knowledge.

In the Attica prisoners' civil rights trial in federal court in Buffalo in 1991, for example, Judge John Elfvin wouldn't let the prisoners' lawyers introduce photographs of retaking brutality during trial in "the interest of judicial economy": it would take too much time. They would, he said, be allowed to look at them when they were deliberating. Then when testimony and summations were finished and the jury retired to deliberate, the judge refused to allow them to see the photographs because they might be inflammatory. Those photos, which provided substance to so many things said by witnesses, were subtracted from the court's narrative and thereby from the jury's awareness of that

narrative. When New York Assemblyman Herman Badillo used the word *massacre* in a hearing before his testimony in the 1991 trial, Judge Elvfin told him he was not to use it. "How can I describe a massacre if I can't use the word *massacre*?" Badillo said. The judge told him to find another word.

From his first ruling in the Great Northern case, on December 30, 2021, setting the date for the first hearing on January 3, 2022, Judge Colaiacovo set the boundaries of admissible information and what questions could be asked: "The court's decision rests squarely on whether there existed a rational basis to issue the demolition order." He repeated that again and again in his subsequent decisions and opinions and spent a good portion of each of them justifying that narrow window of admissible information. All the Campaign for Greater Buffalo had on its side were facts about the way the elevator was really built, evidence of the elevator's local and international significance, and expert opinions contradicting opinions and conclusions offered by ADM's hired engineers. Judge Colaiacovo excluded the first two as irrelevant and chose not to believe the third.

He focused on Comerford's "rationality" and seemed uninterested in asking if Comerford should have looked further than a brief handed to him by ADM, a letter from a fire department official who did nothing but have a conversation in Comerford's office, and Comerford's own outside look.

So far as I know, the judge never asked, "Did Commissioner Comerford do due diligence in assembling the facts on which he made his rational decision?" It seems like those "stand your ground" acquittals in the South: "I believed the ham sandwich in his hand was a gun so I shot him."

The Campaign, and the Great Northern, had their days in court, but they never had a chance.

11

Four Red Herrings

Soft and Friable Mortar

Several of ADM's engineering reports asserted in their documents and in court testimony that the softness and friability of mortar a few feet above ground level are significant indicators of the brick curtain's fragility. The reports mentioned again and again that the mortar could be "scraped out with a knife." Judge Colaiacovo referred to that testimony several times in his opinions denying the restraining order.

Fired brick, invented about 3500 BC, lasts. St. Mary's Church in Gdansk, on which construction began in 1379, is the largest brick building in the world. The St. Pancras railway station in London opened in 1868 (an attempt to demolish the station in the late 1960s received such public opposition that it got an £800 million makeover). The Hospital de Sant Pau in Barcelona, built between 1901 and 1930, was in service until June 2009, when it was restored as a museum and cultural center; it was declared a UNESCO World Heritage Site in 1998. The oldest all-brick house in the United States is the Peter Tufts House in Medford, Massachusetts, built around 1680, and it is still in use. All of Frank Lloyd Wright's surviving Buffalo houses are brick.

But buildings, whatever their composition, don't last forever on their own. They need inspection and maintenance. Sometimes the mortar between the bricks needs pointing—that is, replacement. Often, that pointing is not an indicator of a problem in the brickwork or even the original mortar, but rather a symptom of lack of maintenance elsewhere in the structure. The cause of mortar decay may reside in leaking roofs or gutters, settlement, or capillary action,[1] all issues related to ordinary building maintenance.

1. Robert C. Mack, FAIA, and John P. Speweik, "Preservation Briefs; Repointing Mortar Joints in Historic Masonry Buildings," US Department of the Interior, Heritage Preservation Services, October 1998, 2.

The Great Northern's mortar issues were not a problem in their own regard; they were evidence and symptoms of decades of neglect.

There is a further problem: other than observing softness of some mortar at eye level, there was no investigation of how deep that softness went. The brick walls at that height were over two feet thick; the piers were even thicker. Was the mortar compromised beyond the first wythe (vertical wall of bricks) and did its state have any significance, given that the wall was supported not by mortar but by its own pier and panel construction? No one seems to have checked; no one seems to have gone beyond scraping out a bit of first wythe mortar.

Paul McDonnell pointed this out during his testimony. Over time, he said, "the biggest change would be—would be on—to the mortar that's closest to the exterior of the brick. Because of moisture, because of wind, that gets, you know, over time, does get washed away. So it's basically environmental stuff, again, that is exposed directly to the outside. So, internally it is much less because it's not exposed to the environment." McDonnell, alas, was, in Colaiacovo's court, the Great Northern's most informed and least valued witness.

Bows and Cracks

Schenne, other ADM consultants, and the judge referred to a bow in the west wall and cracks in the brick wall at various places. Comerford said he'd seen both when he looked at the building.

I found only one mention of either of these that included a number: it occurs in a five-page 1994 report prepared for Scheid Architectural by Jason-Kiener Consulting Engineers (Buffalo), "Structural Evaluation & Feasibility Study for the Exterior Masonry Walls, ADM Great Northern Grain Elevator, Ganson Street, City of Buffalo." It addresses the bulge:

> Our observations at the site indicate that lateral displacement of the exterior brick walls is apparent. Upon further investigation of ADM files we found a drawing prepared by Herthe & Sonnenberger Surveyors, which depicts information compiled from a series of studies performed for the previous owner of the elevator, The Pillsbury Company. These studies measured the lateral movement in the brick walls and were apparently performed in 1948, 1951, 1964, 1968, and 1971. Based on our interpretation of the Herthe & Sonnenger's drawings, their most recent measurements indicate that the West masonry wall of the structure if bowing with an eastward lateral displace of the West masonry wall of almost ten inches.

This was included in the December 15, 2021, submission to Comerford by ADM lawyers Brian M. Melber and Richard E. Stanton. This is the only document in all the submissions I've found with anything specific about the bulge; there is nothing specific about the cracks.

Consider what this is: a 2021 submission of a 1994 report based on an undated drawing found in ADM's files purportedly based on six studies done between 1948 and 1971 that show a ten-inch bulge in the west wall.

There is no indication that the size or shape of the bulge changed over the years of the purported Pillsbury measurements or if it has changed from the first measurement that went into the drawing, 1948, to now. There is no indication of how big the bulge is. Nor is there any information about when the bow occurred: has it been there since the wall was built?

And how significant is that ten-inch bow of unspecified size in the wall's forty-thousand-square-foot surface? Are walls like that plumb bob straight until they're about to collapse, or is this something to be expected?

Which is to say, yes, there is a bow, but we don't know how long it's been there, if it has changed since it first appeared, or if it matters.

Same thing and more with the cracks. How many are there? How big are they? Are they contained within single panels, or do the run through several panels, passing through the piers? As with the mortar, do they go deep, or are they just in the exterior or interior surface wythe?

Paul McDonnell testified that many of the cracks he saw seemed to have been old and patched, and that there was no way to tell from a surface crack what meaning it might have without thorough interior inspection, which no one seems to have done. The fact that the patched cracks did not crack again indicated to him that they didn't go deep.

Without specific numbers attached to each of these bits of eyeball data and an old drawing found in an ADM file, the fact of the bow and the presence of cracks tell us nothing.

The Endangered and Dangerous Cupola

Judge Colaiacovo accepted ADM's engineers' assertions that the cupola was supported by the brick wall and rejected Paul McDonnell's insistence, in his affidavit and his testimony, that the cupola and the wall were fully independent of one another.

In his court testimony, Schenne said the cupola was "definitely supported by the walls and not the interior steel frame." But in the December 2021 ADM brief requesting demolition permission, he wrote, "The cupola was made up of structural steel trussed framework that was clad in corrugated iron that rose to a height of 184'. *The weight of the entire structure was carried by the basement column extensions.*"[2] What got him to change his mind about that easily documentable fact?

"Agreeing with Schenne," the judge wrote, "Whitlock testified that the exterior walls supported the cupola. The fact that the walls were compromised presented a dangerous condition for the cupola. . . . With respect to the cupola, relying on Resondents' #13, Whitlock concluded that the weight of the roof and the end of the cupola was supported by the exterior brick walls." And then, "With respect to the cupola, relying on Respondent's #13, Whitlock concluded that the weight of the roof and the end of the cupola was supported by the exterior brick walls. . . . Because the cupola is poorly supported, in Whitlock's opinion to be 'pushing down,' Comerford had a rational basis to conclude the building to be 'unsafe and unsound.' "

2. Exhibit B: "Report on the Structural Condition of the Great Northern Grain Elevator, Buffalo, New York, prepared by Schenne and Associates," 3. Emphasis mine.

This was more pooling of ignorance and error. Whitlock's testimony was based on what he was told, his reading of prior ADM reports, and what he saw in a single photograph.

Judge Colaiacovo wrote that he also accepted the evidence apparently provided by that photograph: "When #13 was enlarged, it was clear that the smaller beams rested on the brick walls."

In his section on "Credibility," Colaiacovo wrote, "the Court found Dr. Allan Rhett Whitlock to be the most credible witness. The Court found him to be singularly impressive and quite persuasive. Like Schenne, he found the Commissioners [sic] determination to be rational. However, Whitlock was able to corroborate each finding with photographic evidence that supported the prior determination. As such, the Court afforded his testimony significant weight."

Photos like Respondent's #13, "cupola after collapse, brick debris," proved nothing of the kind. It is impossible to tell from a single photograph the distance between distant objects. The appearance of depth (along what a modeler would call the z-axis) is a function of the distance between the objects, the distance from the lens to the objects, and the focal length of the lens being used. A telephoto lens or an enlargement or a small section of a photo taken with a normal lens all make objects seem closer on the z-axis than they are in reality; a wide-angle lens makes them seem further apart. An object close to the lens can appear larger than a much bigger object some distance away; positioned correctly, a photographer can produce a photograph showing a five-year-old child holding the Empire State Building in the palm of his hand.

Every photographer knows these things. I don't know if Allan Rhett Whitlock did or if Judge Emilio Colaiacovo did. I'd think, in a case as important as this, one of them would have asked how much that photo could be trusted or at least asked, "What does that photo *really* tell us?" Neither did.

Only one report in evidence involved a thorough inspection of the interior and inspection of the construction blueprints: the 1990 HAER report. That team not only spent time in all parts of the site but looked at plans and building permits still in Buffalo City Hall and the original plans drawn by D. A. Robinson and Max Toltz. Their documentation included dozens of interior photographs by HAER photographer Jet Lowe. That report twice states—once in the body and again in the appendix—that the cupola is entirely supported by steel beams:

The cupola consisted of a structural steel trussed framework clad in corrugated iron and rising to a height of 184'. The entire weight of the structure was carried by the extensions of the basement columns.

Full cupola, 4 stories high, to a total of 181'; extends length of building; supported by extensions to the basement columns between the bins.

Judge Colaiacovo elected to accept Allan Rhett Whitlock's and his own interpretation of a photograph over Paul McDonnell's testimony that the photographs in evidence didn't show the real relationship of some of the objects in them and the only disinterested report on the Great Northern available.

Colaiacovo and Whitlock made a defective assumption: if the cupola touched the brick curtain, then the brick curtain was supporting the cupola. There was a very good reason for the cupola touching the brick curtain that had nothing to do with support: if it didn't, if it stood above the

curtain with no contact (which it could have done, since it was supported by steel columns integral to the elevator itself), then the interior of the building would be subject to wind-driven rain and snow—exactly what the brick curtain was there to keep out.

Up to Code

All of the ADM-hired consultants, Permit and Inspections Commissioner James Comerford Jr., Commissioner William Renaldo, and Judge Emilio Colaiacovo said or wrote that the Great Northern was not "up to code." That means, if you were building that structure now, you'd have to do a lot of things differently. That is true, but so what? No structure in Buffalo built before the current building code is "up to code," unless it has been significantly retrofitted. The great mansions on Delaware Avenue are not up to code. The Albright-Knox-Gundlach Gallery is not up to code. My house (built in 1918) is not up to code. Most of the city's hospitals are not up to code. City Hall is not up to code. The county courthouse in which Judge Colaiacovo held his two hearings about the Great Northern grain elevator is not up to code.

12

Reason

For Judge Colaiacovo, the entire case hinged on whether or not Commissioner Comerford had acted "reasonably."

Here is an example of logical reasoning most people encounter in high school: "*If a=b and b=c, then a=c.*" It is perfectly reasonable.

But *reasonable* refers to logic, which is abstract. What if *a* does not equal *b* or *b* does not equal *c*? The statement is still perfectly reasonable—but it is not true.

That was the point of the Article 78 lawsuit filed by the Campaign for Greater Buffalo. And that, the factual basis undergirding Comerford decision, is what Colaiacovo effectively kept out of the trial. As he wrote in his first ruling in the case (December 30, 2021), the hearing he scheduled "will be limited to the issue of how the city reached its decision and, specifically, whether the Commissioner had a rational basis for issuing the Order for the demolition. The authority to issue such an order is vested solely with the Commission. *As such, what other witnesses or experts would opine is of no moment.*"

From the beginning, Colaiacovo opted for the abstract logical equation. Logic is a language in which facts are by definition mute. Logical truth is entirely limited to the logical statement. Reality is another matter entirely.

13

If

So far as I know, no one at ADM or in Commissioner Comerford's office tried to find out why the north wall failed. That's important not for assigning responsibility, but to know what to look for in the remaining part of that wall and the other three walls.

Nor did anyone at ADM or Commissioner Comerford's office make any effort to determine if the hole in the north wall in any way endangered the massive steel structure within it or the four-story cupola above it.

No new data was introduced to the argument about the Great Northern's viability that ADM had lost twice before the City Council and the Preservation Board, and once less than two years earlier before Comerford himself.

All the engineers' reports antedated the hole in the wall. The second[1] was mostly an unattributed word-for-word copy of the first, with changed dates and cost estimates; it claims that the entire wall, which was over two feet thick at eye-level, was fourteen inches thick and drew conclusions from that. The fourth admitted no examination of anything but made wild claims about the stability of the cupola floor.

Everything else the court accepted was "might," "could," "possibly," "if," and such.

What if an ADM engineering consultant had come in with a report that said,

Yes, there is a bow in the wall, but it hasn't changed size or shape since it was first noticed in the early 1960s, so I don't think it's significant. And, yes, there are some cracks, but we don't know how long any of them have been there, or how deep they go, so without further study, there is no reason to assume they present a danger to the brick curtain. And yes, some of the mortar on the front wythe of bricks can be picked out with a knife, but we don't know if

1. Exhibit H: December 15, 2021: "Condition Assessment: Great Northern Grain Elevator," Petrilli Structural & Consulting Engineering, P.C., January 28, 2014. Based on a "walkthrough of the above-mentioned grain elevator." Much of it is lifted, without citation or quotation marks, from a report done in 1994.

that condition goes beyond that wythe, or even to the back of it, so let's do some borings to find out before any assumptions get made. In the meantime, you should replace the missing gutters, downspouts, and flashing to prevent more of this problem, if problem it is.

Had such a report arrived at ADM, do you think ADM would have offered it to the Buffalo Preservation Board, Commissioner Comerford, or Judge Colaiacovo? I'm not saying such a report exists or that such a report was sought. I'm just asking, "What if?"

On the basis of future conditionals and *ifs* that pointed in one direction only, the Great Northern was doomed.

14

What Paul McDonnell Said

There is a line in Euripides' *Bacchae* I've always liked. It is variously translated as "You see what you want to see," "You see what you need to see," and "You see what you ought to see."

I think all apply to the last days of the Great Northern, each of them as they fit the needs and capabilities of the various advocates and actors: ADM president Tedd Kruse and other company officials and their hired consultants advocating demolition; public-interest advocates like Anne Dafchik and everyone involved in the Campaign for Greater Buffalo; and appointed and elected government officials like Rep. Brian Higgins, Mayor Byron Brown, Commissioners James Comerford and Renaldo, and Judge Emilio Colaiacavo.

The Great Northern is dead and gone, so all this is history now. I've read all the documents I could find about the death of the Great Northern: court transcripts and orders, consultants' reports, newspaper articles, all that jazz. The single document that seems to me to nail the reality out there better than any other is the letter Paul McDonnell sent Buffalo Mayor Byron Brown on January 9, 2022.

McDonnell, as I noted earlier (and as Judge Colaiacavo noted in court) was, while all the demolition litigation was going on, president for the Campaign for Greater Buffalo History, Architecture & Culture. He was chair of Buffalo's Preservation Board and a city architect for thirty-two years. He was the witness Judge Colaiacavo singled out in his July 5, 2022, ruling as the one whose testimony he valued least. I am, at the end of this, most baffled by that.

In that January 9 letter, McDonnell urged Brown to rescind Comerford's condemnation order. He nailed the gambit in it: "The existence of the emergency declaration itself provides a pretext." He said the building was in no danger of collapse and that the cupola was in no "danger of blowing off." The current problems with the metal and brick cladding could be repaired. He noted the skimpiness of the ADM's documents seeking demolition: a "page-and-a-half narrative on a structural assessment by engineer John Schenne. There are no exhibits attached that corroborate statements made regarding the structural stability of the Great Northern (photographs, drawings, test results).

The same applies to correspondence of three other engineers included in the 'Submission Concerning Emergency Demolition Order Due to Safety' compiled by the law firm." He noted that during his eleven years on the Preservation Board, requests for demolition would "run to dozens, if not hundreds, of pages of fact-finding, analysis, and recommendations. . . . The Schenne letter is grossly inadequate, unsupported by fact, and uncorroborated."

McDonnell went on to note "that the brick cladding of the Great Northern is not load bearing, but it shares characteristics with other solid brick walls stretching back to antiquity," and that the "problem" of the Great Northern's lack of control joints raised by ADM's consultant engineers was nonsense: "Control joints were conceived to solve the problems of cheaper construction from the 1930s onward."

"The cupola of the Great Northern," he wrote, contradicting Comerford and ADM "is supported by a steel frame that is independent of the brick walls." Later in his letter he provided documentary evidence for this.

He noted that the current public safety concerns from ADM had been in previous demolition requests, all of which had been turned down. "Each of the Commissioner's findings regarding the need for demolition lack substantive support in fact. These are factual issues in which the Commissioner was mistaken and not matters of opinion."

He commented on the skimpiness of the ADM reports on which Comerford relied: "They are four-to-seven page text-only briefs of opinion on certain aspects of the building. None include photographic evidence or structural diagrams in support of conclusions or other means of verification."

He also noted that the only specific data on the bowing of the west wall was based on a half-century-old drawing and that the same geriatric data was cited in three subsequent reports.

Finally, he commented on John Schenne's contention that the Great Northern's six thousand underwater wood pilings were in danger of drying out and that the Great Northern was at risk of earthquake damage. There was no evidence, he said, that the ground beneath the Great Northern ever went dry, and that "in 200 years there has never been a report we've been able to find of an earthquake that produced structural damage in Buffalo."

He attached photographs showing bushes growing at the top of the north wall because of missing flashing and gutters, and water-level reports showing that the subsurface pilings haven't been dry for a century, and more. He included several of Jet Lowe's photos for the HAER report and a schematic diagram showing the massive column support of the roof and cupola and a drone photograph showing those supports.

He would repeat much of this in an affidavit and in his testimony before Judge Colaiacovo.

And he was the witness Judge Colaiacovo valued least. Perhaps I picked the wrong classical character to introduce this note. Maybe I should have cited Priam's daughter Cassandra, cursed with telling the truth but not to be believed.

15

Utility

What use is there in an old industrial structure that is no longer functional? Why not tear it down—as ADM did in this case—to make room, perhaps, for a truck parking lot?

ADM wasn't alone. Letters from readers endorsing that notion appeared regularly in the *Buffalo News*. Robert Kresse, one of the former three trustees of the Margaret L. Wendt Foundation (at that time one of Buffalo's three major foundations dedicated to local affairs) told me the elevators are "a bunch of junk on the river. They should all be torn down."

If you see them as part of Buffalo's architectural heritage, they should be preserved or repurposed. If they're "a bunch of junk on the river," then what happens to them matters only to the owners.

You might as well ask what use there is in the Coliseum in Rome: an arena with eighty entrances and room for fifty thousand spectators, built from 70 to 72 CE by the Emperor Vespasian as a site for gladiatorial games, dramas, and public executions. It has been derelict since the fall of the Roman Empire. In 2021, it had nearly 1.7 million visitors.

16

Some Things I Heard

There are some things I heard related to all this. I have no evidence for the veracity or even likelihood of any of them. They may derive from a *post hoc ergo propter hoc* ("if this, then that") assumption. They were part of the Buffalo conversation while the court proceedings and demolition were going on, so I'm going to tell you about them.

The first group of comments had to do with why ADM wanted to demolish Great Northern: "That's prime waterfront property; ADM is demolishing it so a developer can put pricey condos there." I heard variations of that more than once.

It seemed to make sense: the same had happened on the other side of the Buffalo River, within a mile or so of the Great Northern, at sites previously occupied by nineteenth-century industrial buildings.

I was disabused of that story once I started spending time photographing the demolition on Ganson Street. The ADM mill adjacent to the Great Northern is very noisy; it puts a lot of dust in the air and attracts noisy geese and gulls. Trucks servicing the mill and the General Mills operation on Michigan Avenue at the north end of Ganson roll all day long. Living there would not be very pleasant.

I next began hearing that ADM wanted the space for a truck parking lot. That, too, seemed plausible. As several of the photos indicate, space between the railroad tracks and City Ship Canal is jammed with trailers waiting to be loaded and sent elsewhere. But was that a problem when ADM tried to get the building condemned in previous decades? Or when Pillsbury, the previous owner, also tried and failed to accomplish the same thing?

Another explanation came from a city planner who had worked in this area. Whatever the past reasons for demolition, he said, that strip of waterfront land does have residential potential now. No developer would touch it as long as the Great Northern stood; if they purchased the property now, the Great Northern would be the same kind of albatross it was for Pillsbury and ADM. But, he said, if the Great Northern were gone, then purchase and razing of the adjacent mill would make a great deal of sense. That would provide about eight hundred feet of waterfront property on the east side

of the ship canal. The factory noise and dust would be gone and so would the screeching gulls and honking geese. Truck traffic on Ganson would be significantly reduced; all that would remain were the trucks servicing the General Mills factory, and they didn't operate at night or on weekends. The only downside might be the odor of roasting Cheerios, which on baking days permeates that part of Buffalo. But some people who live there like the odor, and others say, "I don't notice it anymore."

Another possibility is that ADM officials felt that the Great Northern, inoperative since 1981, was a financial drain and nothing more: it produced no income and was a potential liability.

Now that the Great Northern is gone, it seems to me that any or, at different times, all of these could have been possible. A year or two from now, perhaps, we'll know. But that will be another story.

Another I just heard once, from a worker at the site. The original plan, he told me, was to take down the rest of the north 140' wall and the east 400' wall, then take apart the elevator and cupola. (I assume the west 400' wall, the one facing the City Ship Canal would have been saved for last because, with the elevator still standing, there would have been no place to dump the bricks but in the water.) But when demolition began, it changed to a more segmented process: first they chewed up some of the steel closest to the north wall, then the December 11 hole was widened and the 160' crane continued tearing at the steel. More east and west wall were knocked down and more steel was ripped and carted away.

Was the guy informed, or was he hypothesizing? I don't know. I like his report because it suggests that ADM officials and engineers feared that if the brick curtain were torn away, the magnificent structure it protected from Buffalo weather would be there for all to see. The beams supporting the cupola would be there for all to see. The perfect stability of the structure would be there for all to see. And so many of those claims justifying demolition would collapse and the demolition process might be stopped by a court willing to consider what was really there.[1]

But that's just hearsay and speculation. I don't know the reality of it; I doubt any of us ever shall.

1. During one of the mediation sessions, leaders of the Campaign for Greater Buffalo were asked if they would accept demolition of just the wall. Confident that demolition of the wall would make perfectly clear the real support structure of the cupola and stability of the entire interior, they said, "Yes." ADM, however, would have none of it.

17

Me

Much of what I've written here is based on my close reading of documents available to anyone. I went to engineering school and I've taught graduate seminars in the University at Buffalo's School of Law and School of Architecture and Planning. But I'm not an engineer or architect or lawyer, and I claim none of the subtle discriminations those professions make—the engineers and architects in their designs and reports and the lawyers in their citations. I did my graduate work in language and literature.

I *do* know how to read a blueprint and a spreadsheet; I can do numbers; I can read text for content and for inconsistency, waffles, manipulation, fog, and befuddlement. An engineer's report, however detailed, warrants a critical eye if its predicate—the question the report was designed to answer—is itself questionable. A judge's decision, however many cases he cites in support of it, warrants a critical eye if its predicate—the question the judge decides the proceeding is about and uses as the basis for what he lets into the record and excludes from the record—is itself questionable.

All the hired engineers' reports for ADM seem to me loaded toward demolition; they are all short on facts and full of opinions and hypotheses. I do know that there was not one independent evaluation of the state of the brick curtain of steel interior of the Great Northern grain elevator in all of this. Not one. The closest anyone came was the 1990 HAER inspection, which had no hysteria about a chimerical "emergency."

Nor can I say that Judge Colaiacovo shut out of serious consideration any arguments or factual claims the preservationists or Douglas Jemal or anyone else might have offered before he gaveled that first hearing open. I can only say that my readings of the texts of his decisions, his critical narrowing of the question at hand, and his discounting of witnesses who questioned the mission and reliability of the ADM consultants' reports made that conclusion inevitable for me. The only real question, I think, was how long it would take for the axe to fall.

18

What the Great Northern Said

The Great Northern is demolished; the tons steel and millions of bricks have been shipped elsewhere—the steel to be melted down and reused, the brick to restore old buildings like the Great Northern or for new buildings trying for a certain look.

But, in a way, the building itself had the last word on all the self-serving ADM reports, on Comerford, on the judge who sought reason but not facts, on the fire commissioner who generated a key letter full of imagined dangers.

In the ten months from December 11, 2021, to the commencement of demolition on September 16, 2022, nothing happened other than the demolition itself. Even though that gaping hole made the brick wall more vulnerable to wind, rain, and snow, to summer heat and winter cold, than it had been since it went up 126 years earlier, none of it fell to the ground; there were no reports of new cracks appearing or old cracks widening. The cupola, which ADM and Comerford insisted was supported by the brick wall, didn't tilt, slip, or dip. If there really was an emergency situation when Comerford signed his December 17, 2021, demolition order, it slipped out of town in the dark of night.

And it stayed out of town. During the eight months of demolition, the only parts of the wall that fell to the ground were the parts that were knocked or pulled down. The only parts of the steel elevator itself and the cupola above it that fell to the ground were pieces that were ripped out by the 165-foot crane.

The demolition was a noisy affair: in addition to the usual mechanical noise from the mill and the honks and screeches from the geese and gulls, there was the chatter and clanking of the 165' Ultra High Demolition Excavator tearing at the steel and two or three smaller devices moving the torn steel pieces to mounds a hundred yards away. There were also the screams and groans from the Great Northern itself as chunks of bent and twisted steel were ripped from the elevator's rivets and welds.

On April 3, 2023, there was another sound: a shriek, like the gulls, only far louder. It wasn't the chattering shriek of the gulls; it seemed anguished and angry. It continued the entire time I was there that day, almost without pause. It grew louder every time the UHD Excavator dropped a piece

of steel and moved back in for another bite. I finally located it in the small portion of the cupola still standing, the southwest corner. It was probably an eagle—the only bird around here capable of so loud a cry—protecting its eggs or nestlings. After all, what could be a safer place for a nest than the far corner of a space nearly 150 feet above the ground that no human had visited for decades?

The final part of the elevator to come down was the south marine leg, which the fire commissioner had insisted was in imminent danger of toppling into the City Ship Channel. It crashed to the ground eleven minutes after noon on April 26, 2023. It didn't fall. Earlier that day, workers with torches had cut large notches in the elevator's east supporting beams. When they were done, two thick steel cables attached to the upper part of the leg were connected to two pieces of construction equipment to the north of the elevator. The equipment backed up slowly. Pulleys let their northward motion draw the cables attached to the marine leg eastward, toward Ganson Street. The time between the first of my photographs showing the tower beginning to tilt and the last showing it on the ground with bits of metal and brick in the air was six seconds.

When that tower came to ground, there was a large crash. No surprise there. But there was something else—a subsonic wave that I didn't hear but felt in my bones, in my teeth. I don't know if it moved through the air or, like the subsonic rumble of some earthquakes, though the ground. I've never felt anything like it; it was awesome, uncanny. My audio recording of those last minutes has chatter among the dozen or so of us inside the barriers on Ganson Street blocking traffic during the pull-down. After the crash there are several seconds of silence, then someone says, "Wow!" Someone else says "Yeah." There is more silence, then the sound of vehicles as the barriers are moved away and traffic resumes.

That was the Great Northern's last word. If I had to translate it, it would be something like this: "Those guys lied. They used all kinds of legal maneuvers to get what they wanted, and they got it. What are the rest of you going to do to keep this kind of atrocity from happening again?"

All I can offer now is what I saw: some archival photos of the Great Northern in its youth and maturity, the Great Northern when I first started looking at it in 2010, the demolition project that wiped it from Buffalo's urban landscape, and some of the documents I've mentioned in these comments.

II

Photographs

The first three photographs (plates 2–4) show the Great Northern when it was fully functional: the first two are dated 1900; the third is undated but must be before 1922, since all three original marine towers came down in 1922 and were replaced by the two marine towers of later design that stood until the Great Northern was demolished.

The second group (the image facing the title page and plates 5–17) shows the Great Northern in retirement. I took them all in 2010. The Great Northern was then a significant part of Buffalo's visual industrial landscape. The photos show it from the Buffalo River, the City Ship Canal, Lake Erie, Fuhrman Boulevard, and the Michigan Avenue Bridge.

The third group (plates 18–58) show the hole in the wall caused by the December 11, 2021, storm; the widening of that hole by demolition equipment as tearing away the steel interior began; the exposed interior after more of the east wall was demolished; the long process of tearing apart the steel bins and the cupola and moving the huge fragments to scrap piles, where they were picked up and shipped off for recycling; and, finally, the last fragment of brick wall standing after the south marine tower was pulled down in late May 2023, eight months after demolition began.

The brick curtain varies in color in some of these images. Part of that is a result of my processing of the images; more is a function of the changing light. The perceived color of any object results from a combination of its reflectivity and the color of the light impinging on it. This far north, the light temperature changes significantly with the time of day and time of year. Our brains adjust to this without thought, but the camera reports what it sees.

What perhaps astonished me most during the demolition process was how bright, shiny, and uncorroded the bin interiors were 126 years after they were built and more than 40 years since they'd had any maintenance. Those bins were built to keep grain dry, and dry they remained until the demolition process ripped them apart.

Plates

All photos except 2, 3, and 4 are by the author.

1. (frontispiece) Great Northern Grain Elevator from Ganson Street, 2010.

2. "Unloading Grain at Great Northern Elevator, Buffalo, N.Y.," 1900. *Source*: Detroit Publishing Co., Photographer unknown; courtesy Library of Congress. Public domain.

3. "Great Northern Elevator and shipping, Buffalo, N.Y.," 1900. *Source*: Detroit Publishing Co., Photographer unknown; courtesy Library of Congress. Public domain.

4. Great Northern, before 1922. *Source*: Photographer unknown; courtesy Buffalo History Museum. Public domain.

5. From railroad tracks along Ganson Street, 2010.

6. From Lake Erie, 2010.

7. From City Ship Canal, 2010.

8. From City Ship Canal, 2010.

9. From Buffalo River, 2010.

10. From Buffalo River, 2010.

11. From Buffalo River, 2010.

12. Under Skyway from Fuhrmann Boulevard, 2010.

13. Under Skyway from Fuhrmann Boulevard, 2010.

14. From west side of City Ship Canal, 2010.

15. From Ganson Street, 2010.

16. From Michigan Avenue Bridge, 2010.

17. From west side of City Ship Canal, 2010.

(All remaining photos are from Ganson Street, except for plates 33 and 34, which are from the west side of the City Ship Channel.)

18. Hole caused by December 13, 2021, storm. July 15, 2022.

19. Slightly enlarged hole and beginning of ripped steel interior. November 19, 2022.

20. Much enlarged hole and further interior demolition. November 22, 2022.

21. Detail, interior demolition. November 19, 2022.

22. Detail, interior demolition. November 22, 2022.

23. With the brick curtain gone, the steel girders supporting the bins and cupola are clearly visible. November 27, 2022.

24. With the brick curtain gone, the steel columns supporting the bins and cupola are clearly visible. November 27, 2022.

25. With the brick curtain gone, the steel columns supporting the bins and cupola are clearly visible. November 27, 2022.

26. With the brick curtain gone, the steel columns supporting the bins and cupola are clearly visible. November 27, 2022.

27. March 20, 2023.

28. Remaining section of cupola, perfectly level after removal of brick curtain, March 20, 2023.

29. April 3, 2023.

30. April 5, 2023.

31. April 6, 2023.

32. South wall and spiral staircase. April 5, 2023.

33. From west side of City Ship Canal. April 6, 2023.

34. From west side of City Ship Canal. April 6, 2023.

35. April 7, 2023.

36. April 7, 2023.

37. April 12, 2023.

38. April 12, 2023.

39. April 12, 2023.

40. April 12, 2023.

41. April 16, 2023.

42. April 17, 2023.
43. April 17, 2023.
44. April 17, 2023.
45. April 19, 2023.
46. April 19, 2023.
47. April 19, 2023.
48. April 19, 2023.
49. April 19, 2023.
50. April 20, 2023.
51. April 21, 2023.
52. April 19, 2023.
53. The Great Northern's south marine leg, the last standing steel structure, just before it was pulled down. April 26, 2023.
54. The Great Northern's south marine leg as it is being pulled down. April 26, 2023.
55. The Great Northern's south marine leg just after it was pulled down. April 26, 2023.
56. Dumping parts of the marine leg into a scrap metal truck. April 27, 2023.
57. Dumping parts of the marine leg into a scrap metal truck. April 27, 2023.
58. Remaining part of south end of brick curtain. May 5, 2023.

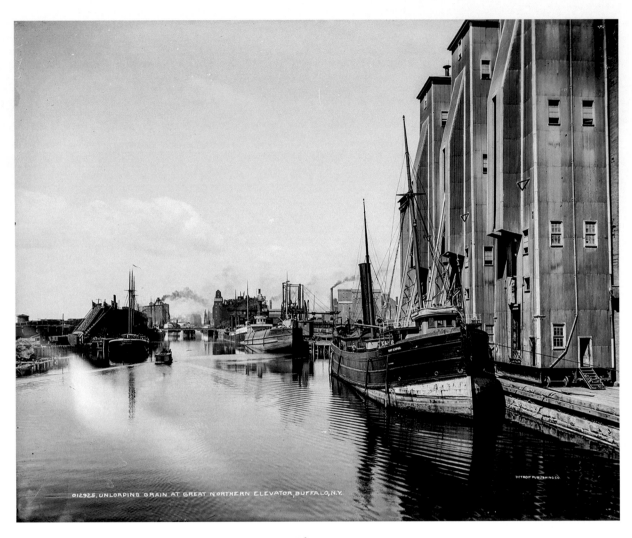

Plate 2.

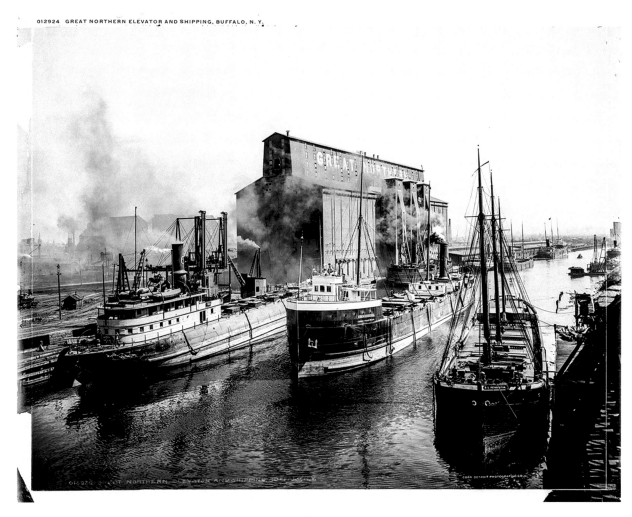

Plate 3.

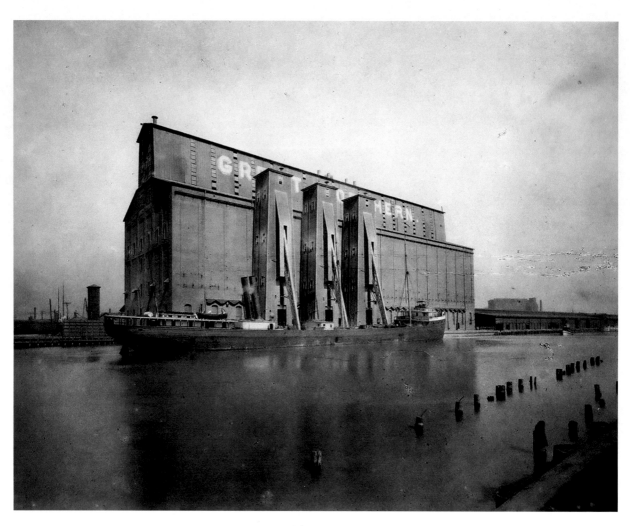

Plate 4.

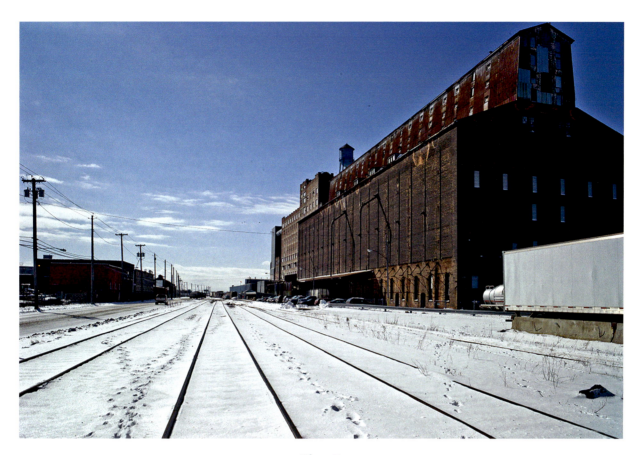

Plate 5.

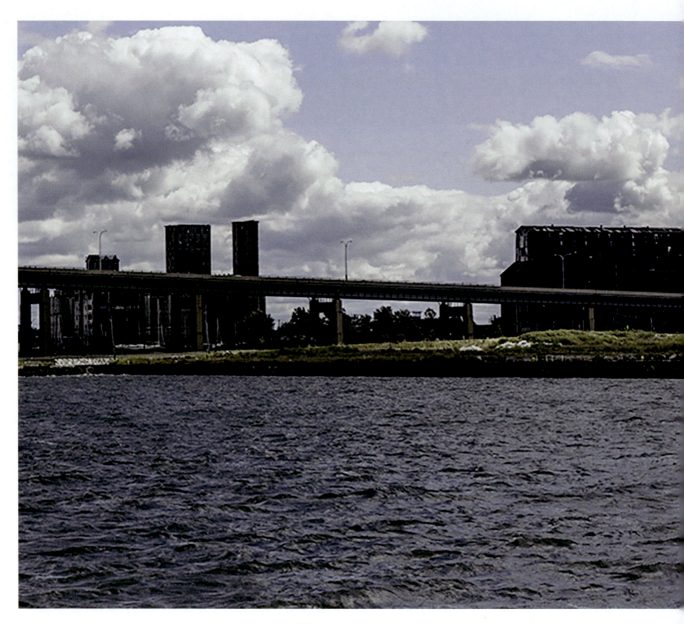

Plate 6.

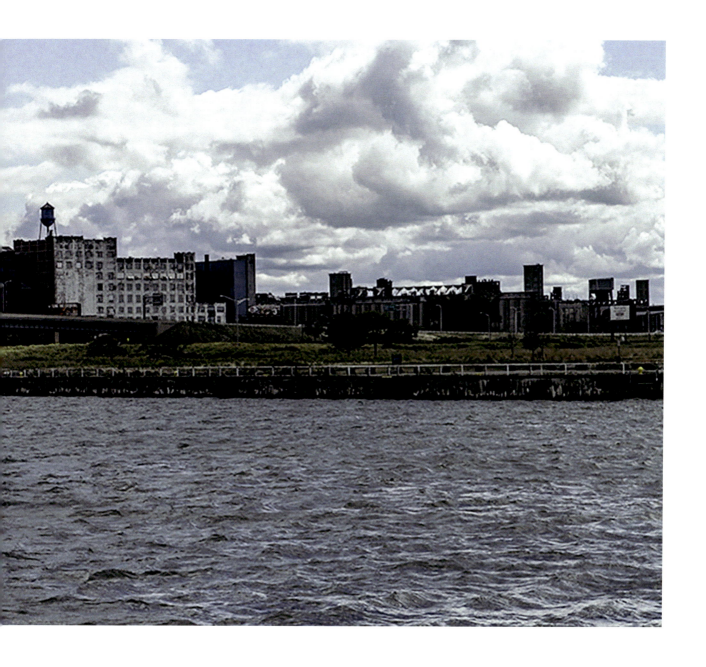

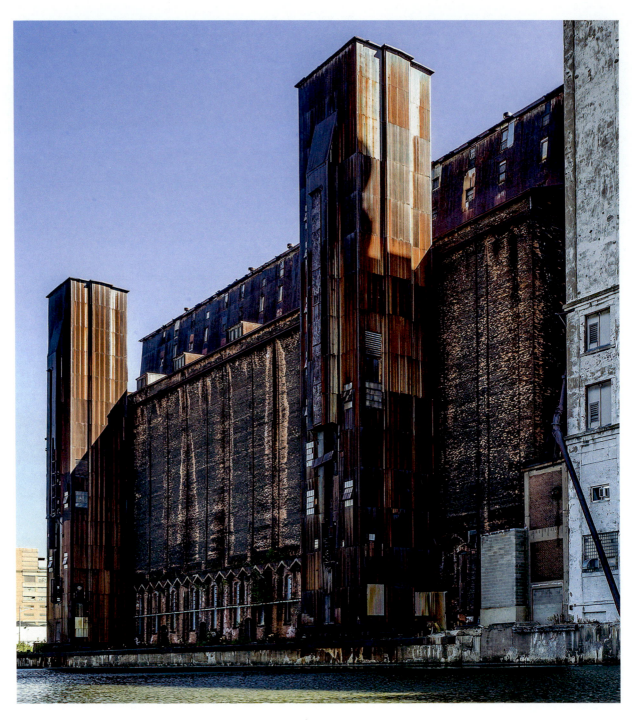

Plate 7.

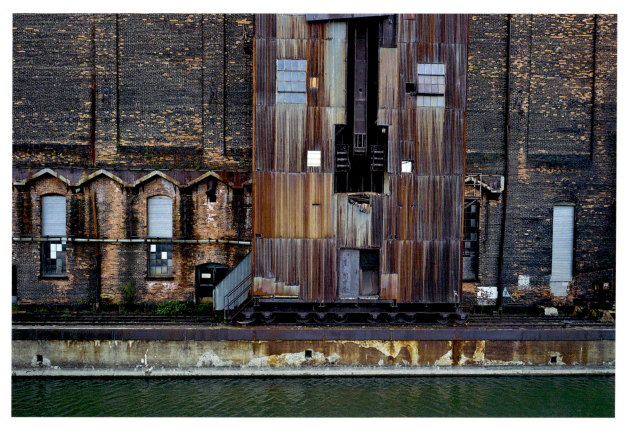

Plate 8.

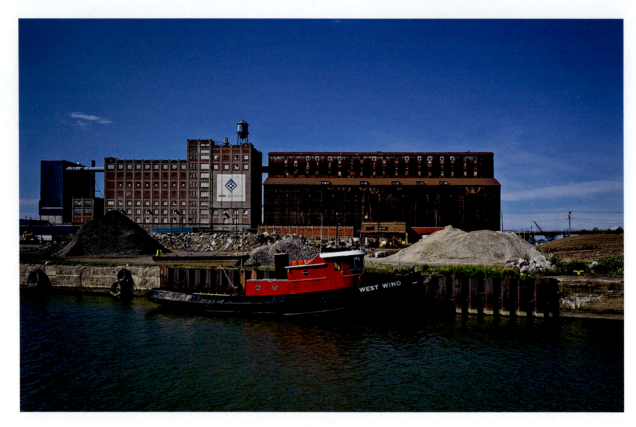

Plate 9.

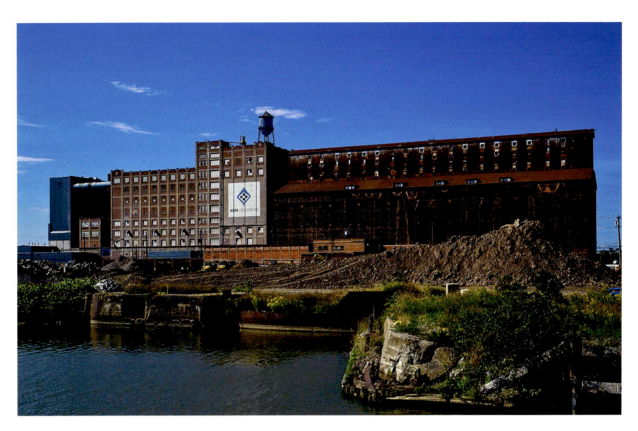

Plate 10.

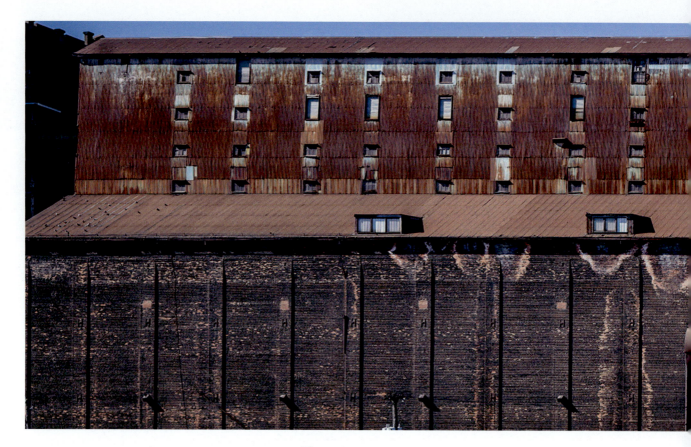

Plate 11.

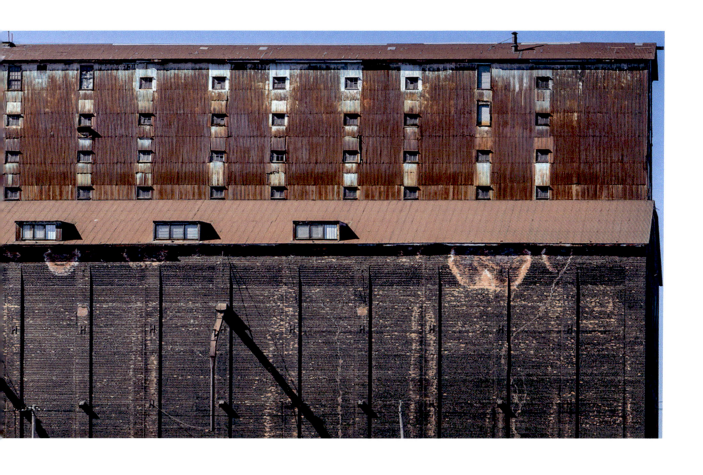

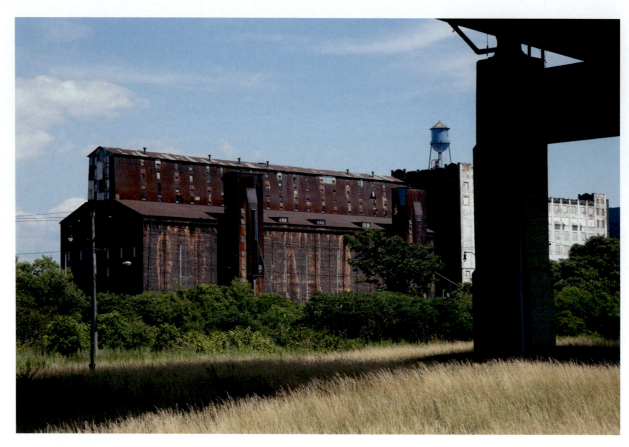

Plate 12.

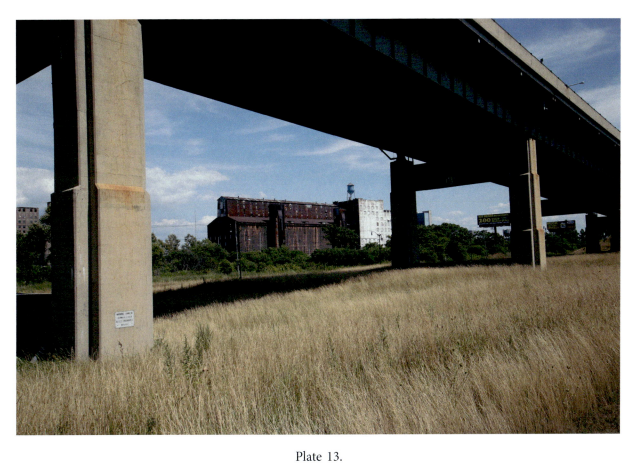

Plate 13.

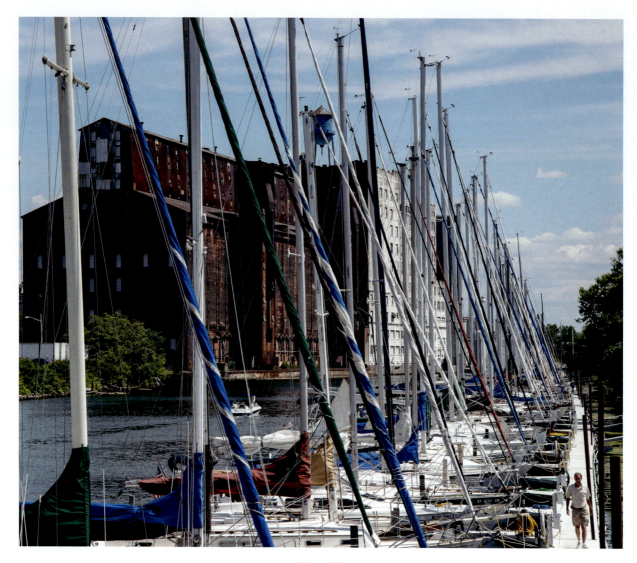

Plate 14.

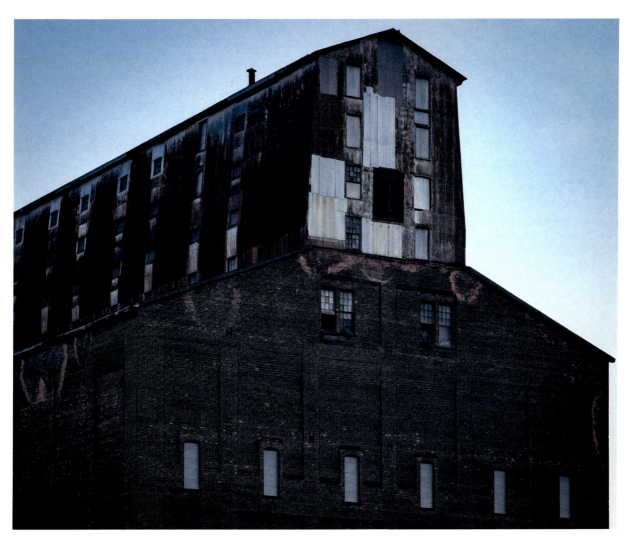

Plate 15.

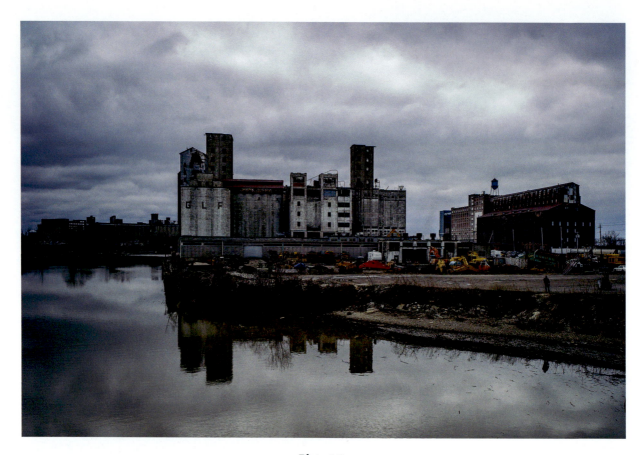

Plate 16.

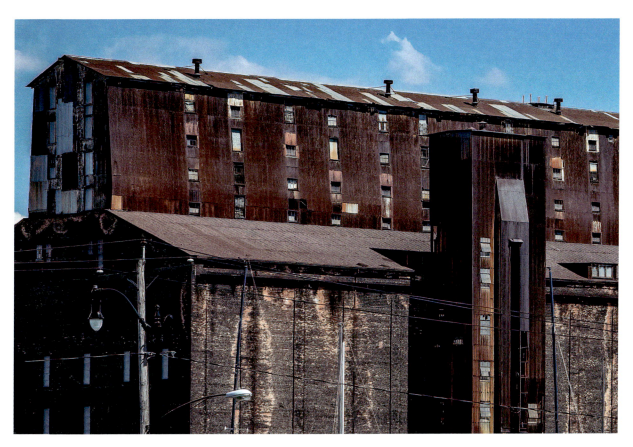

Plate 17.

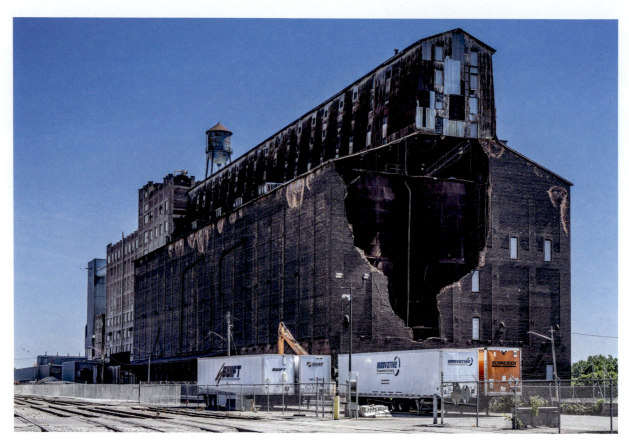

Plate 18.

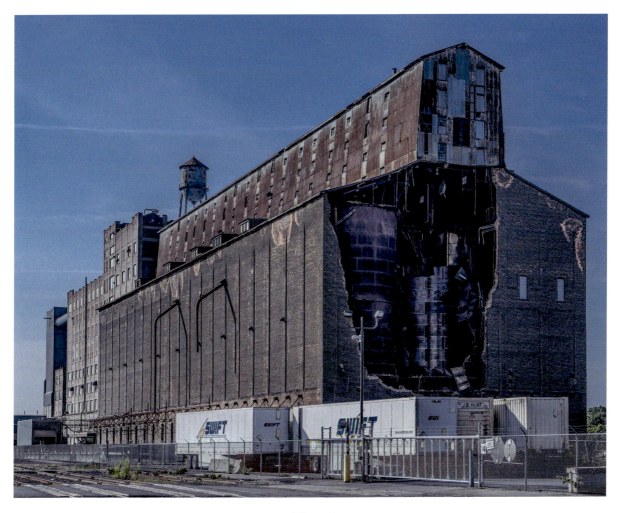

Plate 19.

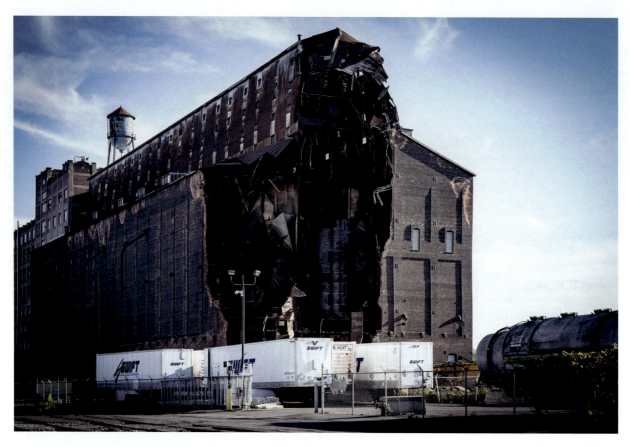

Plate 20.

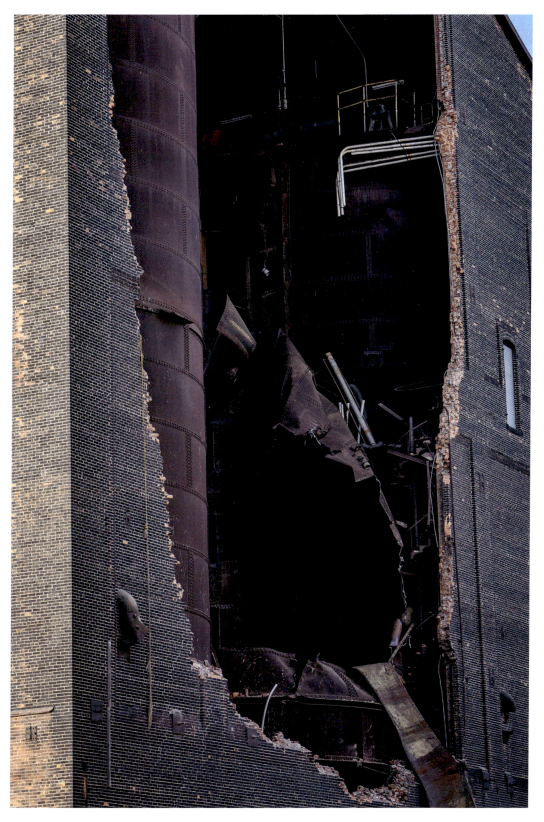

Plate 21.

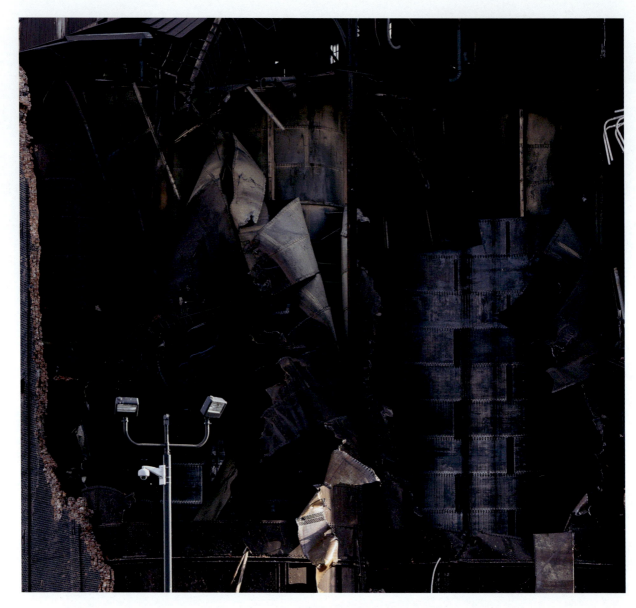

Plate 22.

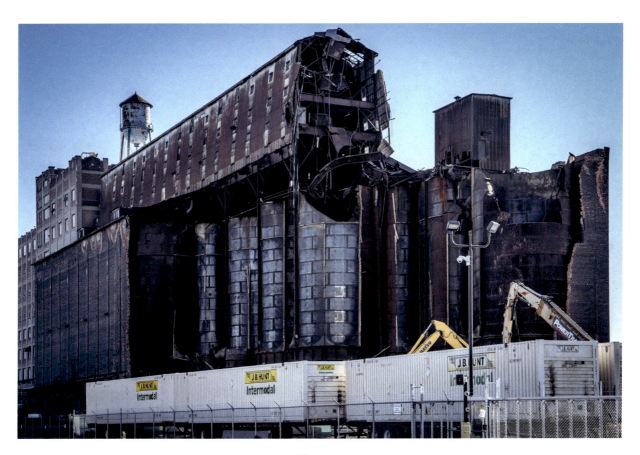

Plate 23.

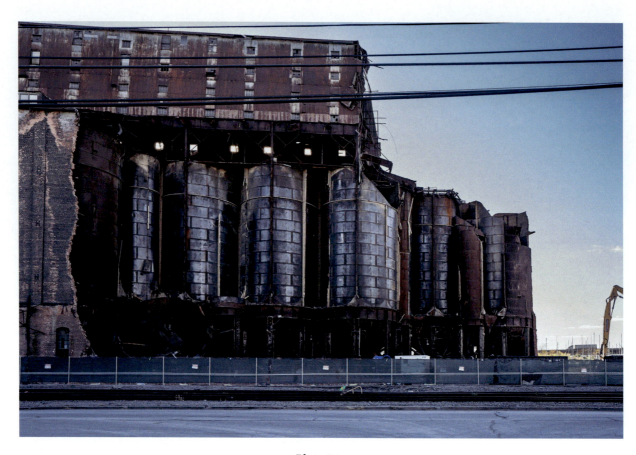

Plate 24.

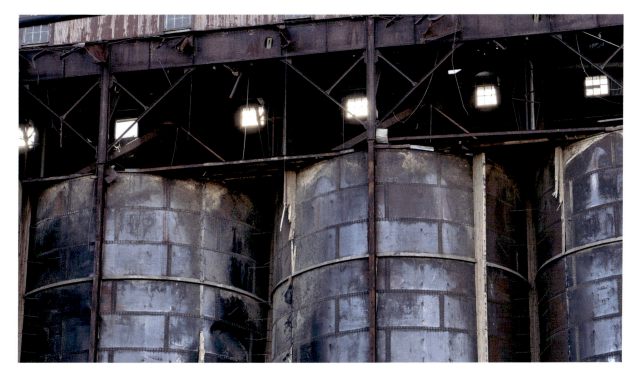

Plate 25.

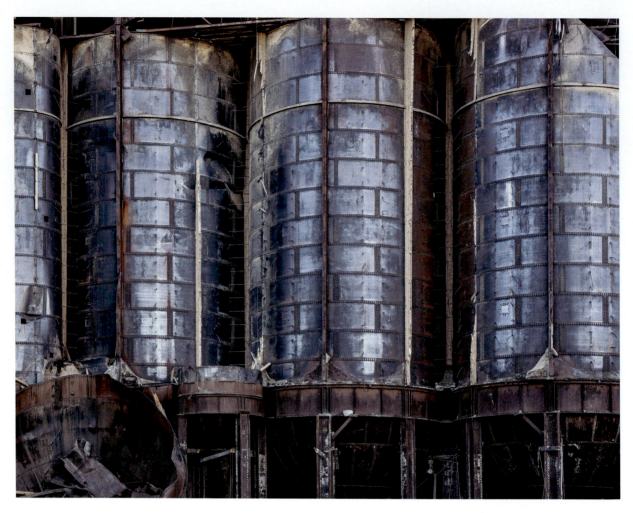

Plate 26.

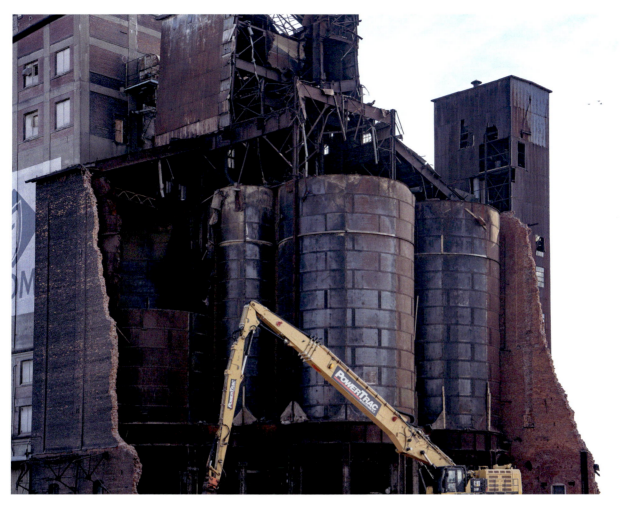

Plate 27.

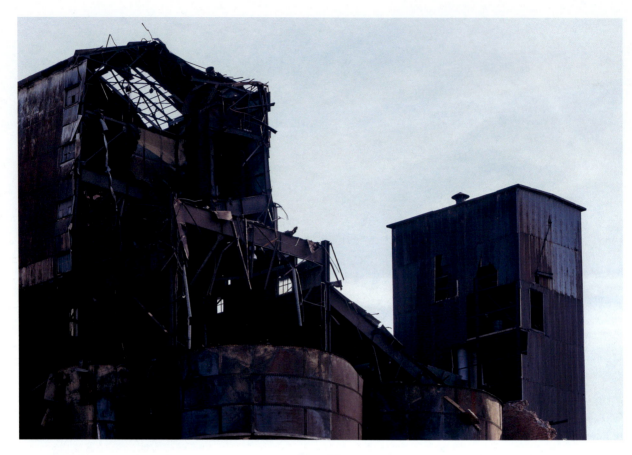

Plate 28.

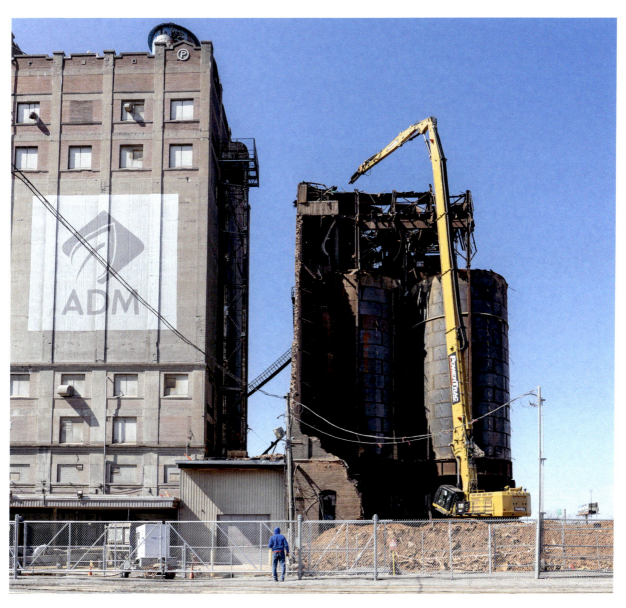

Plate 29.

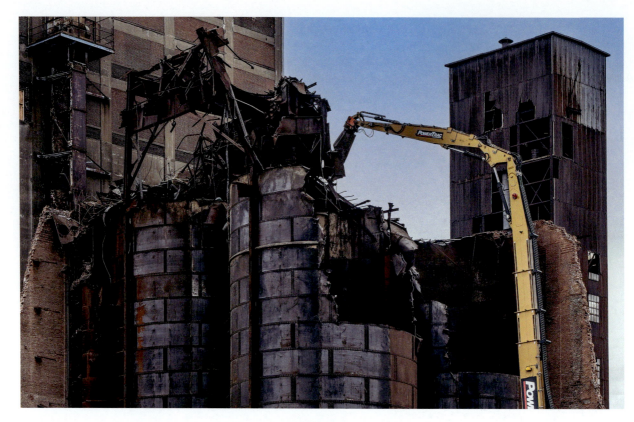

Plate 30.

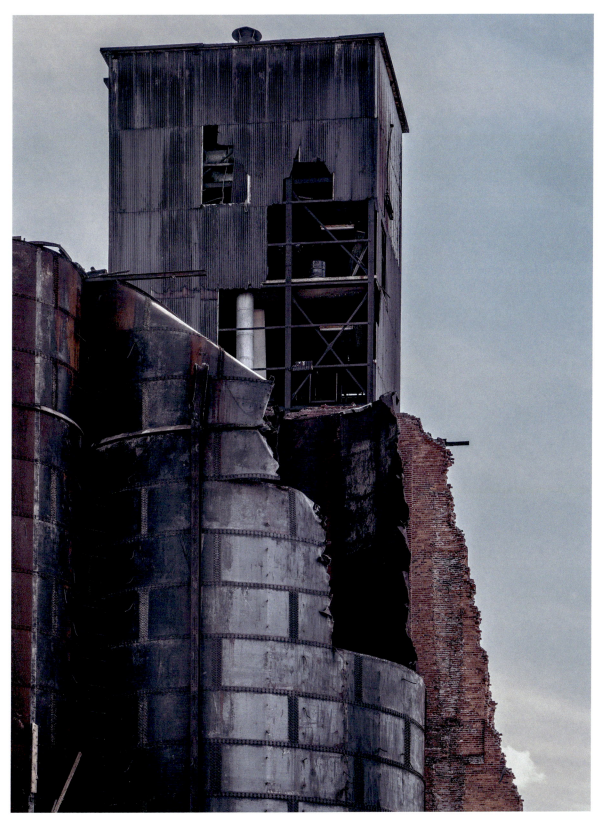

Plate 31.

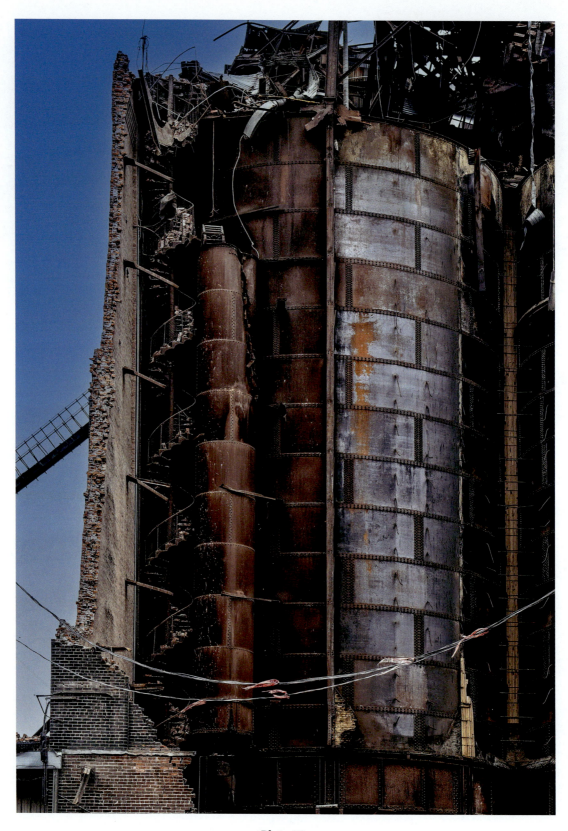

Plate 32.

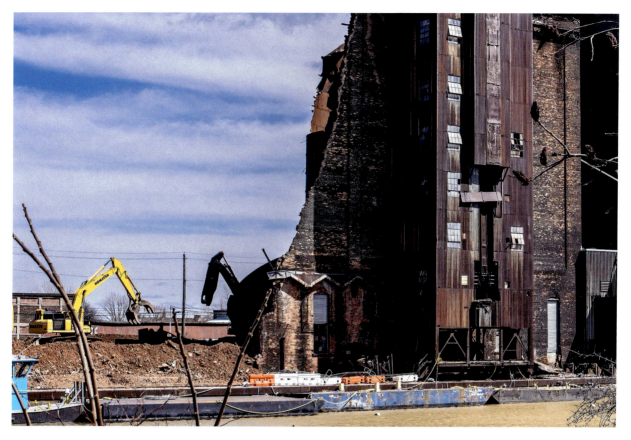

Plate 33.

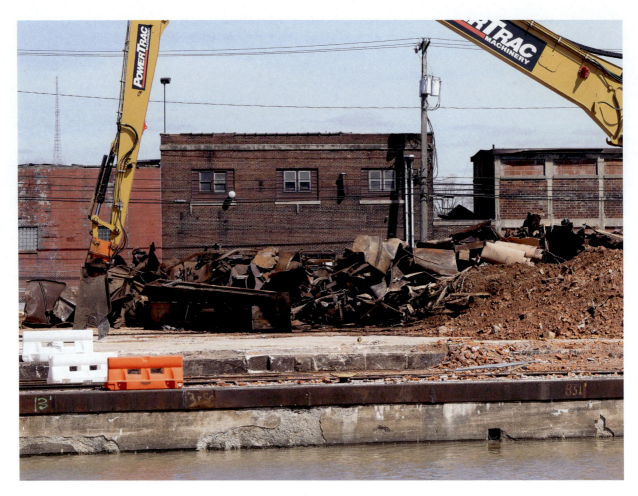

Plate 34.

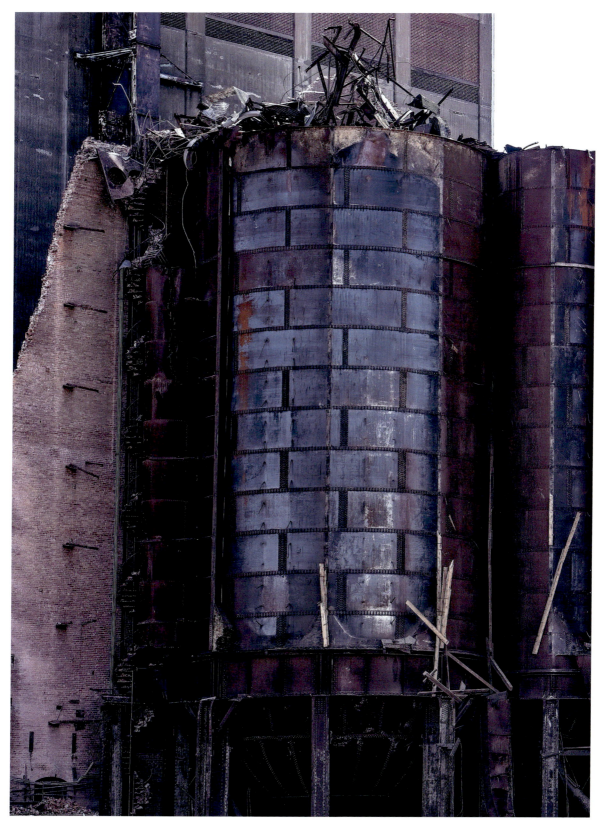

Plate 35.

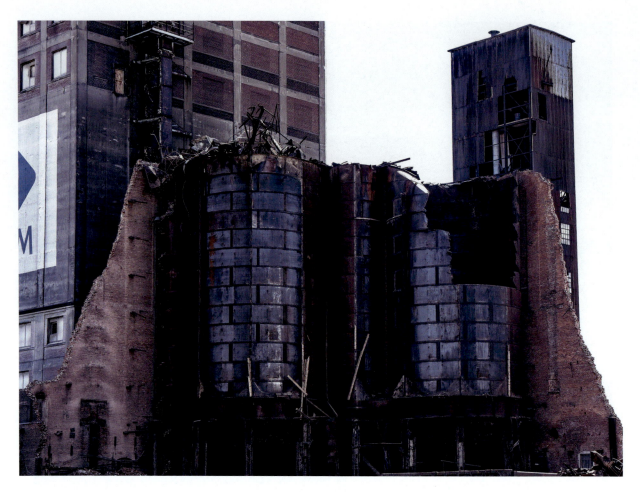

Plate 36.

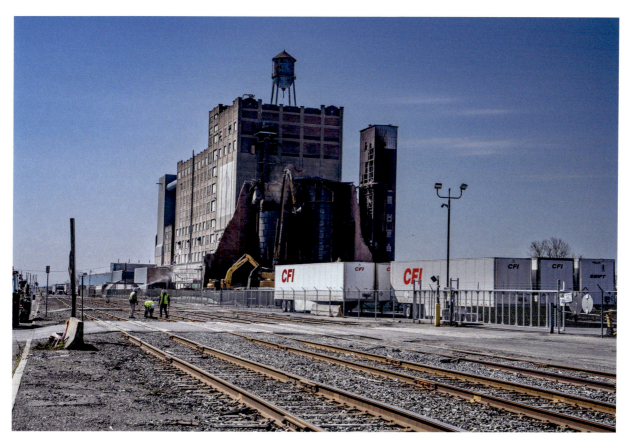

Plate 37.

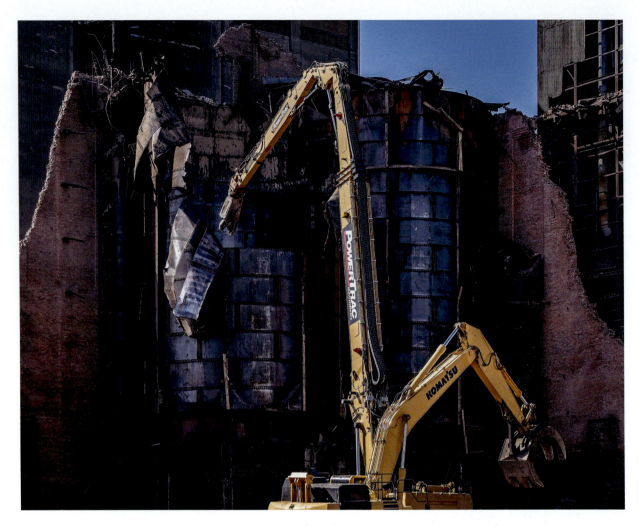

Plate 38.

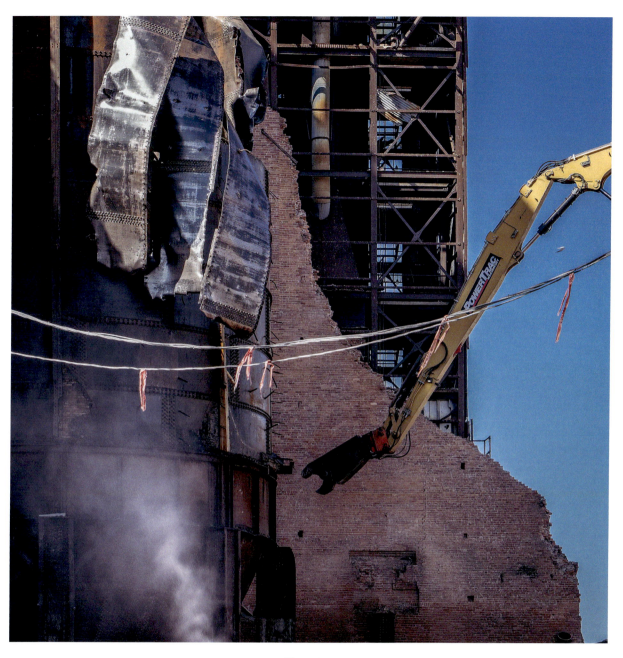

Plate 39.

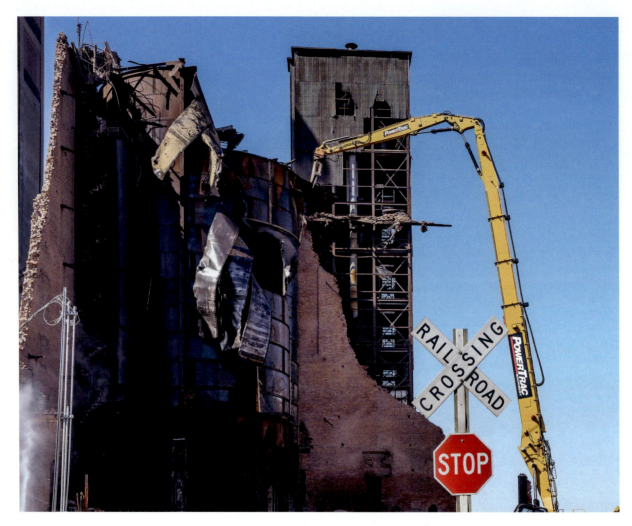

Plate 40.

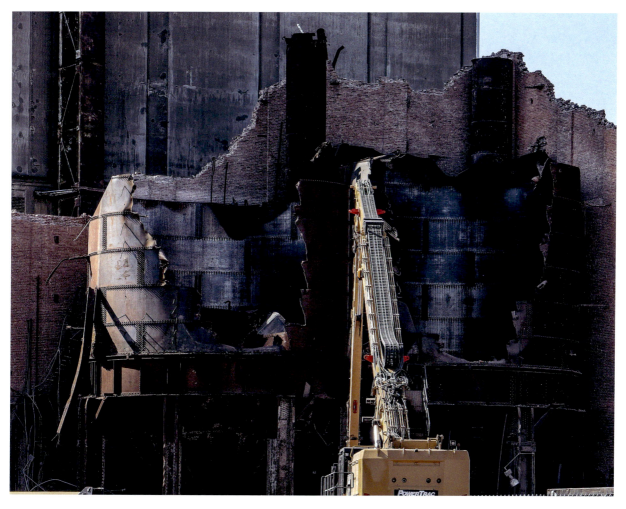

Plate 41.

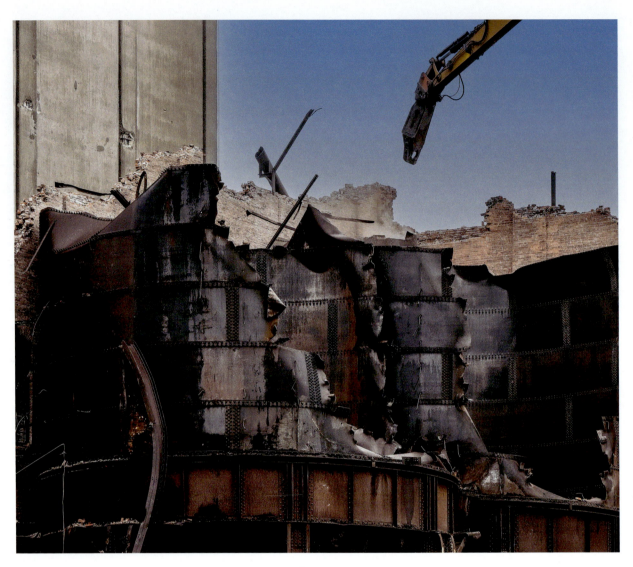

Plate 42.

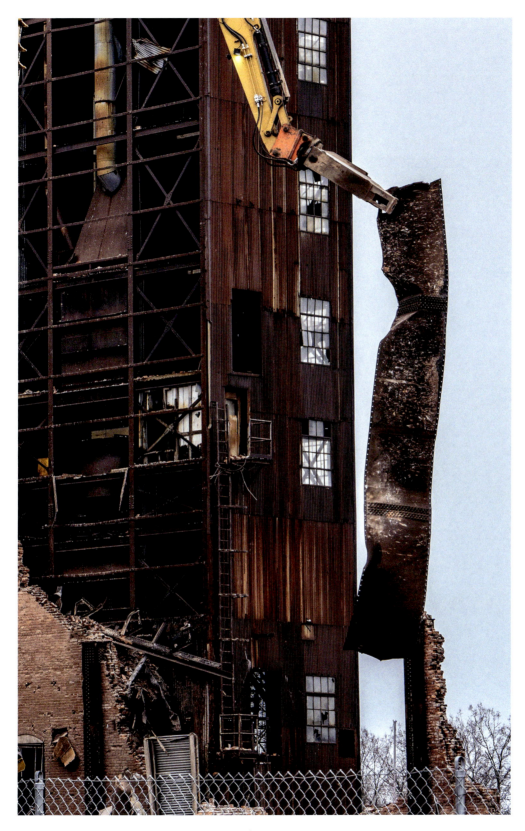

Plate 43.

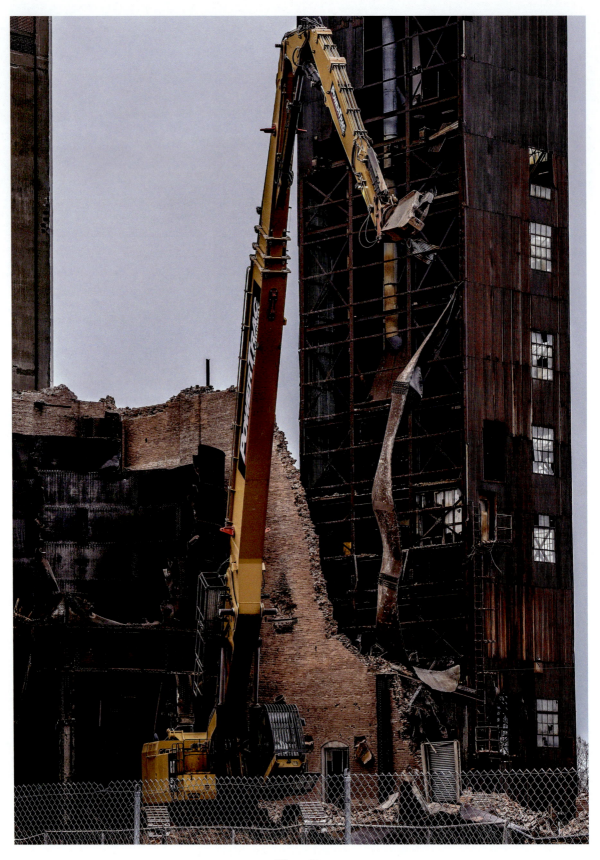

Plate 44.

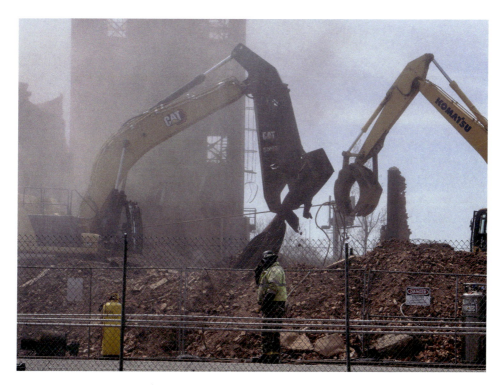

Plate 45.

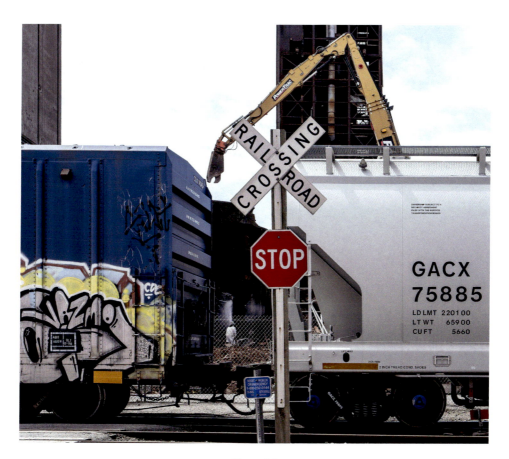

Plate 46.

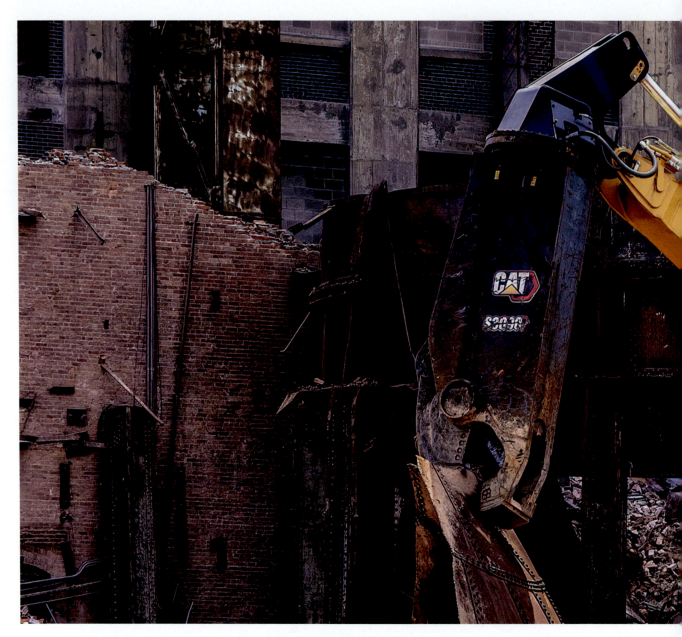

Plate 47.

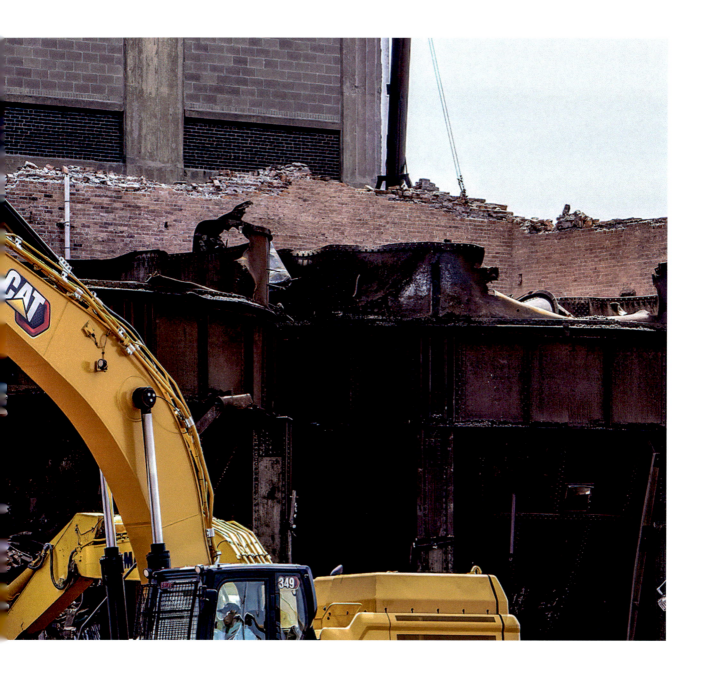

Plate 48.

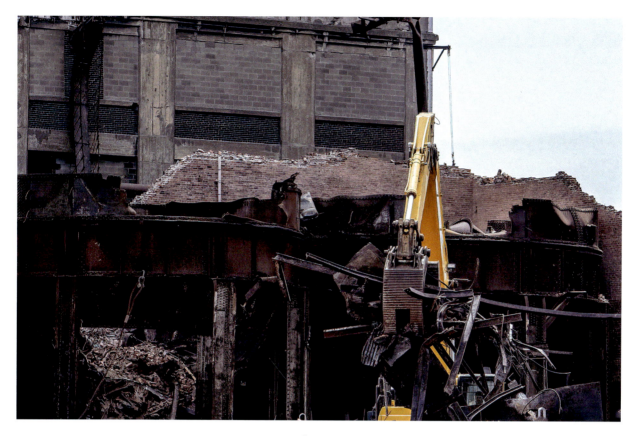

Plate 49.

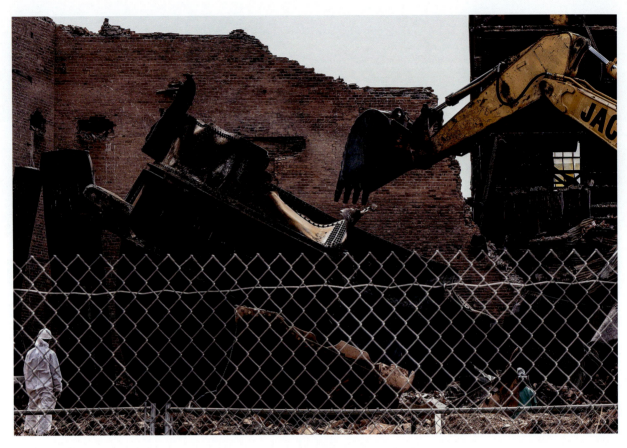

Plate 50.

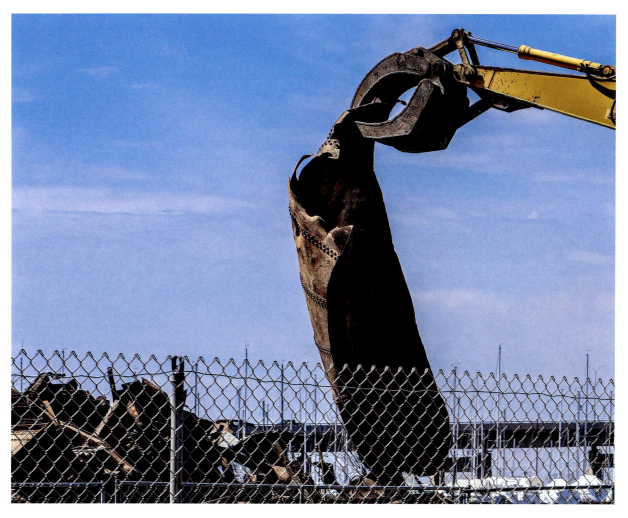

Plate 51.

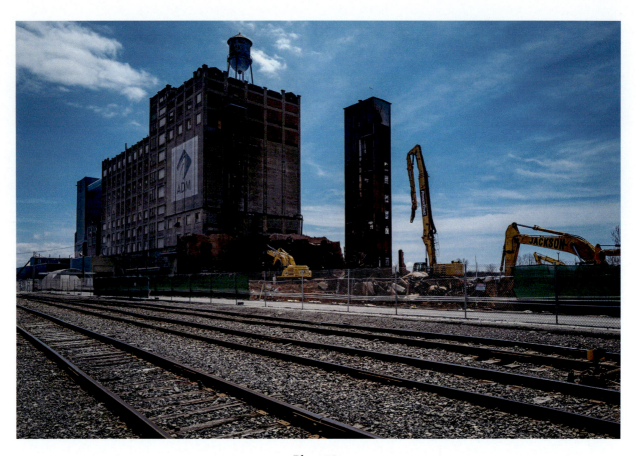

Plate 52.

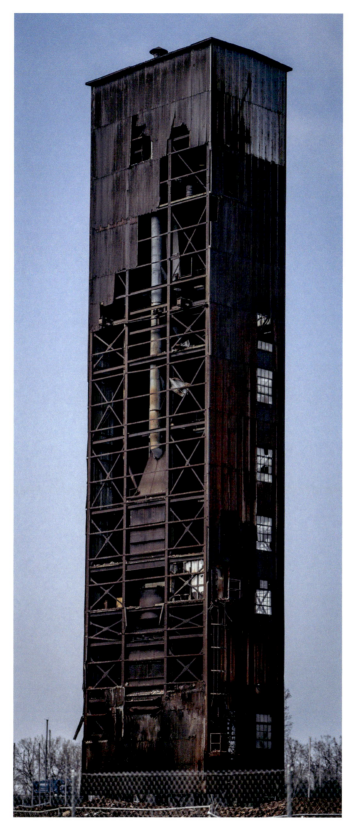

Plate 53.

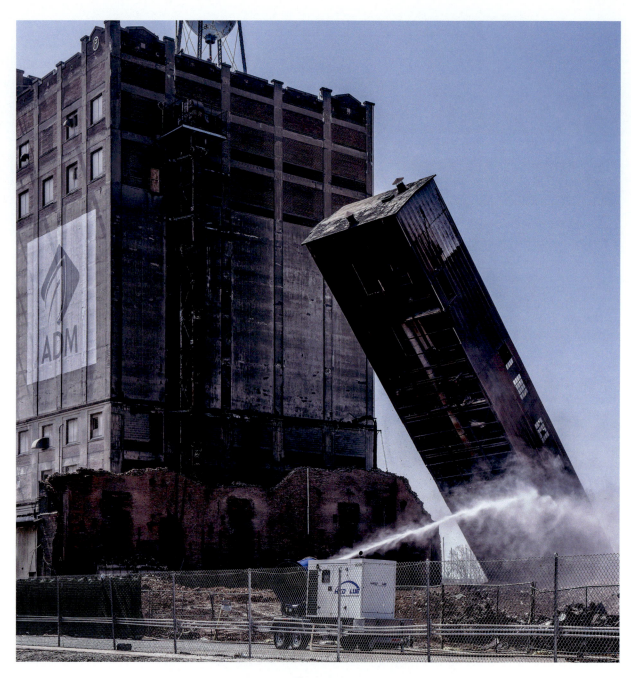

Plate 54.

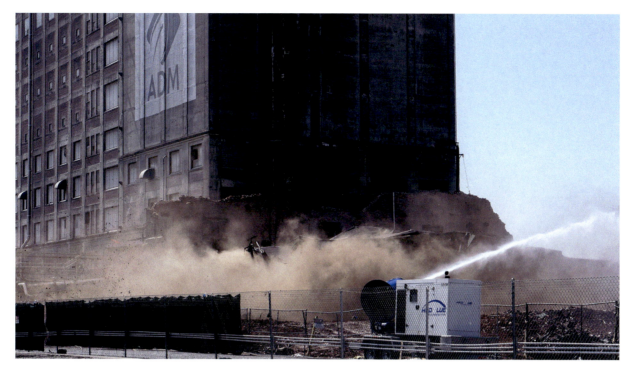

Plate 55.

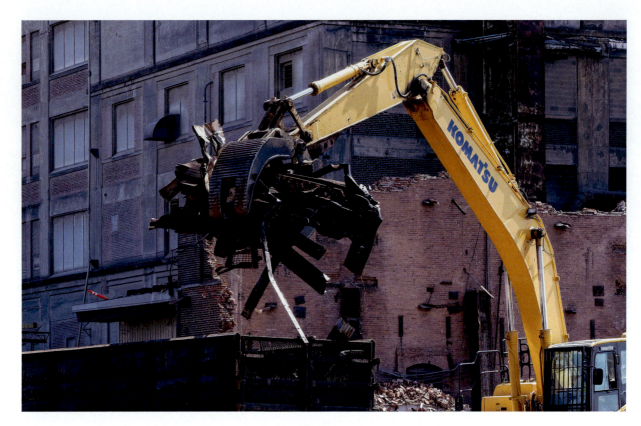

Plate 56.

Plate 57.

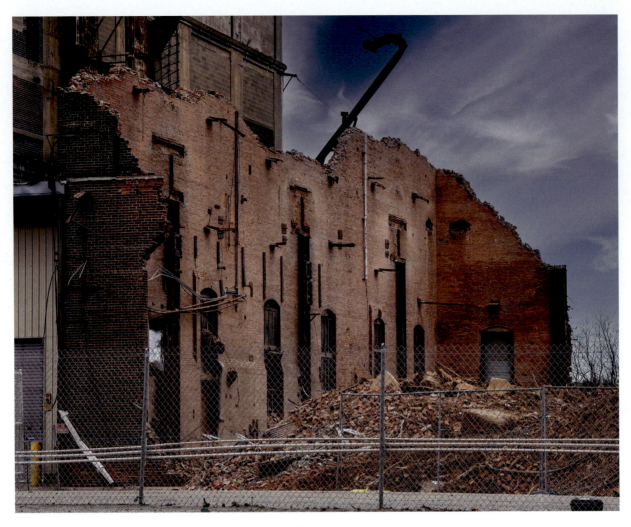

Plate 58.

III

Documents

The ten items that follow begin with the 1990 HAER Report and its two drawings (1–3: pp. 122–156). Next is the December 15 "Submission Concerning Emergency Demolition Order Due to Safety" delivered to Commissioner Comerford by two of ADM Milling's Buffalo lawyers, Brian Melber and Richard E. Stanton (the document does not include the Submission's many exhibits) (4: pp. 157–166). That is followed by Comerford's December 17 demolition order (5: pp. 167–168).

Then there are four letters: Rep. Brian Higgins to ADM CEO Juan Luciano (December 13, 2021) (6: p. 169), Anne Dafchik to Mayor Byron Brown (December 16, 2021) (7: pp. 170–171), Mayor Brown to ADM CEO Juan Luciano (December 23, 2021) (8: p. 172), and Paul McDonnell to Mayor Brown (January 9, 2022) (9: pp. 173–182).

The final item is the Campaign for Greater Buffalo's computer-generated graphic showing the vertical-column support structure for the bins and cupola, which ADM's engineering witnesses said didn't exist (10: p. 183). Those beams are clearly visible in plates 19, 20, 23, 24, and 27–30.

GREAT NORTHERN ELEVATOR
(Mutual Elevator)
(Pillsbury Company Elevator)
250 Ganson Street
Buffalo
Erie County
New York

HAER No. NY-240

HAER
NY
15-BUF,
32-

WRITTEN HISTORICAL AND DESCRIPTIVE DATA
REDUCED COPIES OF MEASURED DRAWINGS
PHOTOGRAPHS

Historic American Engineering Record
National Park Service
U.S. Department of The Interior
P.O. Box 37127
Washington, D.C. 20013-7127

1. 1990 HAER Report.

HISTORIC AMERICAN ENGINEERING RECORD

GREAT NORTHERN ELEVATOR
(Mutual Elevator)
(Pillsbury Company Elevator)
HAER No. NY-240

HAER
NY
15-BUF
32-

Location:	250 Ganson St., Buffalo, Erie County, New York
Date:	Building permit issued March 31, 1897
Designer:	Max Toltz and D. A. Robinson
Builders:	D. A. Robinson, Chicago; Riter Conley, Pittsburgh, steel fabrication; Buchan Bros., steel erectors
Status:	Not in use
Significance:	The grain elevators of Buffalo comprise the most outstanding collection of extant grain elevators in the United States, and collectively represent the variety of construction materials, building forms, and technological innovations that revolutionized the handling of grain in this country.
Project Information:	The documentation of Buffalo's grain elevators was prepared by the Historic American Engineering Record (HAER), National Park Service, in 1990 and 1991. The project was co-sponsored by the Industrial Heritage Committee, Inc., of Buffalo, Lorraine Pierro, President, with the cooperation of The Pillsbury Company, Mark Norton, Plant Manager, Walter Dutka, Senior Mechanical Engineer, and with the valuable assistance of Henry Baxter, Henry Wollenberg, and Jerry Malloy. The HAER documentation was prepared under the supervision of Robert Kapsch, Chief, HABS/HAER, and Eric DeLony, Chief and Principal Architect, HAER. The project was managed by Robbyn Jackson, Architect, HAER, and the team consisted of: Craig Strong, Supervising Architect; Todd Croteau, Christopher Payne, Patricia Reese, architects; Thomas Leary, Supervising Historian; John Healey, and Elizabeth Sholes, historians. Large-format photography was done by Jet Lowe, HAER photographer.
Historians:	Thomas E. Leary, John R. Healey, Elizabeth C. Sholes, 1990-1991

GREAT NORTHERN ELEVATOR
HAER No. NY-240
(Page 2)

This is one in a series of HAER reports for the Buffalo Grain Elevator Project. HAER No. NY-239, "Buffalo Grain Elevators," contains an overview history of the elevators. The following elevators have separate reports:

NY-240 Great Northern Elevator
NY-241 Standard Elevator
NY-242 Wollenberg Grain & Seed Elevator
NY-243 Concrete-Central Elevator
NY-244 Washburn Crosby Elevator
NY-245 Connecting Terminal Elevator
NY-246 Spencer Kellogg Elevator
NY-247 Cooperative Grange League Federation
NY-248 Electric Elevator
NY-249 American Elevator
NY-250 Perot Elevator
NY-251 Lake & Rail Elevator
NY-252 Marine "A" Elevator
NY-253 Superior Elevator
NY-254 Saskatchewan Cooperative Elevator
NY-256 Urban Elevator
NY-257 H-O Oats Elevator
NY-258 Kreiner Malting Elevator
NY-259 Meyer Malting Elevator
NY-260 Eastern States Elevator

In addition, the Appendix of HAER No. NY-239 contains brief notations on the following elevators:

 Buffalo Cereal Elevator
 Cloverleaf Milling Co. Elevator
 Dakota Elevator
 Dellwood Elevator
 Great Eastern Elevator
 Iron Elevator
 John Kam Malting Elevator
 Monarch Elevator
 Pratt Foods Elevator
 Ralston Purina Elevator
 Riverside Malting Elevator

GREAT NORTHERN ELEVATOR
HAER No. NY-240
(Page 3)

The president of the Great Northern Railroad, J. J. Hill, provided the impetus for the construction of an innovative fireproof elevator to transfer grain from his steamships for the onward dispatch, primarily by railroad, from Buffalo. The Great Northern Elevator was one of a new generation of economically and operationally successful steel elevators, and shared with the contemporary Electric Elevator a pioneering application of electric power to elevator functions.[1]

Although iron and steel had been applied to grain storage bins before the 1890s, the technology had not been widely adopted due to the high initial costs, misgivings about the materials' suitability for grain storage and the relative cheapness and ease of wooden construction. Iron and steel were applied to several pioneering elevator designs during the 1860s. In 1861 an iron-binned elevator was built in Brooklyn, New York. Seven years later the iron-binned and brick-clad Plymton Elevator was constructed in Buffalo, and, also in 1868, the first steel-binned elevator was built at Girard Point, Philadelphia. However it appears that there was little subsequent application of either iron or steel to grain storage. The availability of cheap open hearth steel from the late 1880s promised a revival of interest in metal grain storage. It is thought that a derivative of a patent by a man named Weber was employed in the construction of the Electric Elevator.

A notable pre-1897 patent for steel bins was that of Edward O. Fallis. His design, patented in 1895, featured freestanding hexagonal bins. The walls were of double thickness with steel sheets shallowly curved, the outer sheet curved outward and the inner sheet curved inward. A tubular steel column was placed at every corner of the hexagon, and into this the wall sheets were slotted. Provision was made for insulation and ventilation within the cavity created between the two wall sheets.

The Great Northern Elevator was built to the general design of the noted Chicago elevator builder D. A. Robinson, although the idea of raising the bins on columns may have come from J. J. Hill himself. Robinson was also responsible for the design of the machinery within the elevator. Robinson was thirty-five years old at the time of his appointment as "Engineer and Superintendent of Construction," and had been responsible for the construction of about 13 million bushels of elevator capacity. Much of his experience to this date had been in timber construction, for which he held a number of patents, particularly in the area of countering the substantial structural movements inherent in this form of construction.

The design work was carried out in collaboration with Max Toltz, bridge engineer to the Great Northern Railroad, who was appointed "Consulting Engineer" during construction. Toltz appears to have been responsible for the detailed working of Robinson's general designs. This collaborative effort was to culminate in the granting of a number of joint patents covering the various innovations introduced in the Great Northern. A patent granted in 1897, for example, detailed the construction of the bins, particularly an annular ring girder raised on columns above floor level within which the main cylindrical body of the bin rested, and from which hung the hemispherically shaped bin bottoms. Another patent, also granted in 1897, dealt with the vertical sub-division of the bins by the addition of hemispherically shaped dividers within the bins.

Although the Great Northern contained many novel features, the elevator was a structure in transition. The provision of a full height basement lacking horizontal transfer systems is an enigma, particularly since the contemporaneous and structurally less sophisticated Electric Elevator featured such systems. Previously such basements had been constructed to provide for the direct loading of railroad cars within the elevator, yet with the exception of a short length of internal track for grain dumping, all railroad loading functions were carried out below the car loading canopy attached to the outside of the building.

In the absence of basement conveying systems, lofting legs had to be provided along the length of the building and positioned so that grain drawn off from any one bin could be spouted directly by gravity to a convenient elevator boot tank for reelevation to the cupola for weighing and loading out (shipment). A lofty basement was required not only to provide the necessary spouting angles from the bin bottoms, but also to allow for the manipulation of the complex articulated spouting equipment that enabled all bins to feed to an elevator boot. The lofting requirements dictated by basement operations determined the necessity of a full height cupola the length of the building.

Contemporary journals remarked on the speed at which the building was conceived and executed. A building permit was issued in February of 1897 and work on the excavation of the site was underway by the end of that month. The building was sufficiently complete to receive its first cargo on September 29, 1897. The main outline of the design was barely sketched out when excavation began, detailed plans being worked out as needed. Robinson is said to have commenced work on the drawings in April of 1897, and surviving signed plans show that he was working on the designs until at least July.

GREAT NORTHERN ELEVATOR
HAER No. NY-240
(Page 5)

By the end of March, despite ground frozen so hard as to require dynamite to break it up, the entire site had been excavated to the required depth of 8'. Piling commenced after the excavations had been completed. Six thousand hemlock piles were driven by six steam pile drivers. The piling operations took about six weeks and were completed by mid-April. With the completion of piling, work commenced on the substantial masonry foundations.

After completion of the foundation, steel erection commenced. Substantial elements of the steel work were prefabricated in Pennsylvania at the shops of the steel contractor Ritter Conley Company. The basement columns were built up and delivered to the site complete, while the ring girders were shop fabricated and delivered to the site in four sections. The shipping bins arrived at the site as completed cylinders up to about 25' long. The components for the storage bins were delivered to the site on a plate by plate basis. The plates for the cylindrical sections of the bin had been rolled to shape, and the holes for the fastenings punched and reamed. The plates for the bin bottoms were shop sheared to shape, punched flat and forged to profile at white heat between the dies of a 400-ton hydraulic press. The columns, weighing some 10-1/2 tons, were lifted into place by derricks and held there by anchor bolts. The segments of the ring girders, weighing about five tons, were then lifted into place and riveted together. The first two rows of basement columns, complete with ring girders, were in place by the end of May, and the completion of this job took approximately seven weeks. By the middle of July, the erection of the columns and girders was virtually complete, and the first two rows of bins were in place.

The shipping bins varied in depth from 22' to 53'. The bin arrangements designed by Robinson wasted about 20 percent of the potential volume of enclosed space. This deficiency was corrected at a later date by the addition of sixty small elliptically shaped bins within the spaces between the main and interstitial bins. Four such bins were installed in the gaps between interspace bins and the four adjoining main bins. The date of this additional capacity is not known, but the extension was probably carried out during the remodelling works commissioned by Pillsbury upon acquisition in 1922. An updated Sanborn map from that era, however, while showing modifications to the marine towers carried out at that time, failed to note any additional storage capacity.

Unlike later concrete elevators, the bins were designed to withstand full fluid pressures. Apparently the theories on the behavior of grain in deep bins were sufficiently speculative at this date for Robinson and Toltz to behave with due prudence and,

in the light of subsequent experience, to considerably overspecify the material requirements.

The main bins consisted of a 65' cylindrical section above the ring girder together with a 21' tapering bin bottom below the ring girder. The upper part of the bin bottom was hemispherical in profile while the lower portion was of conical section. The main cylindrical part of the bin consisted of thirteen rings of steel plate. Each ring was 5' deep and the thickness of successive rings decreased from 1/2" at the bottom to 3/16" at the top. The joints between rings were made by bolted lap joint. The width of the lap joint decreased from 5-1/4" to 4-1/2" from bottom to top. Each ring was comprised of eight annular segments.

The segments butted against each other with the joint made by bolted fillet plates. The fillet plates were placed both internally and externally and were of the same specification as the main plates in that segment. The bins were stiffened both at their tops and 15' below by an internal ring of channel steel. The bottom of the bins was fabricated of three rings of 1/2" plate. In the lowest section, twelve wedge-shaped plates were riveted together to form the conical section of the bin bottom. The upper two rings were composite profiled wedge-shaped plates riveted together to form the hemispherical section of the bin bottom. All bin bottom connections were made by riveted lap joints.

Eight central main bins were modified immediately after construction to provide for the storage of grain in smaller lots. The method of sub-division was designed according to one of Robinson and Toltz's patents. Each bin was sub-divided vertically into four compartments by hanging from the cylindrical bin walls three hemispherical assemblies analogous to the bin bottoms. Supply spouts fed each bin from the bin floor, while draw-off took place through a shared 30" centrally placed tube. The construction of the interspace bins, composed of thirteen rings with four plates each, was analogous to that of the main bins. The cylindrical section of each bin extended over 67', and the bin bottom was 9' deep. The bin bottom was almost entirely hemispherical in section and lacked the noticeable conical apex present in the main bins. The bin tops were covered by plates riveted to I-beams that rested on the upper stiffening ring. The plates extended across the entire structure to form a continuous bin floor.

Both main and interspace bins were supported on a network of basement columns. The columns were of box girder form built up from medium steel plate. They were designed to carry 700 tons, including portions of the load of the grain, the dead load of the

GREAT NORTHERN ELEVATOR
HAER No. NY-240
(Page 7)

bin steel work, and the dead, live and wind loads from the cupola. Each column was 25'-6" tall and eight such columns were placed below every main bin to directly support the annular steel ring girder within which the bins rested. Columns measuring 30" x 29" were located at the points where the bins were almost in tangential contact. Four such columns were located below any one main bin, and four columns measuring 18" x 22" were placed at intermediate points between the larger columns.

In addition to supporting a part of the main bin ring girder, the intermediate columns also supported the interspace bin ring girders. Four such columns, one from each of the four main bins that form the interspace, were used to support interspace ring girders. The ring girders bore directly on the tops of the columns and were located around the outside of the main bins at the point where the bin cross section changed from cylindrical to hemispherical. The cylindrical part of the bin rested within the girder, and the hemispherical bin bottom was hung from it. All connections between the various components were made by rivets.

The ring girders were designed to distribute the bin loading on the columns more evenly about the circumference of the bin, and could carry twenty tons per linear foot. The ring girders for the main bins were 6' deep, and those for the interspace bins were 3'-8" deep. The webs of these girders were stiffened by flanges of 5" x 5" angles at the points of support, and by 3-1/2" x 3-1/2" angles elsewhere. The shipping bins were supported on plates attached to the main bins and rail set within the brick curtain walling. They imposed the only external loading upon the brick curtain walling. The additional elliptical bins were set on beams attached to main and interspace bins.

The basement columns bore on foundation piers of Kettel River Sandstone. The base of each pier was 9' square, and was made up of four stepped courses capped by a single 5' square stone, upon which rested a cast iron base plate which located the base of the columns. The foundation piers in turn bore on groups of twenty to thirty, 12"- 14" diameter hemlock piles driven on 24" centers. These were arranged so that no pile carried more than twenty-five tons. The piles extended to rock at depths of between 45' and 50'. The pier masonry was laid on a grillage of 12" x 4" timber bolted to the top of the piles. The basement columns extended upward between the bins to support the structure of the cupola and the machinery within. The columns rested directly on the ring girder. They were of built up H-sections to the top of the bins, Z-bars to the scale floor, and H-sections again to the roof.

The cupola consisted of a structural steel trussed framework

GREAT NORTHERN ELEVATOR
HAER No. NY-240
(Page 8)

clad in corrugated iron and rising to a height of 184'. The entire weight of the structure was carried by the extensions of the basement columns. The first floor of the cupola extended across the full area of the building and contained the spouts and conveyors necessary to distribute the grain to any bin. All subsequent floors were contained within the narrow monitor. The second floor contained ten 1,200-bushel scale hoppers, and the third floor housed seventeen 900-bushel garners and ten 1,600-bushel garners. The upper floor contained the elevator heads. The brick curtain walling was of pier and panel form. The piers were 4' wide, and the panels 15'-7-1/2" wide. The first 12' of wall was 25-1/2" thick, the next 12' to 28' of wall was 21-1/2" thick, and above this point the wall was made up of 21" thick, 4' wide piers and 17" thick, 15'-7-1/2" wide panels.

As originally constructed, the elevator was equipped with three movable marine towers. These were of structural steel clad in corrugated iron and measured 30' x 20' and 125' tall. The sides of the towers were slightly tapered and featured hipped roofs. After the southern and middle towers blew over during a storm in 1922, they were replaced by two new 145' high towers built by Monarch Engineering. The replacement towers had straight sides and a flat roof. The remaining original tower appears to have been retained for some time, and this northerly tower was certainly in place in the late 1920s. While the towers were being replaced, the opportunity was taken to rebuild the dock in reinforced concrete.

BUSINESS HISTORY

The Great Northern Grain Elevator was the premier Eastern grain facility of railroad magnate James J. Hill's Great Northern Railroad. Built in 1897, the elevator was the third of its type to be designed by elevator architect Max Toltz. It was considered the most modern of his facilities for its capacity of three million bushels, its use of huge steel bins, and its fully electrically powered machinery.[2] The chief focus of the Buffalo construction project was to fireproof the building by using steel bins to reduce the chance of outside sparks from lanterns or other sources of flame. The Buffalo elevator was the first to adopt the new steel bins, but even these sometimes caused grain to "sweat," thereby producing gases that could spontaneously combust. Toltz's design offset that contingency by allowing workers to transfer grain from unaffected cylinders to dry, empty bins. Such protective measures reduced the Great Northern's fire insurance premium by $25,000 per year.[3]

More significant than the physical design of the building,

GREAT NORTHERN ELEVATOR
HAER No. NY-240
(Page 9)

however, were the forces that brought one of the most important
railroad lines in the western and Great Plains states to Buffalo.
The rail line itself did not extend eastward, but the growth of
the Great Northern as a corporation outstripped the physical
dimensions of the company's property. The expansion of the Great
Northern Railroad is a leading example of the diversification and
expansion of American capital during the 1890s. The railroad's
establishment of an important facility at the eastern end of the
Great Lakes was a typical action characteristic of the growth of
business empires in that era.

There is no question that Hill's primary interest lay in
expansion westward from the Mississippi River. A Canadian Scot
by birth, Hill migrated to Minnesota Territory in the early 1850s
when he was only eighteen. He began his spectacular career as an
industrial baron under very modest conditions, working as a
shipping agent for a new railroad branch based in St. Paul.
Through Hill's hands passed the golden bounty of grains, cereals,
and flour that emerged from the verdant soils of the northern
Great Plains. In the early days of Hill's career, only a few
railroads and a handful of hardy settlers produced the harvest
that trickled east to urban markets. But after the Civil War,
the flow of immigrants that followed the rail lines' expansion
became a stream, then a river, then a flood.

In 1873, however, one of the two chartered rail lines
established to open the western plains could not continue to
operate, despite the huge volume of crops demanding transport.
The St. Paul & Pacific (SP&P) collapsed, giving James J. Hill his
entree into the world of railroad ownership as well as shipping.
The rail line was particularly desirable since it had both a
state charter and a Homestead Act grant, the latter of which had
endowed the railroad with five million acres in Minnesota to
develop. The railroad's weaknesses stemmed from
overcapitalization; SP&P had $28 million outstanding in a variety
of bonds upon which it could no longer pay the interest. Company
expenses vastly outran profits, and no more financing was
available.

In 1874 the railroad was in receivership, its frantic
bondholders willing to settle the debt at almost any price just
to recoup what they could of their principal. Through a two-year
series of confidential arrangements, Hill quietly absorbed the
now-undesirable bonds at mere pennies on the dollar. He observed
the steady influx of new migrants whose farms would steadily
increase crop output and predicted the need for rail shipping to
market. Hill determined to be fully in control when the new
homesteads began to produce. To secure his dominance over the
rail line and eliminate competitors who might wish to cash in on
the improving fortunes of the company, Hill endeavored to

GREAT NORTHERN ELEVATOR
HAER No. NY-240
(Page 10)

suppress notice of the line's slowly improving earnings in 1877.

By 1878 the line was still in bankruptcy, with Hill as its effective, if highly unofficial, operating executive. In this capacity, he directed construction of a leg that tied the SP&P to the mammoth Canadian Pacific Railroad, thereby establishing a link from the grain lands of Manitoba to the Mississippi River. Finances for this venture came from sales of the St. Paul & Pacific's five million acres to new homesteaders at $2.50 to $5.00 per acre. As Hill expanded his control over the railroad, he established important alliances with other industrialists and financiers; his partner, Canadian George Stephens, was able to secure a much-needed capital infusion from the Bank of Montreal where Stephens was an agent.

Hill's gamble paid off in 1879, when company earnings tripled as the rail line became the beneficiary of an enormous crop yield of thirty-two million bushels of grain, all needing transport to urban markets. Hill and his partners renamed the line the St. Paul, Minneapolis & Manitoba (SPM&M) and were able to capitalize the burgeoning transportation giant at $31,486,000--$15 million in stock, the rest in bonds.[4]

Hill underscored this massive achievement by concentrating on key strategies to build his new business. He actively recruited immigrants from Europe, underwriting their passage to what he considered to be "his" fertile farming region. He expanded business through high volume and low rates and steadily improved shipping capacities by learning engineering principles that allowed him to work with his land surveyors to develop the simplest track lines at the cheapest costs. He developed a thorough knowledge of locomotive design and worked alongside engine builders to construct the largest and most powerful steam engines of the era. He worked cooperatively with new grain merchants, such as the Cargill family, to establish a complex system of country and terminal elevators lining the SPM&M tracks. Hill then combined that distribution system with a fleet of Great Lakes steamers to move the region's produce beyond St. Paul to the Great Lakes and from there overseas. By the early 1880s, just under a decade after he began, Hill had transformed his railroad into a major transportation empire.[5]

Between 1883 and 1885, a general recession caused the rail line's profits to decrease. The heavy flow of grain traffic from Manitoba and to the Canadian west had dropped off. To raise funds for new development, SPM&M decided to increase its stock offerings. In July, 1883, the shares had taken a precipitous plunge as rumors arose that senior partners were going to sell

GREAT NORTHERN ELEVATOR
HAER No. NY-240
(Page 11)

out to eastern interests organized by Cornelius Vanderbilt. That was untrue, especially given the concentration of control over the stock by Hill and his partners. To improve their control, in August, 1883, the stockholders approved plans for consolidating all of the affiliated lines owned by the St. Paul but operating as quasi-independent entities.[6]

Hill continued to expand the railroad empire. He pushed his rival Henry Villard, head of the Northern Pacific Railroad, to the brink of personal bankruptcy and assumed effective control over that line upon Villard's resignation. Hill then cast his eye eastward. The Chicago, Burlington & Quincy (the "Burlington") was his next choice to become the feeder line into his existing railway complex, although it was a cooperative agreement rather than a purchase. Hill established a virtual transportation monopoly very quickly. He no longer had to encourage new business by luring farmers to his rail line through cheap rates. As usual with monopolists, Hill could now set very high rates because farmers no longer had other options for shipping their goods. The man once revered for encouraging small farmers, quickly became as despised as the plagues of nature, particularly when it became obvious that his 1883 profits would be ten times those generated in the rail line's first year of operation.[7]

Despite such rapid success, the St. Paul, Minneapolis & Manitoba still had financial pressures. However, such strains did not stop Hill from developing new subsidiaries, one of which, the Island Railway Company, began in 1883. This tiny subsidiary appears to have been primarily a paper company established to acquire property. In Buffalo there were two property transactions along the Blackstone Canal in 1883, both of which involved the Island Railway. Pennsylvania Coal transferred two parcels to Island Railway (variably called Island Railroad), while a third parcel was sold to Island in 1890. Two years after the latter transaction, Union Dry Dock sold a fourth parcel to Island Railway in February, 1892. These four lots comprised a coherent tract of land--part of lots forty-six, forty-seven, and forty-eight of the Holland Land Survey.

The whole tract became the site for the Great Northern Elevator built in 1897. The tracts of land were never officially transferred to Great North Railroad even upon the construction of the elevator. However, in 1900, a lease from Great Northern back to Island Railroad confirmed the dominance of Great Northern as the primary owner. The 1900 lease was signed by W. C. Farrington on behalf of both companies. It is clear that as early as 1883 James J. Hill had aspirations to enter the eastern and western

GREAT NORTHERN ELEVATOR
HAER No. NY-240
(Page 12)

rail operations and that the Island Railway property was his toe-hold at the eastern end of the Great Lakes.

The first active presence of the Great Northern as an operating company in Buffalo did not occur until 1889, the year both the Island Railroad Company docks and the Northern Steamship line appear as Buffalo businesses. By 1897 the Island Railroad was gone and only the Great Northern Elevator existed along with the steamship line.[8]

The years after the recession were turbulent for the railroad company. Hill had diversified his board of directors, but its ties to large finance capital made loyalty to Hill suspect. To prevent the kind of corporate raiding on SPM&M that Hill himself had engaged in with respect to other rail lines, Hill worked once again to consolidate control over the company's stock and to assure his own voting control over matters of policy. Once again, Hill was forced to become more competitive, this time not only to increase traffic volume, but also to lower the stock's attractiveness by reducing its market value. To that end, he granted tariff relief to farmers and restricted new growth in the hope that both outside interests and his untrustworthy inside directors would look elsewhere for a takeover opportunity. As a by-product, Hill also hoped that volume would increase, but the latter goal was not realized. Rates were reduced 25 percent but traffic remained static.

The railroad reduced its quarterly dividend and established a reserve fund. In 1884 the board voted that all revenues over costs by 6 percent per year dividend would be placed in the fund. Consequently, in 1885 bonds sold in New York were languishing and new investors were scarce. Boston investors involved in the Burlington now wanted to consolidate their westward connection with the SPM&M to which Hill assented, since he remained in control. Simultaneously Hill decided to dissolve a more restrictive relationship with the Canadian Pacific of which he was a director but not a controlling owner. The two lines' agreement to cooperate yet compete freed Hill from having to underwrite the Canadian Pacific's operations. That dissolution further encouraged the Burlington's investors to underwrite Hill's enterprise, which could do business in a less encumbered atmosphere.[9]

Despite his sophisticated maneuvering with respect to railway coordination, the 1880s were a difficult time for Hill. Consent agreements with the other lines, capital formation with friendly banks, and reorganization were complex maneuvers. Bold in some operations, cautious in others, Hill and his board of directors had to determine which programs to undertake in an era

of sluggish recovery and uncertain politics. These structural limitations no doubt account for the time lag between the initial purchases of property in Buffalo and its actual development; other decisions had to be made and other steps had to intervene before this large western railroad could embark on eastward expansion.

The first critical link was strengthening grain handling and distribution systems. In 1886 SPM&M moved to the head of the Great Lakes in Superior, Wisconsin, where the company built a grain elevator that was leased to a new subsidiary, the Great Northern Elevator Company. Hill then sought an independent entry to Superior and nearby Duluth, Minnesota that would supplement the existing rail line. He announced, and the board supported, the development of a fleet of lake steamers that would ply the Great Lakes between Duluth and Buffalo.

The only bar to Hill's successful operation of a rail line competitive with the giant eastern and western railroads had been the rates of other lake vessels and the control Chicago-based and eastern rail lines had over rates outside his immediate jurisdiction. Hill had no choice but to enter lake commerce with his own fleet. Northern Steamship was formed in June, 1888, and by 1889 Hill's six steamers carried 42 percent of the flour going west from Duluth, while the railroad to Duluth remained a virtual monopoly. Hill had by-passed the trap of dependence upon other, unfriendly carriers to become a superpower in his own right.[10]

The greatest obstacle to Hill's expansion plans came not from competition with other lines and steamship companies, but from his own financial backers and the directors on his board. The latter were concerned about a potential general panic and about a shaky financial market already flooded with railroad bonds. Although too many rail companies were accused of "laying rails to carry bonds, not freight," the St. Paul, Minneapolis & Manitoba was not one of them. With his banks loathe to increase the company's indebtedness, the logical alternative was to issue another sale of stock. This Hill rejected; the more outstanding shares available for sale, the greater the risk of stock being purchased by enemies and competitors who would cost him control over the company.

By contemporary standards, the SPM&M shares were closely held; there were 150 owners in 1885 and still only 750 in 1889. But even this modest expansion was worrisome to Hill. His debate over whether to expand, and therefore how to finance the growth, was decided for him with the advent of yet another depression. Hill determined correctly that the downturn was likely to last at least five years, and plans for growth were shelved.[11]

These factors all contributed to Hill's decision to delay entry into eastern markets and even into open competition for a midwestern rail line. In 1893, however, a new ally joined forces with Hill and radically altered the western rail company's growth. In 1889 the company had changed its name, taking the title of the Superior, Wisconsin grain elevator as that of the entire system. The majestic "Great Northern" became the corporate appellation for the whole of Hill's operations. The name was apt since the Great Northern had eclipsed virtually every other western line save the Union Pacific. Despite depressions, intractable financiers, and a multitude of other problems facing his expansion plans, James J. Hill had become a formidable presence within American capitalism.

His chief opponent was New York financier J. Pierpont Morgan who directly and indirectly controlled 45-50 percent of the nation's railroad mileage through his control of bank loans to a myriad of transportation companies. Morgan had undertaken to refinance the chronically bankrupt Northern Pacific, which was managed but not controlled by Hill. By the 1890s, Hill was too powerful for Morgan to break and too competent for him to ignore. Soon the two men joined together to exercise unified control over the western lines.[12]

With Morgan's backing, Hill pursued several key projects that had been forsaken over the prior decade. Hill's push for eastern grain markets began with his steamship company but could not be fully realized until he had a terminal elevator at the eastern end of the Great Lakes. In 1897 the company once again hired architect Max Toltz, designer of the Superior, Wisconsin and Duluth, Minnesota elevators, to create the new grain storage facility for Buffalo due to be erected on the Island Railway property. The new structure was of novel design and more complicated to build than the earlier Toltz plans, but Hill raced to complete the construction before the end of the 1897 shipping season. Construction took only six months, start to finish, and the first cargo reached the elevator September 29, 1897, aboard Northern Steamship's SS North Star. The company had not bothered to incorporate in Buffalo until only six days before, a testament to Hill's disdain for legal formalities and belief in his own power.[13]

Hill's personal direction of both the design and construction standards is a well-propagated legend without any clear foundation. The literature of his day certainly asserted his central role, but the accuracy of the contentions cannot be proven. Regardless of whether or not Hill was the technological and engineering whiz he himself purported, his influence as head of the company is indisputable. There remains, embodied in the

GREAT NORTHERN ELEVATOR
HAER No. NY-240
(Page 15)

elevator itself, a possible tribute to his command; the visible ends of the elevator's tie rods, generally fashioned in round or star shapes, are instead crafted in the form of the letter "H."[14]

Although the Great Northern shut down soon after its gala opening for the traditional winter season, it reopened the following spring with the kind of flair expected of a J. J. Hill enterprise. In early May of 1898, the elevator received the most valuable grain cargo ever brought to Buffalo. The Great Northern took in a single shipment of 210,539 bushels of wheat assessed at $1.30 per bushel.

The Great Northern Elevator turned out to be a mixed blessing for Hill and his railroad. He had embarked on the Buffalo venture as a way of reducing elevator charges on his grain shipments paid to other elevator owners. The Great Northern Elevator did reduce Hill's costs for scooping and storage, but his satisfaction did not last. One obstacle was the crowded condition along the riverfront restricting railroad car movement and impeding the progress of stored grain to New York City. He later calculated that the overall costs of land and construction were far too high for the per-bushel price at Buffalo to be competitive, especially when transportation costs were added.[15]

Simultaneously Hill was once again engaged in a titanic struggle for railroad dominance. In May, 1901, Hill became locked in battle with the country's other great railroad magnate, E. H. Harriman, owner of the Union Pacific and the Southern Pacific lines. Longtime rivals, the two men were in a formidable race for dominance over the Northern Pacific Railroad. Hill's and Harriman's "seconds" in the duel were the financial houses of, respectively, J. P. Morgan and Kuhn, Loeb & Company. Hill raced to New York City on May 3, only to discover that Harriman already had controlling interest over the Northern Pacific preferred stock.

Through J. P. Morgan, however, Hill set out to gain the majority of the more critical common stock which still could give him dominance over the operation of the rail line. Harriman caught wind of Hill's interest, and the two battled for days to corner the stock and gain the upper hand. The stock value soared from $140 to over $1,000 per share in a frenzied bidding war. The price floor under other stocks collapsed, ultimately bringing the Northern Pacific stock back down as well but undermining those who had bought large quantities at high prices. Harriman finally won out, forcing Hill and his backer, J. P. Morgan, into a compromise giving Harriman representation on both the Northern Pacific board of directors and on Hill's Burlington line. The

GREAT NORTHERN ELEVATOR
HAER No. NY-240
(Page 16)

bidding war had hurt Hill financially with far less return.[16]

While J. J. Hill was far from destitute, the Northern Pacific fiasco undoubtedly made him considerably more fiscally cautious. His impatience with Buffalo as a grain transfer and storage site was increasing. In 1903 he was made an offer he could not ignore: a combination of several eastern rail lines proffered an impressive profit for the property and later the stock of both the Great Northern Elevator and the steamship line for which it was named. Island Railroad, the Great Northern subsidiary that bought the lots upon which the elevator was built, was exempt from the initial sale made March 4, 1903. By September, however, the same syndicate that bought the elevator had acquired the rail spur line company as well.

The Mutual Elevator Company which bought the Great Northern included Wall Street financiers William Anderson, Origen Seymour, Theophilus Parsons, and Philip Huetwohl, as well as Buffalo attorney Henry Sprague. The Island Railroad Company was incorporated by James Stevenson, John Middleton, Charles Goldsborough, and Frank H. Silvernail among others. All of these men were directly employed by or interlocked with major eastern railroads, primarily the New York Central, the Lake Shore & Michigan Southern, the Erie, the Delaware, Lackawanna & Western, the Lehigh Valley, the Atlantic & Great Western (later the New York, Pennsylvania & Ohio), and even the Missouri Pacific. The Pennsylvania Railroad was a more "silent" partner. All of the rail lines represented in the Mutual Elevator, the steamships, and the railroad spur, stood to benefit enormously from the captive grain traffic the elevator would provide on the haulage to Buffalo and then to eastern port cities. The takeover was a major coup for those railroad interests.[17]

The presence of the railroad consortium was an extension of a long-time battle between local grain traders and the railroads that owned or otherwise controlled much of the land around Buffalo's waterfront. The very railroads that had too often gouged grain traders without transportation affiliates now possessed one of the city's paramount elevators. They clearly had a significant advantage over small grain elevators, gleaning preferential storage as well as haulage rates. It was in this period that a good number of Buffalo's smaller elevators went out of business, although very little documentation exists to indict unfair practices as the sole cause. Nevertheless, the Mutual flourished for eighteen years, even as the landscape of Buffalo's riverfront saw the decline of small, once-flourishing elevators and the elimination of many prominent local names from the competition.[18]

GREAT NORTHERN ELEVATOR
HAER No. NY-240
(Page 17)

Throughout the years that Mutual Elevator (later Mutual Terminal Corporation) owned the Great Northern, the company put very little into the elevator in the way of expansion or improvements. Despite the lack of capital infusion, the railroad consortium certainly used the elevator as a source of non-productive revenue. One month after acquiring the elevator, Mutual stockholders authorized a $5 million, fifteen-year 4 percent mortgage on the property drawn on J. P. Morgan's Guaranty Trust in New York City. Guaranty Trust issued the loan in variable amounts over the next twelve years with the sums declining as time went on. At no point do records indicate that Mutual satisfactorily repaid the loan, backed by bonds, and that use of the elevator as a "cash cow" may have led to the sale of the property and the ultimate dissolution of the company in 1921 and 1923 respectively.[19]

In 1921 Mutual sold the elevator and its property, including the Island Railroad rights-of-way, to a local Buffalo group named the Island Warehouse Corporation. This organization, formally chartered June 7, 1921, entered into the sale agreement on the property twenty-two days later. Island Warehouse was comprised of the three men who had already made their mark on Buffalo's grain business through the establishment of several very important elevators including Concrete-Central--Nisbet Grammer, John T. Rammacher, and Edwin T. Douglass. Although the purchase price from Island to Mutual was not disclosed, Mutual must have been seriously damaged in the transaction since Island Warehouse required only a $600,000 mortgage to cover the transaction, a far cry from Mutual's $5 million debt. Clearly, the mere fact of size and advantage did not necessarily make the railroad consortium good grain traders and handlers.[20]

Despite the owners' extensive experience in operating grain elevators, Island Warehouse spent little time developing its own line of business for the Great Northern. Instead, the Buffalo company established a complex relationship with one of the nation's true grain trading and milling giants, Pillsbury Flour Mills Company. Island sold 100 percent of its stock to Pillsbury, all the while retaining control of the elevator, the flour mill, and the property. These, in turn, were leased to Pillsbury on a twenty-five year agreement that began May 1, 1923. Island had taken a much larger, $5 million mortgage just a little less than two months before the lease agreement was signed and clearly retained the legal obligation to make payments on the mortgage on behalf of Pillsbury's continued smooth operations at the site. In return Pillsbury paid Island $237,780 per year. Apparently the financial burden upon Island was greater than the remuneration. In 1935 Island sold the property outright to Pillsbury, before filing for dissolution six months later as the

GREAT NORTHERN ELEVATOR
HAER No. NY-240
(Page 18)

result of legal actions ordering payment schedules the company had difficulty meeting.[21]

Pillsbury's history is one of convoluted ownership patterns coupled with a clear, linear progression in business operations. The company was founded in 1869 in Minneapolis by Charles A. Pillsbury who began his business by leasing a small, 400-cwt mill. Charles was supported in his business by his uncle, a hardware merchant and later a three-term governor of Minnesota and a founder of the state's university. Charles Pillsbury's father was a trolley operator. The elder Pillsburys were owners but did not involve themselves in the mill's operations. By 1878 the younger Pillsbury had substantially enlarged the mill and had built the Pillsbury "A" mill, then the largest in the world. His success was due, in part, to his interest in technological innovation and adaptation. The Pillsbury Mill was among the first with the capacity to grind hard northwestern wheat into the soft, white flour desired for its finer texture in fancy baked goods. By 1886 Pillsbury was doing $15 million in business annually and was probably the largest milling company in the world.

Three years later, the Pillsbury Company was acquired by a British financial syndicate. Pillsbury was merged with other American milling firms owned by Senator William D. Washburn to become the Pillsbury-Washburn Flour Mills Ltd. There was no relationship between the senator and the Washburn family in the early formation of General Mills, but both sets of Washburns established large and powerful milling combines in the state of Minnesota.

After the death of C. A. Pillsbury, head of the company from 1889 to 1899, Pillsbury-Washburn was beset with financial problems. It was dangerously overcapitalized, which meant increasingly large proportions of income had to be directed toward shareholder dividends. Then, in 1907, the company faced a damaging crop shortage that eradicated much of its flour production. Seriously short of cash, in 1908 the company went into receivership. On June 23 of that year it was reincorporated as Pillsbury Flour Mills Company to absorb the liquid assets of Pillsbury-Washburn and to run the mills under a lease agreement with the British company. The arrangement lasted until 1923, when Pillsbury formally acquired title to the real estate and other tangible and intangible assets of Pillsbury-Washburn. The next year Pillsbury became a publicly-traded company with somewhat greater public accountability, and its improved financial picture allowed Pillsbury to begin expansion programs again. Part of that effort included establishing milling operations in Buffalo.

In 1928 Pillsbury dissolved its New York charter to reorganize with a Delaware incorporation seven years later as Pillsbury Flour Mills Company. At that time it acquired the assets of Pillsbury Flour Mills, Inc. and all of its subsidiaries, including Island Warehouse, which was dissolved under difficulty the following year. Despite the Depression and general agricultural slowdown, Pillsbury fared well during the 1930s and entered the war years with a strong market and financial position. In 1944, after a series of acquisitions, the company was again called Pillsbury Mills, a name lasting until 1958 when it became Pillsbury Company. In addition to flour milling, the company's only operation in Buffalo, Pillsbury added the production of baking mixes, refrigerator dough products, snacks, and other consumer food lines. By the 1960s, the company owned restaurants and extended its line of merchant goods designated for bakeries, restaurants, and institutional food preparers. The company also extended its holdings overseas in South America and in Europe.[22]

On January 3, 1989, Pillsbury was once again acquired by a British financial conglomerate, Grand Metropolitan. Grand Met, as it is familiarly called, has no particular business focus outside of acquisitions, but its line of businesses tends toward operating licensed premises such as inns, hotels, and restaurants and buying companies that provide food, drink, and luxury items for consumers. Grand Met remains Pillsbury's owner to date.[23]

Pillsbury's tenure in Buffalo continues to the present time, although the Great Northern Elevator is idle. Upon its own internal assessment, the company decided that the original brick structure was unsound and abandoned the facility in 1981, when it replaced the Great Northern's functions with the nearby Standard Elevator. The Great Northern has not been used for grain storage since that time. In recent years the elevator has become a focus for historic preservationists, but to date no significant suggestions for adaptive reuse or rehabilitation have been made. The structure's demolition would be a great loss of a unique and historically significant landmark.

MATERIALS HANDLING: HISTORY AND DESCRIPTION

Receiving by Water

Original equipment for unloading grain from vessels moored in the Blackwell (City) Ship Canal consisted of three marine towers, each containing a leg capable of elevating 20,000 bu./hr. Rolling on sixteen pairs of truck-mounted wheels, the towers traversed a masonry dock, 24' in width, along a pair of 94-lb. T-

GREAT NORTHERN ELEVATOR
HAER No. NY-240
(Page 20)

rails; these standard gauge tracks were supported by I-beams resting on subterranean stone rib arches. Each tower could shift its position along the dock at a rate of 15' per minute. through a cable haulage arrangement. Power was supplied by a 50 hp motor with worm gear reduction drive located on the ground floor of the elevator. Since the towers could be maneuvered independently, they could be aligned to unload from three hatches simultaneously, giving a nominal overall transfer capacity of 60,000 bu./hr. from ship to elevator.

The dimensions of each tower measured 20' x 30' at the base, 20' square at the top and 125' up to the apex of the hip roof. The structural framework consisted of upright channel columns with diagonal bracing and a sheathing of corrugated iron. Despite weighing in excess of 150 tons, the towers demonstrated considerable instability in high winds and were attached to a track in the elevator wall, located about 100' above the dock. Each marine leg, housed within its respective tower, consisted of a double box girder with diagonal bracing. The head pulley, 72" in diameter, and the 18" boot pulley were spaced 86' apart. Running around the pulleys and through the box girder framing, a 19" seven-ply belt with 30" x 8", 9" deep galvanized steel buckets carried grain from a vessel's hold up into the tower for weighing.

In operation, a 100 hp motor located on the first floor of each tower powered the marine leg through a rope drive to the distant head pulley. This motor also powered the hoist that lifted the counterweighted leg out of the hold when required, as well as driving the power shovels used for moving grain to the boot pulley. A screw-drive pusher on the second floor controlled the lateral travel of the leg as it moved out from the tower and over the ship. Grain raised by the marine leg discharged into a 300 bushel garner and was then weighed in a 250 bushel scale below. Weighing was carried on in 200 bushel lots.

Since the original marine towers did not feature internal lofter legs, instore grain was discharged at a relatively low level rather than at the top of the storage tanks. From the second floor of the marine towers, the contents of the scale hoppers flowed by gravity into a trough or series of receivers situated along the west brick curtain wall of the elevator. From these points grain was spouted down into the boot tanks of the multiple house lofter legs for the trip up to the cupola.

At least three of the Great Northern's original marine towers were replaced during the mid-1920s by upgraded units, two of which remain in place on the rebuilt dock. Visual evidence suggests that the newer towers coexisted, with one surviving 1897 model. Monarch Engineering Co. of Buffalo designed and

GREAT NORTHERN ELEVATOR
HAER No. NY-240
(Page 21)

constructed the replacement towers to incorporate incremental improvements in power transmission. However, constraints posed by the elevator's structural and functional characteristics dictated some deviations from the standard practice represented by other marine towers surviving from the 1920s. The Monarch towers stand 144'-7" high and measure 30' x 19' in plan. By the late 1930s, nominal marine receiving capacity through the upgraded towers was rated at 45,000 bu./hr. Shortly thereafter, the increasing dimensions of lake vessels generally precluded simultaneous unloading by more than two towers; the elevator's maximum marine receiving capacity declined further to 25,000 bu./hr. During the last years of operation, nominal marine unloading rates sank to 10,000 bu./hr. per leg or 20,000 bu./hr. overall.

Receiving by Rail

In contrast with the relatively prodigious handling rates of its marine towers, the Great Northern's original capability for unloading grain from rail cars was decidedly modest; the Hill interests presumably contemplated receiving the vast preponderance of shipments to the new terminal via laker. To facilitate the spotting of rail cars, the elevator was equipped with a 50 hp motor, located on the ground floor, which also performed double duty for the cable haulage system that moved the marine towers.

Car switching was accomplished through an underground cable to nearby rail yards; the maximum rate of car movement was 90' per minute. A single track entered the elevator from the north and ran along the east wall in a slight depression. A portable power shovel operated by a 10 hp motor was used in unloading the cars. Whether grain could be transferred directly from the cars to the elevator boots remains undetermined but appears unlikely. It was anticipated that the portable shovel would also be capable of clearing excess grain accumulated on the ground floor at the close of the navigation season. Rail receiving may therefore have involved a two-step process--from car to floor and from floor to lofter leg boots.

By the mid-1920s the practice of unloading cars inside the house appears to have been discontinued. Great Northern's rail receiving equipment at that point consisted of a single car pit, presumably including a set of conventional power shovels and, perhaps, a belt conveyor to at least one of the house lofters. This arrangement would have dedicated a house leg to specialized receiving, as distinguished from the dual shipping-receiving functions inherent in the original D. A. Robinson design. Nominal rail unloading capacity during this period was rated at only two cars per hr. At the close of the elevator's active life,

the comparable receiving rate had risen to eight cars per hr., possibly indicating further improvements of an undetermined nature.

Receiving by Vehicle

As of 1897, the Great Northern featured no capacity for handling grain arriving by wagon. However, during the course of subsequent modifications, provision was made for receiving 4,500 bu./hr. by truck. These undetermined arrangements may have involved use of the car pit.

Instore Distribution: Horizontal Transfers and Vertical Handling

Grain received via either lake or rail was lifted to the cupola atop the storage bins by a set of ten internal lofter legs. Nine of the legs passed upward through the interstices between the west row of intermediate (15'-6" diameter) storage tanks and the center row of large (38' diameter) tanks. The remaining lofter was situated at the north end of the building between the central tanks and the east row of intermediate tanks. The double lofter arrangement at the north end may have been designed to facilitate shipments out via the canal slip or, perhaps, rail receipts. Each lofter originally stood 168' high. The house legs carried a double row of 640 30" x 8", 9" deep buckets attached to a 32" six-ply rubber belt. Each bucket could hold about eighteen lbs. of wheat. The legs were capable of raising 20,000 bu./hr., each at a belt speed of 636'/min.

Power transmission to the lofters was one of the distinguishing characteristics of Great Northern's original equipment. Each leg was driven by an independent 50 hp motor through a variant of the single-leg rope drive system first patented by Robinson and John Simpson in 1891.[24] Nine of these motors were aligned along the west wall of the scale floor in the cupola; the tenth motor was located opposite the northernmost leg. The driving ropes ran in grooved sheaves. Speed reduction was accomplished through pinion gears located on each sheave and the corresponding leg countershaft at the head pulley of the individual lofters.

Grain elevated for weighing and distribution to storage or shipment without cleaning discharged through turnhead spouts at the head floor of the cupola and dropped into one of ten garner-scale sets. All these weighing units were situated in a continuous row and each corresponded to a particular lofter. The capacity of the garners was about 1,600 bushels and that of the Fairbanks scales approximately 1,200-1,400 bushels. After weighing, the scale was emptied by opening a lever-operated slide valve mounted upon rollers.

GREAT NORTHERN ELEVATOR
HAER No. NY-240
(Page 23)

The contents of each scale discharged into one of ten universal distributing spouts. By the time of the Great Northern's construction, double-jointed swiveling spouts had commenced to supersede the multitude of fixed spouts which had previously given elevator distribution floors the visual appearance of a dense forest. Edward D. Mayo had patented perhaps the most common version of the universal spout in 1891.[25] In devising a patented spout for installation in the Great Northern, Robinson employed a trussed center pole with braces to support the various sections as distinguished from the circular track used by Mayo.[26] An operator could swing the extended spout to reach any bin within a 37' radius.

A pair of belts running longitudinally over the distribution floor provided a means of access to bins lying beyond the reach of a given universal spout. A reversible 20 hp at 750 rpm motor at the north end of the floor drove each conveyor which consisted of a 60" five-ply rubber belt approximately 740'-800' in length, running over terminal pulleys and supported at intervals by idlers. Each conveyor was equipped with concentrators to minimize spillage at discharge points from the spouting system. Two mobile four-pulley trippers transferred grain into the desired tank. At a speed of 1,000' per minute each conveyor had a rated capacity of 40,000 bu./hr., the most rapid mechanical handling capability of any elevator in the world in 1897.

There have been some modifications to the original equipment used in the instore distribution sequence. Perhaps the most noticeable change involves the elimination of the Robinson patent rope drive on the lofter legs. The motors, including several of the original units, are now located on the attic floor of the cupola and drive the lofters at the head pulley through reduction gearing. However, the scales and patented distribution spouts remain essentially intact.

Grain Conditioning

As of 1897 grain received by water or rail that required cleaning was lifted to the cupola via one of the ten lofting legs inside Great Northern. However, instead of discharging into one of 1,600 bushel garners described previously, the flow was diverted into 900 bushel garners supplying the cleaning machinery; a total of seventeen such garners occupied space in the cupola. Original cleaning equipment consisted of four No. 9 Monitor Separators furnished by the Huntley Manufacturing Co., then located in Silver Creek, New York. These machines were installed on the scale floor of the cupola. A motor rated at 100 hp at 500 rpm, located on the same floor, drove the cleaners through a countershaft with belts to individual units. From the

GREAT NORTHERN ELEVATOR
HAER No. NY-240
(Page 24)

cleaners, two Robinson universal spouts distributed grain to storage routes or shipping bins. Subsequent additions to or replacements for the original cleaners remain undetermined.

Dust Control

Another pathbreaking feature of the Great Northern was the extensive provision for collecting and disposing of particulate matter arising from the course of normal operations. The unprecedented arrangements consisted of pneumatic dust collectors and sweepers with independent systems located upstairs in the cupola and downstairs on the ground floor. The dust collecting apparatus relied on low-speed fans to remove finer particles at the principal points of discharge; the sweeper system used high-speed, 3,000 rpm fans for handling larger pieces of foreign matter. Upstairs equipment included a double 60" fan, located on the top floor of the cupola, to clear dust from the lofter heads and garners as well as a double 50" fan on the bin floor to operate the upper sweeper system. Downstairs equipment included a single 70" fan connected to the lofter leg boot tanks and a double 45" fan for the lower sweeper system. The upstairs fans were driven by the same 100 hp motor that operated the cleaners. The 50 hp marine tower/car haul motor drove the downstairs fans. Each marine towers was equipped with comparable fans for dust removal. Sweepings were discharged into the adjacent waterways. Replacements for original equipment remain undetermined.

Shipping Out by Rail, Water and Vehicle

As a terminal house designed for rapid intermodal transfers among water, rail and land transportation systems, balanced receiving and shipping capacity was a primary consideration in the design of Great Northern. As noted above, the maximum unloading rate through the marine towers was 60,000 bu./hr. or 600,000 bushels over a normal working day of ten hours. Loading rates out were projected--perhaps optimistically--at 400 cars per day via rail, 100,000 bushels per day to canal boats, and 200,000 bushels per day to Welland Canal vessels; wagons hauling grain for local delivery could also be accommodated.

All four sides of the elevator were used in the original scheme for outstore loading. Grain was drawn from storage through hoppers in the bottoms of the main and intermediate tanks and conducted to the house lofter boots through portable spouts. Following elevation to the cupola and discharge into a garner, the shipment was weighed in drafts proportioned to the size of the car or vessel being loaded. The ten outstore scales could weigh up to 78,000 lbs. in a single draft.

GREAT NORTHERN ELEVATOR
HAER No. NY-240
(Page 25)

Distribution to the appropriate shipping bins, situated between the walls and main tanks, was accomplished through the spouting system or via the bin floor conveyors to more distant points. Rail cars were loaded on a double track under a steel canopy along the east side of the elevator. Nine 1,400-1,500 bushel shipping tanks situated 60' above ground level delivered to cars spotted below through long bifurcated spouts. As of 1915, the record for loading cars stood at 120 over a five hour period. Through a similar sequence, grain could also be distributed to nine 3,200-bushel shipping tanks of identical diameter on the west wall for loading boats sized to fit the locks on the Welland and St. Lawrence canals. Four 6' in diameter, 1,000-1,100 bushel tanks on the south wall were reserved for wagon shipments.

Facilities for delivery to Erie Canal barges moored in the north slip were more extensive. Four sets of garners and 160 bushel outstore scales were arranged to operate in conjunction with the paired lofter legs previously described. The four canal shipping tanks, each 8' in diameter, held 450 bushels. Contemporary opinion maintained that large-capacity shipping tanks facilitated efficient transfer operations by permitting uninterrupted weighing even as cars or vessels were being shifted. Besides drawing grain from storage, direct transfer from lake vessel to car or barge was also possible via the sequences which have been described.

Alterations to original shipping arrangements include elimination of the north end garners, scales and shipping tanks. Two of the wagon shipping tanks apparently remain extant, as do the rail and dock shipping tanks. Following the elevator's conversion from a transfer house to storage for Pillsbury's adjacent flour mill in the mid-1920s, nominal marine loading rates were listed as 15,000 bu./hr. using a single spout; rail loading could be carried on at the same rate using eight spouts to four tracks. At the close of active operations, marine loading rates had fallen to 11,000 bu./hr. Rail shipments had declined from 150 cars every ten hours to fifty cars around 1940 and thirty-two cars every eight hours by 1961. Truck loading capacity during the 1970s was 4,500 bushels per day.

GREAT NORTHERN ELEVATOR
HAER No. NY-240
(Page 26)

ENDNOTES

1. The following paragraphs are based on several sources including plans and building permits housed in Buffalo City Hall and plans drawn by D. A. Robinson and Max Toltz now in the possession of the Pillsbury Company. Additional information can be found in the following contemporary journals: American Elevator & Grain Trade 16 (15 December 1897): 205; Northwestern Miller 45 (4 February 1898): 174; Scientific American LXXVII (25 December 1897): 406; Engineering News XXXIX (7 April 1898): 218; Electrical Engineer XXV (27 January 1898): 100; and Electrical World 31 (12 February 1898): 211-215.

2. Iron Age 60 (19 August 1897): 4.

3. Buffalo Express, 10 May 1897, p. 9.

4. Matthew Josephson, The Robber Barons (New York: Harvest Books, Harcourt, Brace & World, Inc., 1962), 231-39; Ralph W. Hidy, et al., The Great Northern Railway: A History (Boston: Harvard Business School Press, 1988), 2, 30-34.

5. Josephson, The Robber Barons, 236-37.

6. Hidy, et al., The Great Northern Railway, 48-51.

7. Josephson, The Robber Barons, 248-49.

8. Erie County Clerk (ECC), Deeds, Liber 448, October 3, 1883, 276; Liber 457, December 18, 1883, 43; Liber 557, March 14, 1890, 312; Liber 597, February 17, 1892, 182; Buffalo City Directory, 1889, 1897. I am indebted to Robert Frame and John Wickere for unearthing information concerning the Island Railway as a St. Paul, Minneapolis & Manitoba subsidiary and determining its date of incorporation as 1883. These papers are otherwise hidden in the James J. Hill papers in St. Paul, Minnesota. All Erie County Clerk documents are listed by date of document origin, not by date of filing, unless otherwise noted.

9. Hidy et al., The Great Northern Railway, 50-54.

10. Hidy et al., The Great Northern Railway, 63-67.

11. Hidy et al., The Great Northern Railway, 68, 70.

12. Hidy et al., The Great Northern Railway, 72-73; Josephson, The Robber Barons, 416-17.

GREAT NORTHERN ELEVATOR
HAER No. NY-240
(Page 27)

13. ECC, Corporations, Great Northern Elevator Co., Certificate of Incorporation, September 23, 1897, Box 7142; *Iron Age*, 60 (19 August 1897): 4; *Buffalo Express*, 10 May 1897, 9 and 28 September 1897, p. 9; *Engineering Record*, 27 November 1897; *Scientific American*, lxxvii (25 December 1897): 406-7; *Northwestern Miller*, 45 (4 February 1898): 177-8. The rapid construction was not without its human costs. As the September 28, 1897, *Express* story shows, three men were killed in four days in falls from the top of the elevator during the haste of construction.

14. See for example *The Electrical Engineer*, 25 (27 January 1898): 99-100 and *Northwestern Miller* 45 (4 February 1898): 175.

15. Buffalo and Erie County Public Library (BECPL), Scrapbooks, "Buffalo Harbor," v. 2, 42-44.

16. Bernard Baruch, *Baruch: My Own Story* (New York: Henry Holt and Company, 1957), 133-49.

17. ECC, Corporations, Mutual Elevator Company, Certificate of Incorporations, February 28, 1903, Box 12,232; Island Railroad Company, Certificate of Election of Directors, September 8, 1903, Box 7635; Deeds, Liber 987, March 4, 1903, 202; BECPL, Scrapbooks, "Buffalo Harbor," Vol. 1, 324-25.

18. BECPL, Scrapbook, "Buffalo Harbor," Vol. 8, 63.

19. ECC, Corporations, Mutual Elevator Corporation, Consent to Mortgage, April 30, 1903; Annual Statement: Mortgage, July 31, 1915; Certificate of Dissolution, December 11, 1923, Box 12, 232.

20. ECC, Corporations, Island Warehouse Corporation, Certificate of Incorporation, June 7, 1921; Consent to Mortgage, June 30, 1921, Box 7813; Deeds, Liber 1544, June 29, 1921, 428.

21. Moody's *Industrials*, 1931; ECC, Deeds, Liber 2476, October 29, 1935, 169; Actions & Proceedings, Notice, Petition for Schedule, Dissolution, 85-588, May 6, 7, 1936.

22. ECC, Corporations, Pillsbury-Washburn Flour Mills Company, Articles of Incorporation, February 25, 1908, Box 11091; Statement, Annex to Charter, September 25, 1935, Box 6484; Moody's *Industrials*, 1931, 1964, 1974; Herman Steen, *Flour Milling in America* (Minneapolis: T. S. Denison & Company, Inc., 1963), 284-87; Milton Moskowitz et al., eds., *Everybody's Business* (New York: Harper & Row, Publishers, 1980), 68-69.

23. Moody's *International*, 1990.

GREAT NORTHERN ELEVATOR
HAER No. NY-240
(Page 28)

24. U.S. Patent #460,661, <u>Specifications of Patents</u> (6 October 1891), 201-04.

25. U.S. Patent #464,101, <u>Specifications of Patents</u> (1 December 1891), 142-43.

26. U.S. Patent #622,019, <u>Specifications of Patents</u> (28 March 1899), 2760-2763

GREAT NORTHERN ELEVATOR
HAER No. NY-240
(Page 29)

SOURCES

Unless indicated otherwise by footnotes, descriptions of machinery and process flows have been derived from the following sources.

Baruch, Bernard. Baruch: My Own Story. New York: Henry Holt and Company, 1957.

Buffalo City Directories, 1889, 1897.

Buffalo & Erie County Public Library, scrapbooks, "Buffalo Harbor," Vol. 1, pp. 324-5; Vol. 2, pp. 42-44, Vol. 8, p. 63.

Buffalo Express, 10 May 1897, p. 9; 28 September 1897, p. 9.

Building Permits & Plans, 301 City Hall
#8310 (31 March 1897)

Dunlap, O. E. "The Great Northern Electric Grain Elevator at Buffalo, N.Y.," Electrical Engineer, 25 (27 January 1898):99-101.

Engineering Files, Pillsbury Co., 250 Ganson St, Buffalo, NY

Engineering News, 39 (7 April 1898): 218.

Erie County Clerk, Records, Erie County, NY.

Everybody's Business. New York: Harper & Row, Publishers, 1980.

"A Fireproof Grain Elevator," Engineering Record, 36 (27 November 1897):563-564.

"Fireproof Steel and Brick Grain Elevator," Scientific American, 77 (25 December 1897):406-407.

Folwell, R. H. "A Steel Structure," Northwestern Miller, 45 (4 February 1898):175-179.

"The Great Northern Elevator at Buffalo, N.Y.," American Elevator and Grain Trade, 16 (15 December 1897):206-207.

Green's Marine Directory of the Great Lakes [title and publication data vary]
30th ed. (1938), 326.
32nd ed. (1940), 302.
34th ed. (1942), 344.
40th ed. (1948), 340.

GREAT NORTHERN ELEVATOR
HAER No. NY-240
(Page 30)

 44th ed. (1952), 340.
 48th ed. (1956), 349.
 53rd ed. (1961), 327.

Hidy, Ralph, et al. The Great Northern Railway: A History. Boston: Harvard Business School Press, 1988.

Iron Age, 60 (19 August 1897): 4.

Josephson, Matthew. The Robber Barons. New York: Harvest Books, Harcourt, Brace & World, Inc., 1962.

Moody's Industrials, 1931, 1964, 1974.

Moskowitz, Milton, et al., eds. Everybody's Business. New York: Harper & Row, Publishers, 1980.

"The Steel Tank Elevator 'Great Northern' at Buffalo, N.Y.," Engineering News, 39 (7 April 1898):218-220.

Steen, Herman. Flour Milling in America. Minneapolis: T. S. Denison & Company, Inc., 1963.

Vickers, Albert. "The Great Northern Elevator," Electrical World, 31 (12 February 1898):211-215.

War Department Corps of Engineers, U.S. Army and United States Shipping Board, Transportation on the Great Lakes (Washington: Government Printing Office, 1926), 231-232.

War Department Corps of Engineers, U.S. Army and United States Shipping Board, Transportation Series #1, Transportation on the Great Lakes (Washington: Government Printing Office, 1930), 229.

War Department, Corps of Engineers, United States Army, Transportation Series #1, Transportation on the Great Lakes (Washington: Government Printing Office, 1937), 247.

GREAT NORTHERN ELEVATOR
HAER No. NY-240
(Page 31)

APPENDIX

Cost: $400,000

Foundation: 6000 wooden piles, capped by grillage on which rest 198 tiered stone footings that provide the base for the structural pillars

Basement: Full height, bins lifted on 28' structural steel columns

Hoppers: Hemispherical plate steel bottoms riveted together and fastened to the ring girder

Bins: Steel
Capacity 2,500,000 bushels
Main bins: 38' in diameter cylinders 70' high, 80,000 bu. in 3 non-interlocking rows of 10
Interspace bins: self-contained cylinders, 18' in diameter, 70'-6" high, 15,000 bu. arranged in 2 rows of 9
Outerspace bins: self-contained cylinders, between outer main bins and brick curtain walling. The west side has 9, 9'-9" diameter, boat shipping bins, of 3,000 bu. capacity; The east side has 18, 9'-9" diameter railroad shipping bins, of 1,500 bu. capacity; the north side has 8, 8' diameter barge shipping bins of 450 bu. each, & the south side has 4, 6' diameter wagon shipping bins of 1,100 bu. capacity; the shipping bins are from 22'-53' high
Interspace bins added on or after 1922, 60 elliptical steel bins between the interspace and main bins, 4 placed in the interspace between 4 adjoining main bins
Main bins raised on a circular ring girder supported by 8 steel columns; the bins are riveted to the annular girder
The main and interspace bins are made up of steel plates bolted together; all components pre-fabricated to be assembled on-site; plates graded in the main bins from 1/2" at the base to 3/16" at the top; interspace bins 5/16" at the base decreasing to 3/16" at the top; bins designed to withstand full hydraulic, rather than grain pressures
Bins enclosed within a non-structural brick wall

GREAT NORTHERN ELEVATOR
HAER No. NY-240
(Page 32)

Cupola: Full cupola, 4 stories high, to a total height of 181'; extends length of building; supported by extensions to the basement columns which pass between the bins; structural steel clad in corrugated iron

Marine Towers: Originally three movable towers 125' high; 2 blown down in 1922 and replaced by two 145' towers; remaining original tower retained but demolished sometime after 1929

REFERENCES: The City Plans Book for 1897 gives the estimated cost of construction, and city building permits provide the dates. Reviews of the building occur in the following periodicals: American Elevator & Grain Trade, 16 (15 December 1897): 205; Northwestern Miller, 45 (4 February 1898): 174; Scientific American, LXXVII (25 December 1897): 406; Engineering News, XXXIX (7 April 1898): 218; The Electrical Engineer, XXV (27 January 1898): 100; The Electrical World (12 February 1898): 211. Original plans by Toltz and Robinson are held by the Pillsbury Company.

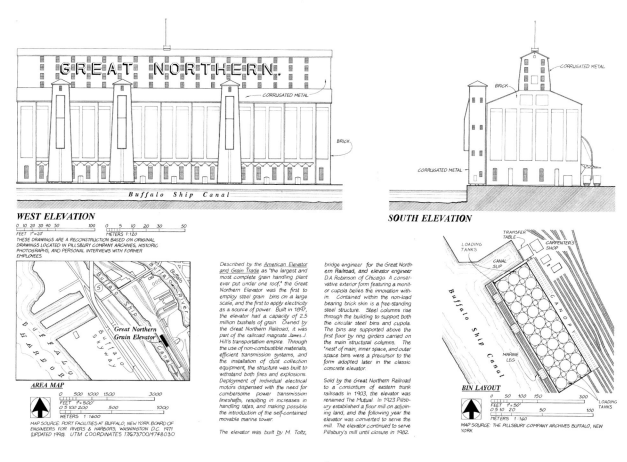

2. HAER drawing.

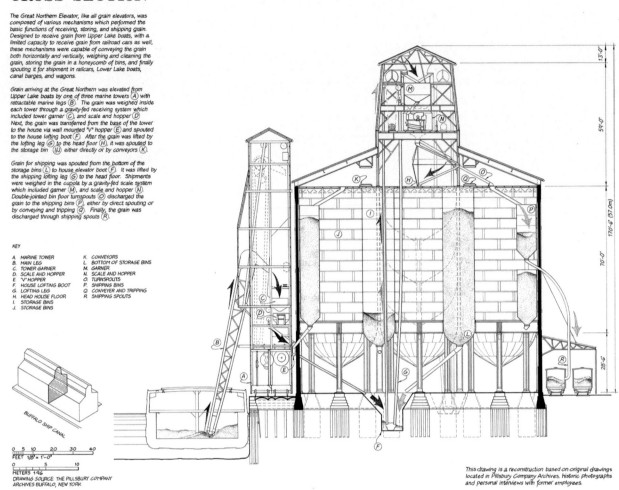

3. HAER drawing.

8 CITY SHIP CANAL / 250 GANSON STREET
CASE NO. GEN21-9498991
ADM MILLING CO.

SUBMISSION CONCERNING EMERGENCY DEMOLITION ORDER DUE TO SAFETY

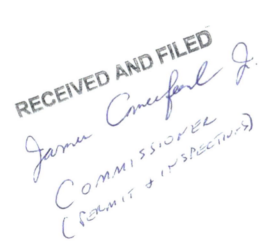

Brian M. Melber, Esq.
PERSONIUS MELBER LLP
Attorneys for
 ADM MILLING CO.
2100 Main Place Tower
Buffalo, NY 14202
(716) 855-1050
bmm@personiusmelber.com

Richard E. Stanton, Esq.
Attorneys for
 ADM MILLING CO.
415 Franklin Street
Buffalo, NY 14202
(716) 842-0550
richard.stanton@yahoo.com

4. Demolition order.

PRELIMINARY STATEMENT

In the interest of safety, the following information, engineering reports and exhibits are presented on behalf of ADM Milling Co., owner of the structure located at 8 City Ship Canal, Buffalo, NY, commonly referred to as the Great Northern Elevator ("GNE"). This application is submitted with an intent to protect the public health, safety and welfare, and in response to the December 12, 2021 Order to Remedy, which is attached hereto as **Exhibit A**.

Through this application we are requesting the Commissioner of Permit & Inspection Services issue an Emergency Demolition Permit pursuant to City Charter provision 17-2(j) and City of Buffalo Code §103-38 which provides "in the case of an emergency condition, the Commissioner of permit and inspection services is authorized to permit emergency demolition work to be done pending the issuance of the demolition permit." The partially collapsed structure at 8 City Ship Canal presents an imminent and substantial threat to life and safety which can only be alleviated by demolition. At the same time, demolition may present opportunities to further the interests of historic preservation by making the historically significant components of the structure more available and accessible to the public.

DECEMBER 11, 2021 PARTIAL COLLAPSE

During the gusty early evening hours of December 11th, 2021, the Great Northern Grain Elevator, suffered a catastrophic collapse on the northern face of its structure. As the picture below depicts, approximately 1/3 of the wall which extended approximately 100 feet in the air collapsed

to the ground, sending a debris field of bricks to the North of the structure.

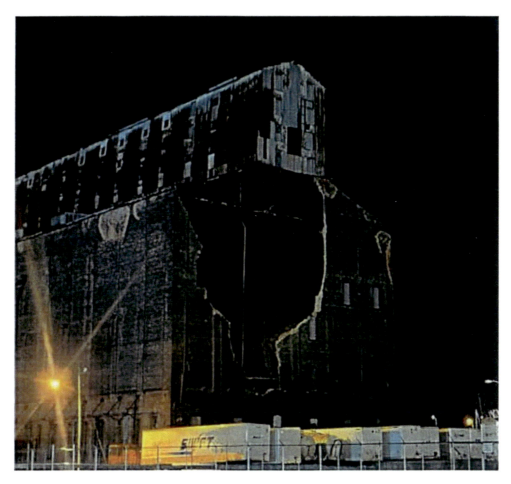

The structure that partially collapsed supported a 30' high metal cupola, that is now suspended and only partially supported, as is apparent from the above photo.

Several engineers have examined the structure, including most recently John Schenne. His December 12, 2021 report is attached hereto as **Exhibit B**. All of the engineers have concluded that the structure was not designed or built to withstand what are now understood to be the expected wind loads in its location, and that there is no safe or feasible way to remedy those design deficiencies. The brick exterior walls are far too high, too thin and are unsupported. And because

the building is over 120 years old the mortar throughout has degraded. In addition, the corrugated panel sheeting on the cupola is corroding and pieces are being periodically blown off the structure by the wind, causing potentially life-threatening debris falls. The unavoidable conclusion is that the only way to protect the public from the dangers of an inevitable further catastrophic collapse, or the ongoing scattering of debris being blown off the structure by high winds, would be a safe and immediate demolition.

PRIOR INCIDENTS OF DANGEROUS DEBRIS FALLS

The latest event was one of several imminently dangerous documented failures of the historic structure that was built before the adoption of building codes.

The structure was built in 1897, and suffered its first catastrophic failure to the North Wall of the structure in 1907. A second catastrophic failure occurred in 1923 when three towers, over 100 feet high, on the western face of the facility collapsed.

In recent years, there have been several dangerous incidents of building components, including bricks and sections of corrugated sheet metal siding, blowing off the building and landing in regularly trafficked areas. Fortunately, there have been no injuries, but these incidents of falling debris present a significant risk of serious physical injury or death to the public. These incidents include:

- A large piece of corrugated metal siding, approximately 5 feet by 2 feet, landed on the top of the parking shelter near the security building and within several feet of the Mill Manager and another employee. **Exhibit C**.

- Several months later, following a period of high winds, numerous pieces of corrugated metal were observed to have fallen to the grounds around the GNE and were photographed. **Exhibit D**.
- During a February 2019 windstorm, bricks and several pieces of corrugated metal were blown off the structure, landing on the surrounding grounds. One security guard reported that a piece of corrugated metal nearly landed on him during this incident. **Exhibit E**.
- In 2021, representatives of Wonder Coffee House, a public café located on the east side of Ganson Street across from the GNE, reported that several pieces of corrugated metal had fallen into their parking lot at various times. Those pieces of corrugated metal were collected and photographed. **Exhibit F**.

These incidents highlight the danger to life and safety of the public posed by how close this structure is to public roads, sidewalks, and neighboring businesses. Fencing off the owner's property is not enough to alleviate these risks. The GNE is some 166 feet tall, and thus the "fall zone" includes at least a radius of approximately 249 feet from the structure. Numerous public rights of way are immediately adjacent to the GNE and well within this zone.

On the West side of the structure, where the outer wall has been measured to be bowing out 10 inches, the City Ship Canal is only 22 feet away. The City Ship Canal is used by pleasure boaters, kayakers and paddleboarders in the warm weather months. On the East side, a CSX rail spur serving both ADM and General Mills runs parallel to the length of the GNE, and only 80 feet away.

Ganson Street is also parallel to the East wall of the GNE, which is also bowed out, and just 104 feet away. The sidewalk on the far side of Ganson, and the structures on the opposite side of Ganson, including Wonder Coffee House, are less than 249 feet away and also well within the Fall Zone.

General Mills employees and visiting tractor trailer drivers in the General Mills facility to the north are within range of falling debris or a catastrophic collapse of the GNE as well. Because of the height of the GNE and the proximity of these other properties and public rights of way, the danger cannot be remedied by fencing and securing the property.

Since acquiring the property, ADM has endeavored to maintain the structure, within the constraints of the original design and construction. The engineering reports indicate there is no safe or feasible way to address the overall structural condition and deterioration of the brick walls. Those reports demonstrate that no amount of maintenance would adequately address the design deficiencies and inexorable effects of time and natural forces on the structure. ADM has nevertheless spent thousands of dollars on the GNE in an effort to maintain the brick walls and exterior metal sheeting on other portions of the structure. Between 2003 and 2019, ADM spent in excess of $100,000 just on external maintenance contractors in that effort, which amount does not include other costs, such as the dedication of internal resources necessary for the completion of that work. Recently, even the maintenance ADM was undertaking on a regular basis has been limited because the contractor refused to allow their workers to go onto the property because of concerns for their safety.

Because demolition is the only feasible means to protect public safety, ADM is prepared to act immediately and to commit the necessary effort and resources to safely dismantle the structure without delay.

ENGINEER JOHN SCHENNE CONCLUDES THE STRUTURE IS NOT STRUTURALLY SOUND

In his report, engineer John Schenne concludes that the Great Northern Elevator is dangerous and presents a serious safety hazard to people and property in its immediate vicinity. He indicates these safety concerns must be addressed immediately and that it is not practical to remediate the structure to make it safe. Instead, the building must be demolished in the interest of protecting the lives and safety of the public.

A licensed Professional Engineer and Geologist, John Schenne has more than 40 years of experience with over 10,000 projects, including all manner of new construction and adaptive reuse of historic buildings. His experience includes 23 years of service as an Officer with the Army Corps of Engineers.

Mr. Schenne's report is based on a thorough review of the available documentation concerning the construction of the Great Northern Elevator as well as an inspection of the structure generally and in light of the recent partial collapse of the north masonry wall. Mr. Schenne indicates there are deficiencies in the design and construction of the brick exterior walls because they are too high, too thin, and not supported sufficiently to withstand either the inevitable wind conditions or eventual seismic events. The recent partial collapse during a wind event of 60-66 mph demonstrates those deficiencies. Current building codes would require the structure to withstand winds of 115 mph. There is a constant and ongoing likelihood of further high wind

events, which may be equal to or great than the most recent event, and which can occur at any time.

There are also questions about the foundation and a demonstrated history of steel panels blowing off the structure due to corrosion. In short, the Great Northern Elevator is not structurally sound either before, or especially after, this recent collapse. Significantly, Mr. Schenne also concludes that it is not practical to remediate the structure. "Given the immense number of bricks and the geometry of the building, there appears to be no satisfactory method of stabilizing the high walls and making them safe."

ADDITIONAL ENGINEER'S REPORTS CONCERNING ASSESSMENT OF STRUCTURAL STABILITY OF ENTIRE STRUCTURE

Between 1994 and 2019 ADM procured three separate structural engineering reports to determine if the structure could be safely repaired, and put into productive reuse. (see Jensen-Kiener Consulting Engineers report dated September 27, 1994, Petrilli Structural and Consulting Engineering PC report of January 28, 2014, and S. Shahriar Structural Condition report dated May 2019, all attached hereto as **Exhibits G**, **H**, and **I** respectively.) As set forth below, and in greater detail in the text of the reports, each structural engineering report documented a failed structure, and an inability to safely repair the same because of its manner of construction

The 1994 Janssen-Kiener report reached four fundamental conclusions which were:

1.) the masonry walls with so severely deteriorated that they lacked integrity, and their safety was questioned at that time; and

2.) the walls were not thick enough to meet building code requirements;

8

3.) The masonry walls, which extended 100 feet in the air were all bowed out, and the lateral displacement of the walls did not appear to be correctable, and leaving in the walls in place did not appear to be safe; and

4.) temporarily supporting the walls during demolition of interior steel structures so that the walls could be replaced did not appear to be feasible from a safety standpoint.

In 2014 the Petrilli structural engineers reported the outward bowing of the walls to be about 10 inches. The report further identified mortar joints deteriorated at about 90% of the locations checked, and reported the walls were not sufficiently supported to withstand wind loads. Unfortunately, the most recent incident of December 11, 2021 proved Petrelli's assessment to be accurate. Petrelli further advised against attempting to repair the structure from within as unsafe due to its condition.

The 2019 report repeated the ultimate findings of the earlier report concerning structural instability, and lack of a safe feasible method to repair, and further identified evidence of cracks developing in the brick walls, and bricks and sheet metal falling off the structure, the upper 20 feet of the brick walls were severely damaged.

OPPORTUNITIES TO ENHANCE
HISTORICAL PRESERVATION AND ACCESS

While the entire GNE cannot safely be maintained intact, there may be opportunities to make the historical significance of the structure more available and valuable to the community. ADM is open to exploring those opportunities, and working with community partners in that effort, while always placing safety first. For example, it may be possible to preserve and donate significant artifacts, many of which are inside the structure and now completely inaccessible to the community. In addition, if it can be done safely, the structure itself might be inspected, studied

and documented at appropriate times during the demolition process in ways that may not otherwise be possible. The Secretary of Interior has established Standards & Guidelines for such mitigation by documentation. **Exhibit J**. While not binding on this effort, these Standards & Guidelines may provide a starting point for a plan of mitigation to preserve and enhance the historical value of the GNE for the benefit of the community.

CONCLUSION

Because of its design and inevitable deterioration over time, the Great Northern Elevator presents an immediate and substantial threat to life and safety which cannot be remedied by creating a perimeter around the structure, or by remedial maintenance to the structure. The only feasible and effective way to protect the public is through safe demolition. ADM remains committed to the safety of the public, its neighbors and employees, and makes this request in the interest of safety.

Dated: Buffalo, New York
December 15, 2021

Brian M. Melber, Esq.
PERSONIUS MELBER LLP
Attorneys for
ADM MILLING CO.
2100 Main Place Tower
Buffalo, NY 14202
(716) 855-1050
bmm@personiusmelber.com

Richard E. Stanton, Esq.
Attorneys for
ADM MILLING CO.
415 Franklin Street
Buffalo, NY 14202
(716) 842-0550
richard.stanton@yahoo.com

CITY OF BUFFALO
DEPARTMENT OF PERMIT & INSPECTION SERVICES
OFFICE OF THE COMMISSIONER

BYRON W. BROWN
Mayor

NOTICE OF CONDEMNATION

JAMES COMERFORD, Jr.
Commissioner

DECEMBER 17, 2021

New York State Department of Labor
Division of Safety and Health
Engineering Services Unit
State Office Building Campus
Albany, New York 12240

RE: **8 CITY SHIP CANAL AKA 250 GANSON**

As Commissioner of the Department of Permit and Inspection Services, I have had the opportunity to review the conditions referencing the aforementioned property. The following conditions were noted:

1. The Building is vacant and abandoned.
2. The Building and/or portions thereof are in a state of structural compromise.

FOLLOWING THE HIGH WIND STORM ON SATURDAY, DECEMBER 11, 2021 AND THE SUBSEQUENT VISUAL AND DRONE INSPECTION THE BUILDING WAS FOUND TO BE STRUCTURALLY UNSOUND AND IN IMMINENT DANGER OF COLLAPSE:

· *The northern masonry wall is compromised and failing.*

· *In inspecting the compromised northern wall, the masonry construction appears to lack reinforcement. Additionally, the height to width ratio appears to be far excessive of design standards.*

· *Upon visual inspection with drone footage, there are multiple visual stress cracks at the east wall (Ganson Street façade). The masonry appears to lack control joints.*

· *There is evidence of structural failure at the northern portion of the building. The roof deck and penthouse/cupola support structure appear to have failed anchorage points where the northern masonry wall failed. The roof deck and penthouse/cupola appear to cantilever for approximately 15 feet without support at the north end. This failure has the potential to compromise the life and safety of individuals in proximity to the building.*

· *There is also a major life and safety issue associated with the corrugated metal panels at the roof and penthouse/cupola detaching from anchorage points in common weather events. There is evidence of metal panels detaching and traveling to neighboring properties. Upon viewing drone footage, there are missing panels at the penthouse/cupola and many panels exhibit significant corrosion.*

· *This site is classified as an Exposure D Category per the 2020 Building Code of New York State. This is the most restrictive category for wind loads which corresponds to a maximum wind speed well over the 70 miles/hour wind speed that contributed to the failure of the north wall on December 11, 2021. There is significant concern of subsequent high wind events*

· *The notice of condemnation is supported by the City of Buffalo Fire Commissioner, William Renaldo, as per the attached letter dated December 15, 2021.*

65 NIAGARA SQUARE / 324 CITY HALL / BUFFALO, NY 14202-3303 / (716) 851-4972 / FAX: (716) 851-4242 / Email: jcomerford@city-buffalo.com

5. Condemnation order.

CITY OF BUFFALO
DEPARTMENT OF PERMIT & INSPECTION SERVICES
OFFICE OF DEMOLITIONS

BYRON W. BROWN
Mayor

JAMES COMERFORD, JR
Commissioner

3. The Building condition is such that the likelihood of a fire exists.

4. The Building condition is such that it poses a health and safety issue for the community.

As this building is in partial structural failure and entering upon these premises poses imminent danger, the Department of Permit and Inspection Services has determined that this structure is in violation of Chapter 113 – "Unsafe Buildings" – of the Code and Ordinance of the City of Buffalo. By the powers vested in me by the Charter of the City of Buffalo, Section 17-2 – "Duties and Powers", **I am declaring this building *condemned* and I am ordering demolition as soon as possible**. The Department of Permit and Inspection Services is in support of the application of an ICR 56, 11/5 – Controlled Demolition/Condemned Buildings – to demolish the structure with the asbestos-containing material in place so as not to place workmen in a dangerous situation. Compliance with ICR 56-3.4(B1) – Notification to the New York State Department of Labor - is <u>mandatory</u>. Due to emergency conditions, we request that the ten-day notification be waived.

If you have any questions concerning this matter, please contact Commissioner James Comerford, Jr. at (716) 851-4972.

Sincerely,

James Comerford, Jr., Commissioner
Catherine Amdur, Deputy Commissioner
Thomas Brodfuehrer, Assistant Director

65 NIAGARA SQUARE / 312 CITY HALL / BUFFALO, NY 14202-3303 / (716) 851-4949 / FAX: (716) 851-5506

BRIAN HIGGINS
26TH DISTRICT, NEW YORK

COMMITTEE ON WAYS AND MEANS
SUBCOMMITTEE ON HEALTH
SUBCOMMITTEE ON TRADE
SUBCOMMITTEE ON SOCIAL SECURITY

COMMITTEE ON THE BUDGET

ASSISTANT WHIP

Congress of the United States
House of Representatives
Washington, DC 20515–3226

2459 RAYBURN HOUSE OFFICE BUILDING
WASHINGTON, DC 20515
(202) 225-3306
(202) 226-0347 (FAX)

726 EXCHANGE STREET
SUITE 601
BUFFALO, NY 14210
(716) 852-3501
(716) 852-3929 (FAX)

800 MAIN STREET
SUITE 3C
NIAGARA FALLS, NY 14301
(716) 282-1274
(716) 282-2479 (FAX)

higgins.house.gov

December 13, 2021

Mr. Juan R. Luciano
Chairman of the Board of Directors, President and Chief Executive Officer
Archer Daniels Midland
77 West Wacker Drive, Suite 4600.
Chicago, Illinois 60601

Re: Repairing damage to ADM's historic Great Northern elevator, Buffalo, NY

Dear Mr. Luciano:

As you surely know, a wind storm this weekend caused the collapse of a significant portion of the northern wall of ADM's historic Great Northern grain elevator in Buffalo, NY. I write today to strongly encourage ADM to rehabilitate this structure, for its own benefit and the benefit of the community I represent in Buffalo and Western New York.

I further urge you to consider the long overdue designation of this structure on the National Register of Historic Places in order to avail the federal Historic Tax Credit program, the New York State Historic Tax Credit program, and potentially other incentive programs to restore this historic structure.

I request a meeting with you in the coming days to learn about the current status of the structure from ADM's perspective, and to offer assistance relative to the above-refenced federal programs.

Thank you very much.

Sincerely,

[signature]

Brian Higgins
Member of Congress

6. Letter from Rep. Brian Higgins to ADM CEO Juan Luciano.

Mayor Byron Brown
City of Buffalo
65 Niagara Square
Room 201
Buffalo, NY 14202

December 16, 2021

Dear Mayor Brown:

On behalf of the Board of Directors of the American Institute of Architects Buffalo/WNY chapter, I am writing to you regarding the Great Northern grain elevator that was damaged days ago, in last weekend's windstorm. This iconic building and its future deserve thoughtful consideration. We acknowledge the significance of this building and its place in the unique history of the City of Buffalo. We respectfully request that the City place a 60-day moratorium on any demolition measures to allow the City and its residents to fully understand the impacts of any proposed demolition. This building, that has been **part of the City of Buffalo's historic fabric for 124 years**, deserves at least a 60 day pause before its powerful presence is potentially erased.

Historical Significance

- The 1897 Great Northern Elevator is the only surviving brick box elevator in North America.
- It is the oldest surviving elevator in Buffalo's Grain Silo District. This carries significant value as Buffalo is the city where the grain elevator was invented —an innovation which was then exported the world over (arguably one of Buffalo's greatest contributions to the world). The oldest and only surviving example of this type should matter greatly in this unique context.
- The Great Northern's location on the Buffalo River renders it an icon of the historically and architecturally significant collection of grain silos, which label Buffalo as the "elevator capital" of America.
- The Great Northern is the only steel structure among the existing collection in Buffalo; the rest are concrete. Designed by Max Toltz, the Great Northern was acclaimed as "among the most important engineering works of modern times." It was one of the first cost effective and thermally efficient methods of bulk grain storage.
- It serves as a primary example of the city's historic role as the center of transportation and commerce in the late 19th and early 20th centuries.

Significance Today

- The Great Northern's significance is not only as an international marvel of engineering and architecture, but also as a cherished monument to the morphological and cultural evolution of the city—as an icon of our history in terms of labor, immigration, urban development, the shaping of our

AIA Buffalo/WNY
3500 Main Street
Suite 130-113
Buffalo, NY 14226

T (716) 427 4242
E info@AIABuffaloWNY.org

https://www.aiabuffalowny.org/

7. Letter from Anne Dafchik, AIA, President of AIA Buffalo/WNY, to Mayor Byron Brown.

- waterfront, industrial heritage, national legacy, etc. Further, <u>the elevators that remain stand as permanent fixtures in the collective memory of now seven+ generations of Buffalonians</u>.
- Buffalo's collection of grain silos on Lake Erie and the Buffalo River are **the** feature that make our city a unique place in the U.S. and the world. **No place else on earth has what we have here**.
- Travelers from around the globe have been coming to Buffalo just to see the grain elevators since the nineteenth century and through today, further evidencing their national and international significance, and enduring legacy.

Again, we respectfully ask that the City of Buffalo allow a period of time for itself, its residents, and the community to fully understand the impact of this building and its possible demolition. The AIA Buffalo/WNY organization understands that safety is of utmost importance in this situation, and firmly believes that there are viable, safe options <u>other than total demolition</u> at this moment.

We are most willing to offer organizational support for this important effort. As a 501(c)6 organization of professional architects, we are uniquely positioned to reach out to our structural engineer colleagues to request professional engineering analysis, either through pro-bono efforts or other avenues.

During this time, we would hope that the City of Buffalo would seek short-term stabilization of the structure and consider an independent structural assessment, while also gaining an understanding of the environmental and social impacts that will forever shape our future skyline and identity as Buffalonians.

Sincerely,

Anne Dafchik
Anne Dafchik
AIA Buffalo/WNY President

cc: Jim Comerford, City of Buffalo Commissioner of Permit & Inspection Services
 Christopher Scanlon – City of Buffalo Councilman, South District
 Gwen Howard, Chairperson, City of Buffalo Preservation Board
 Brian Higgins, Congressman, NY-26
 Sean Ryan, State Senator
 Tim Kennedy, State Senator
 Crystal Peoples-Stokes, NYS Assemblymember
 Pat Burke, NYS Assemblymember
 Mark Poloncarz, Erie County Executive
 Honorable Kathy Hochul, Governor of NYS

CITY OF BUFFALO
OFFICE OF THE MAYOR

BYRON W. BROWN
MAYOR

December 23, 2021

Mr. Juan Luciano
Chief Executive Officer
Archer Daniels Midland Company
77 West Wacker Drive, Suite 4600
Chicago, Illinois 60601

Dear Mr. Luciano,

As you are aware, on December 17, 2021 you received a Notice of Condemnation for 8 City Ship Canal (a.k.a. 250 Ganson Street) to address the imminent danger that the Great Northern Elevator presents following the windstorm on December 11th. While the imminent danger needs to be addressed, there is the possibility of mitigating that danger and saving the elevator wholly or in part. As Mayor of Buffalo, I am asking you to make every effort to preserve the Great Northern Elevator.

The Great Northern Elevator is the only surviving brick box elevator in North America and the oldest surviving elevator in Buffalo's Grain Silo District. The grain elevator was invented in Buffalo, it is central to what put us on the map. Our stories intersect with the Great Northern Elevator; it is one of the places where ADM, Supermarket to the World, connects with a city that grew from the grain industry. I believe that preserving the Great Northern Elevator will tell both our stories to the nation and world for generations to come while showcasing your commitment to the communities and industrial heritage upon which ADM's success was built.

While saving the elevator will carry a hefty cost, there are programs that could significantly offset those costs. The City offers its support in securing resources such as historic and brownfield tax credits, city property tax abatements, sales and mortgage tax exemptions, and working with our partners in the New York State and Federal government levels.

I appreciate that ADM is willing to consider some form of preservation. It is important to note that there are also several offers from reputable entities to either form a partnership in preservation or to buy and save the elevator.

This elevator is central to why Buffalo is labeled the "elevator capital" of the world. Without it, we lose an icon and a structure that was acclaimed 124 years ago as "among the most important engineering works of modern times". The story of our city is told through our buildings and would be deeply impacted by the loss of the elevator. I appeal to you to save the Great Northern Elevator and make our legacy part of yours.

Sincerely,

Byron W. Brown
Mayor

ROOM 201 CITY HALL / BUFFALO, NY 14202 / (716) 851-4841 / FAX (716) 851-4360 / www.city-buffalo.com

8. Letter from Mayor Byron Brown to ADM CEO Juan Luciano.

January 9, 2022

Hon. Byron Brown
City Hall
65 Niagara Square
Buffalo, NY 14202

Dear Mayor Brown,

I am writing you today urging you to rescind the Order of Condemnation on the Great Northern grain elevator issued by Commissioner Jim Comerford. The existence of the emergency declaration itself provides a pretext for the owner to not allow inspection of the site. Absent that, you are empowered to send inspectors and other parties into the building to verify conditions. In addition, a measured review of a demolition request could occur through the normal Preservation Board process.

A substantial part of my career as an architect has been working with you as both the school district's architect or Chair of the Buffalo Preservation Board. I worked as an architect in City Hall for 32 years. As you know, I was architect for the BPS for 25 years, in which capacity I closely reviewed dozens of buildings constructed like the Great Northern.

You have a strong record, dating back to councilmanic days, of being supportive of preservation efforts like Hamlin Park and, dating to state senatorial days, behind-the-scenes efforts to help the efforts at the Richardson Complex. We share the goal of doing the best possible thing for Buffalo. As mayor, I hope you can cement that legacy by saving one of the most important buildings the city has.

After a thorough review of the structure's historic documentation I can confidently say, based on information that would be new to him and you, that Commissioner Comerford's order was in error, and that the building is in no danger of collapse, nor is its top section, the cupola, in any danger of blowing off.

The brick cladding can be repaired, as can the metal cladding. The steel frame and the steel grain bins are, as the Historic American Engineering Record states, if anything, materially "considerably overspecified."

The rationale provided by owner ADM is certainly thinly supported. An engineer's letter provides a page-and-a half narrative on a structural assessment of the Great Northern by engineer John Schenne. There are no exhibits attached that corroborate statements made regarding the structural stability of the Great Northern (photographs, drawings, test results). The same applies to correspondence of three other engineers included in the "Submission Concerning Emergency Demolition Order Due to Safety' compiled by the law firm.

I served for on the Preservation Board For 11 years and I reviewed easily hundreds of demolition requests for houses that had more documentation—because the city requires it. A proper architectural and engineering conditions survey on a structure such as the Great Northern would normally be expected to run to dozens, if not hundreds, of pages of fact-finding, analysis, and recommendations. You doubtless have had similar reports pass through your hands and that of staff. The Schenne letter is grossly inadequate, unsupported by fact, and uncorroborated.

First and foremost, it must be clear that the brick cladding of the Great Northern is not load bearing, but it shares characteristics with other solid brick walls stretching to antiquity. In thick, tall walls, the layers—wythes—of brick are joined together by rotating alternate bricks or rows of bricks so that the long side interlocks with the wythe behind it. This can be done in successive wythes to bond together a wall of any thickness. Since the walls are all-masonry, there is no need to account for material differences of expansion or contraction.

It has been contended that the Great Northern is of substandard construction because it lacks control joints. Control joints were conceived to solve the problems of cheaper construction from the 1930s onward. Most "brick" walls today are only a veneer attached to a steel, wood or concrete substrate. Control joints are then required to solve the problems created by the movement different materials used in combination with cheaper light-weight masonry.

This is evident in the dozens of solid masonry Buffalo public schools I am familiar with constructed before 1930. There aren't any control joints. The more modern schools have them because their walls are only a veneer.

The cupola of the Great Northern is supported by a steel frame that is independent of the brick walls.

C4GB **The Campaign for Greater Buffalo History, Architecture & Culture**
403 Main Street, Suite 705, Buffalo, NY 14203. 716-854-3749. FrontDesk@c4gb.org

9. Letter from Paul McDonnell, AIA, president of the Campaign for Greater Buffalo History, Architecture & Culture to Mayor Byron Brown.

Examination of the pictures show the brick wall is constructed well in front of the plane of the cupola and it is not supported by the brick. Therefore, Mr. Comerford's rationale that "The roof deck and penthouse/cupola lacks structural support where the northern brick wall failed" is unsubstantiated and his statement that the roof deck and penthouse/ cupola appear to cantilever for approximately 15 feet without support at the north end" is, in fact, unsupported.

Any hazardous condition related to ill-maintained or damaged roofing on any building can be resolved by removing, reattaching or replacing any loose or damaged roofing material. This can be achieved at the Great Northern with a crane and bucket so workers do not have to enter the structure. Further, loose roofing material has been cited by ADM to advance previous demolition requests, which the City determined did not justify demolition. Therefore, the rationale that "There is a major life and safety issue associated with corrugated metal panels at the roof and penthouse cupola detaching from anchorage points in common weather events" is unsupported.

Each of the Commissioner's findings regarding the need for demolition lacks substantive support in fact. These are factual issues in which the Commissioner was mistaken, and not matters of opinion.

The Commissioner says his emergency order relied in part on submissions provided by owner ADM. There are four papers from ADM presented to Jim Comerford. None are full-fledged conditions reports such as I am familiar with on the many Buffalo schools and historic landmarks such as Kleinhans Music Hall, the Martin House, or the Richardson Complex. They are four-to-seven page text-only briefs of opinion on certain aspects of the building. None include photographic evidence or structural diagrams in support of conclusions or other means of verification.

The first, by Jansen-Kiener of 1994 as a subcontractor, explicitly states that its purpose is to explore the feasibility of removing the present steel structure and replacing it with a concrete elevator while retaining the non-structural brick cladding. Not surprisingly, the report concludes that once the steel bins and frame are removed that provide lateral support for the cladding, the cladding will be unstable. It then offers a method to fix the instability it would have created.

Jansen-Kiener mentions a bowing of the west wall that is referenced by the three subsequent reports. Jansen-Kiener itself did not make any measurements in 1994. Rather, it reports on a property survey drawing made in 1948 and updated in 1951, 1962, 1964, 1966, and 1971.

It "interprets" the survey drawing to mean that in 1971 the bowing of the 100-foot-high wall was somewhat under 10 inches, or 10 inches in 1200 inches, less than 1%. The bowing was also inward. The "considerably over specified" steel bins (Historic American Engineering Record) and structural columns provide the Support to this wall.

Significantly, Jansen-Kiener offers no interpretation on whether the condition was dynamic or stable, nor do any of the other engineers. Indeed, the bowing could have been present from construction. Certainly, in the 50 years since the last survey date noted, no one has deemed it necessary to re-measure the west wall or any other. Jim Comerford referenced the mention of bowing in the reports as contributing to his decision that the Great Northern is so unstable as to constitute an imminent threat to public safety.

The second submission, by Petrilli Structural & Consulting Engineering of 2014, IS A VERBATIM COPY OF THE 20-YEAR-OLD JANSEN-KIENER REPORT on removal of the steel bins, save for four words in the final sentence and two short paragraphs discussing steel plate flooring, and an inflation-adjustment statement. Petrilli states that its walk-through was limited, as the steel floor plating is so deteriorated it is unsafe to walk on. As floor plating only exists at the four floors of the cupola, it means the entire evaluation occurred from an access stair at an end of a 400-foot long structure.

Further casting doubt on the sole new conclusion of Petrilli, is the notion that the floor plating functions as a horizontal diaphragm and the integrity of the building could be effected by its deterioration and "further overstressing and cracking of the masonry walls." As the attached drawings and photographs prove, the steel frame and bins are independent of the brick cladding. Even where the brick cladding was built up to meet the already-completed roof, the contact point is a steel plate that provides a smooth surface for rafter roller bearings to move about to handle expansion and contraction. Thus, no stress is transferred.

Lastly, Petrilli makes the odd statement that the steel plate acts as a diaphragm, ignoring the robust system of I-Beams attached to trusses at the principal work floor at the top of the bins, the distribution floor, and the girder-and-angle-bracing system which creates a rigid structure for the cupola. You could lay down plywood to provide a safe temporary floor on which to walk and work.

The S. Shahriar paper of 2019, by its own criteria, cannot be used to come to any conclusions of the structural stability of the Great Northern. As stated, the scope of services was "1. One visit...to perform a condi-

tional visual observation of the abandoned Great Northern...Due to access limitations, [the engineer author] was not able to observe all conditions. Visual observations...are to identify any apparent/obvious defects." Unfortunately for those wishing to make rational decisions based on the report, the engineer states in the very next sentence "Design deficiencies of pre-engineered and pre-manufactured structures, bridges, towers, bents, steel bins, and steel storage tanks cannot be established by visual observations."

Shahriar references many photographs and appendices, but none are provided with the report given to Jim Comerford. In any event, the report indicates that no testing was done to ascertain the condition and strength of the steel.

Shahriar closes by stating his "report is based on limited visual observations. There is no claim, either stated or implied, that all conditions were observed." Further, "these conclusions are based on general structural engineering principal and industry knowledge combined with our experience." The author is going out of his way to say that his conclusions are not based on observations of the Great Northern.

The last report is by John Schenne of December 2021. He takes all of 1 1/2 pages on current conditions to argue for immediate demolition. Schenne makes unverifiable assertions and inferences. Despite acknowledging no testing or observations, he offers that the 6,000 Wooden pilings that were sunk to the lowest 19th-century lake level may have been subject to "wet/dry cycles" which somehow may have had an unknown effect on the soundness of the piles. As the graph I attached shows, Lake Erie never has had anything that could be described as a "dry cycle" in the last century. In any event, Schenne himself says the naturally occurring soil at the site is "soft lake sediment clays"—excellent for to keep the soil and pilings hydrated through capillary action .

Further, Schenne raises the specter of earthquakes, stating that Buffalo is a "seismically active area." Records show earthquakes of any kind to be very rare in Buffalo. When they have occurred, they are often not even felt. In 200 years there has never been a report we've been able to find of an earthquake that produced structural damage in Buffalo.

Schenne provides no photographic and testing evidence whatsoever to support its notions of any significant risk to the public from possible earthquakes (very rare and very weak in Buffalo), desiccation of pilings, and compromised structural steel. These are very serious—even outlandish—assertions which need to be verified.

I have spent a great deal of time reviewing all of the information before me— more than Commissioner Comerford had before him— and I am convinced that proper repair and temporary protection for the public is all that is needed to save this important structure.

Please withhold the demolition permit and compel the owners to stabilize and repair this extremely important treasure.

Sincerely,

[signed]

Paul McDonnell, AIA
President

Attachments

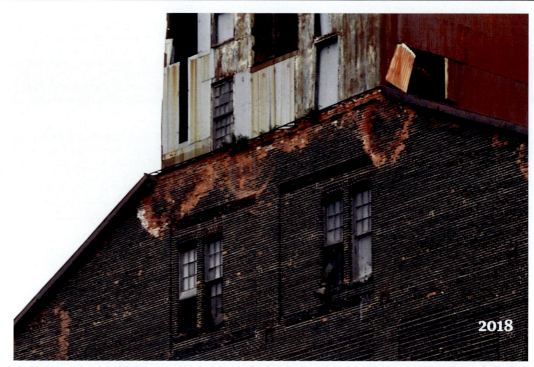

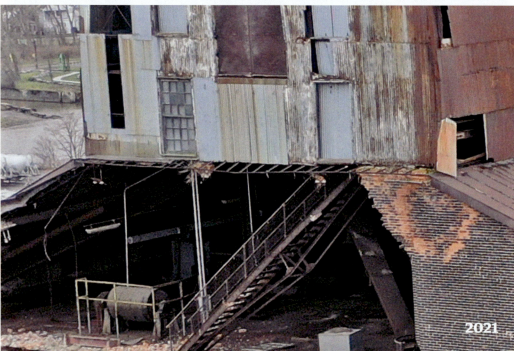

Abandonment and lack of maintenance since 1982 caused the weakening at the top of the north wall, where deteriorated and missing flashing was never fixed. Bushes were growing on top of the wall in 2018.

There is an insinuation in the Schenne letter that "wet/dry cycles" may have effected the groundwater levels at the City Ship Canal shoreline to the extent that the pilings, which extend to bedrock and were topped off at the low water datum, which is about 569 feet. That figure was established in 1933 using the previous century's water-level records, and is two feet below the mean level of the Lake, 571 feet above sea level. There has never been a period where the water has gone more than mere inches below the low datum for even 60 days over the last century. There simply has never been a drying out of the soil at low-water datum, let alone the pilings. Mere age of hemlock pilings is not a cause of concern (they are only 125 years old, and wooden pilings hundreds of years older firmly support houses, cathedrals, and large buildings around the world).

The Schenne report also states that the Buffalo area is "seismically active" without defining the term. Earthquakes in Buffalo that are of a magnitude that are even felt in calm conditions, let alone cause damage to buildings, are rare. Further, the Great Northern is not supported by soil, but by bedrock, by means of the aforementioned pilings. The probability of an earthquake of a moderate 5.0 scale in Buffalo is 2.64% over 50 years. The probaility of a 6.0 earthquake over 50 years is .51%. Thus earthquakes that may cause damage to structures in Buffalo have not happened (we haven't found any recorded or reported) and are unlikely to happen.

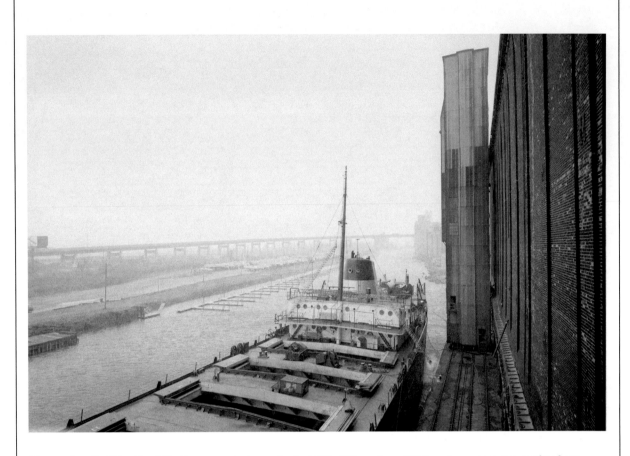

The west wall of the Great Northern, as photographed c1980. Although an ADM engineer interprets a land survey as indicating in 1971 that there was an almost-10-inch inward bow of the wall over its 1200-inch height (where it would be supported by the steel grain bins and columns). There is no indication of movement— indeed the bow could have been there since construction— and it has not been measured in 50 years, no ADM engineer evidently feeling it necessary.

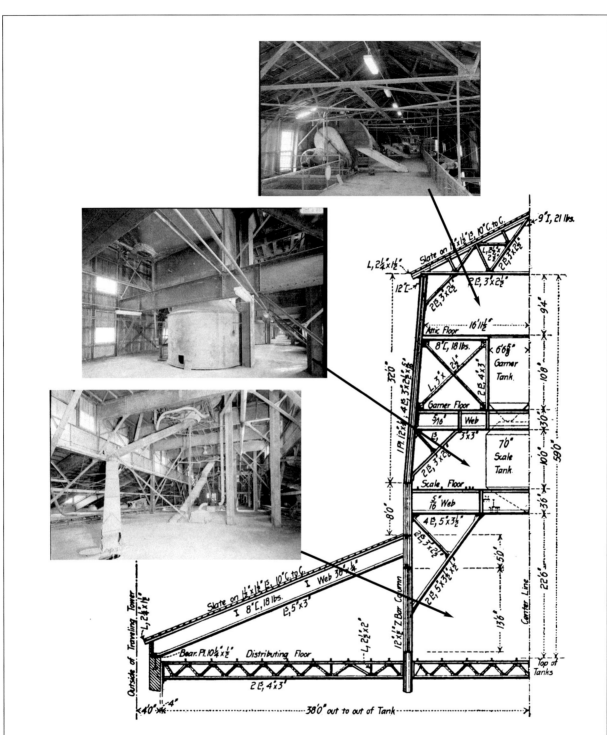

The Great Northern's roof and workhouse, or cupola, are composed of massive 60- 40-, and 36-inch girders, cross bracing, trusses and structural columns which extend to the foundation. The roof and cupola have corrugated steel cladding which has not been properly maintained

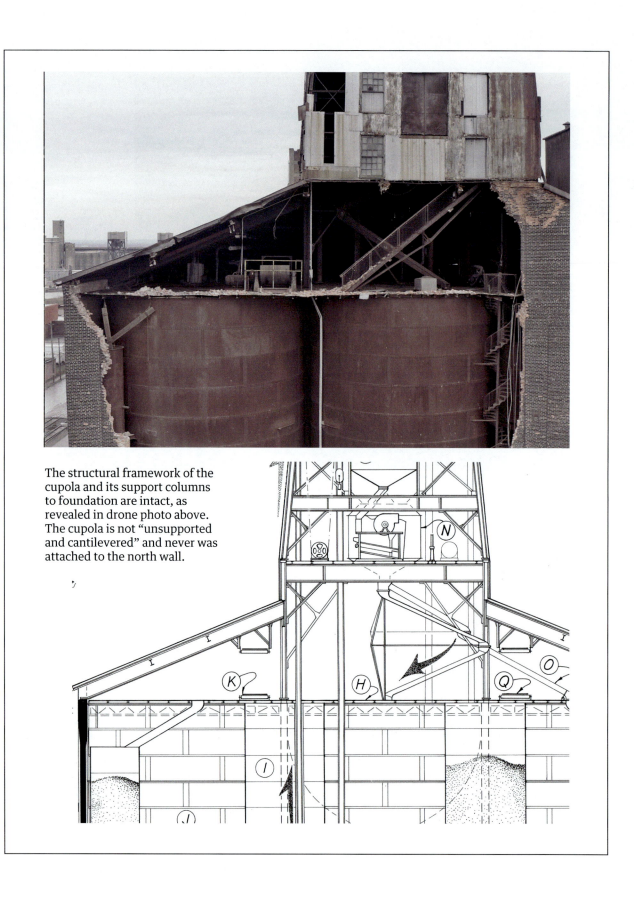

The structural framework of the cupola and its support columns to foundation are intact, as revealed in drone photo above. The cupola is not "unsupported and cantilevered" and never was attached to the north wall.

Massive 29" x 30" main columns, plus scores of others, combine with the steel bins to form a single immovable mass of steel that will keep the Great Northern stnding for centuries

Each bin is bolted to each of eight surrounding columns, which are bolted to all abutting bins, forming a monolithic construction which would survive the strongest earthquake imaginable in Buffalo.

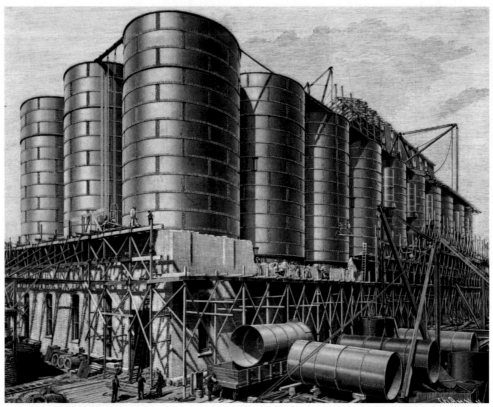

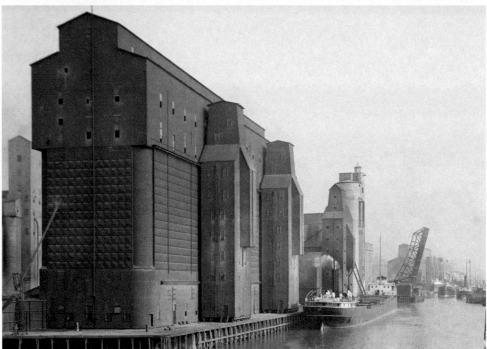

The Great Northern structurally doesn't need its brick cladding, as the construction engraving shows (top); later steel elevators dispensed with cladding the bins, as at the Dakota (1906) downstream. The workhouse and basement had metal siding, while the bins had steel screens for shading.

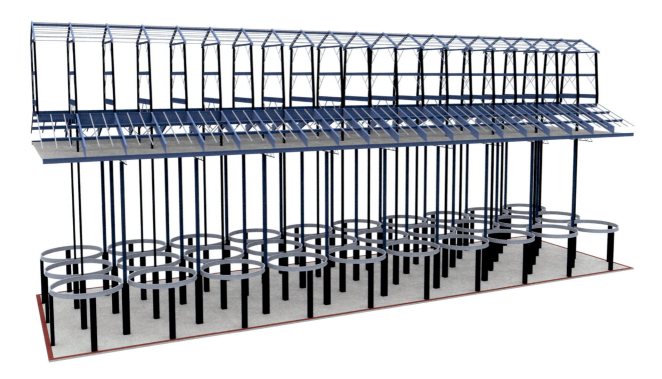

10. Computer-generated drawing showing the vertical steel columns supporting the Great Northern's bins and cupola.

Index

ADM mill, 51
ADM Milling Company (ADM), vii, xii, xiv, 3, 4, 8, 11, 14, 17, 19, 21, 28, 30, 34, 36, 41, 45, 49, 51, 53, 55, 121, 169, 172, 174, 178
Anthony, Susan B., 34
Appellate Division, New York, xiii, 28
Article 78, xiii, xiv, 25, 28, 43
Attica, 35

Bacchae, The (Euripides), 47
Brick wall (Great Northern: 3, 31, 33, 38, 39, 55, 57, 174; bow, 38, 39, 45, 178; cladding: 47, 48, 173, 174, 182; cracks, 30, 38, 39, 45, 55; curtain, 3, 10, 24, 30, 40, 41, 45, 52, 53, 57, 60, 61; mortar, 25, 28, 37, 39, 45; North wall, xii, xiv, 3, 9, 11, 14, 23, 24, 26, 27, 30, 31, 45, 48, 52, 176, 180
Brown, Byron, Mayor, xii, xiii, 11, 12, 17, 19, 30, 47, 121; letter to Juan Luciano, 172
Buffalo News, 12, 17, 18, 21, 22, 26
Buffalo River, 6, 8, 13, 51, 57, 59, 170, 171
Buffalo Ship Canal, xiii, 6, 12, 13, 15, 31, 51, 52, 57, 59, 60, 177
Burnham, Daniel, 15

Campaign for Greater Buffalo, xiii, xiv, 3, 18, 22, 24, 25, 27, 28, 30, 36, 43, 47, 52, 121, 173
Cassandra, 48
Caterpillar 165' Ultra High Demolition Excavator, 4, 10, 34, 55, 165

City Ship Canal, xiii, 6, 13, 15, 51, 52, 57, 59, 60, 177
Code (building), 18, 30, 41
Colaiacovo, Emilio, Judge, xiii, xiv, 3, 4, 25–36, 41, 43, 46, 48, 53
Coliseum (Roman), 49
column (Great Northern support), 48, 121
Comerford, James, Jr., xii, xiii, 3, 8, 11, 15, 17, 19, 25, 33, 36, 38, 39, 41, 43, 45, 48, 55, 121, 171, 173, 175
Common Council, Buffalo, 3
computer-generated graphic (Great Northern structure), 27, 121, 183
Corbusier, Le, 7
cupola (Great Northern), 9, 10, 29, 31, 33, 39, 40, 45, 47, 48, 52, 55, 57, 60, 121, 173, 174, 179, 180, 183

Dafchik, Anne, xii, 11, 47, 121; letter to Mayor Byron Brown, 170–171
Dart, Joseph, xi, 6
demolition, xii, xiv, 3, 4, 7, 8, 10, 12, 14, 15, 18, 19, 21, 28, 30, 36, 39, 43, 47, 48, 51, 53, 55, 57, 60, 121, 157, 170, 171, 173, 175
Dunbar, Robert, xi, 6

Elevator Alley, 8
Elfvin, John, Judge, 35
Erie Canal, xi, 5, 6

Fire Commissioner, Buffalo, *see* Reynaldo, William
Fourth Department, xiii, 28

General Mills, 13, 51, 52
Grain elevators, Buffalo: Agway-GLF, 8; Cargill Superior, 14; Concrete Central, 8; H-O Oats, xii, 8; Lake and Rail, 14: Silo City, 8
Gropius, Walter, 7
Guaranty Building, 7

Higgins, Brian, Rep., 11, 47, 121; letter to Juan R. Luciano, 169
Historic American Engineering Report (HAER), v, viii, ix, 8, 27, 29, 31, 40, 48, 53, 121–156

injunction, 28, 33
Island Warehouse Company, xii

Khanna, Sanjay, 21
Kresse, Robert, 49
Kruse, Tedd, 22, 23, 47

Lake Erie, xi, 6, 8, 59, 171, 175
Larkin Administration Building, 7
Lowe, Jet, 29, 40, 48
Luciano, Juan, xii,xiv, 11, 17, 19, 121, 169, 172

marine leg/tower, xi, xiv, 6, 9, 13–15, 56, 57
McDonnell, Paul, vii, xiii, 18, 23, 29, 30, 32, 33, 38, 40, 47, 48, 121; letter to Mayor Byron Brown, 173–182
Mead, McKim and White, 7
Melber, Brian, 14, 26, 121
Michigan Avenue Bridge, 15, 57, 59
Mutual Elevator Company, xi

National Register of Historic Places, 11
"Notice of Condemnation," 12, 18, 26, 31, 167–168

Olmsted, Frederick Law, 7
"Order to Remedy," xii, 11

passive voice, 19
Permit and Inspection Services (Buffalo), 3, 18, 19
Pillsbury Company, xii, 38
Preservation Board (Buffalo), xiii, 8, 12, 19, 23, 27, 29, 30, 32, 45, 47, 48, 171, 173

"rational basis," 26, 28, 33, 36, 39, 40, 43, 175
Reynaldo, William, 12, 13–15, 25, 27, 30, 31, 55
Richardson, Henry H., 7
RiverWorks, 8, 13
Robinson, D. A., 40

Schenne, John A., 12, 25, 28, 31, 33, 38, 40, 47, 48, 173, 175, 177
Sommer, Mark, 12, 17, 18, 21, 22, 26
St. Lawrence Seaway, xii, 6
"Submission Concerning Emergency Demolition Order Due to Safety," xii, 121, 157–166
Sullivan, Louis, 7

Temporary Restraining Order (TRO), xiii, xiv, 25, 28, 33
Termini, Rocco, 17

Vespasian, Emperor, 49

Welland Canal, xi, xii
White, Stanford, 7
Whitlock, Allen Rhett, 31, 33, 39, 40
Wright, Frank Lloyd, 7, 37